The Real Business of Photography

Richard Weisgrau

ALLWORTH PRESS

NEW YORK

AMERICAN SOCIETY OF
MEDIA PHOTOGRAPHERS

© 2004 Richard Weisgrau

07 06 05 04 03 5 4 3 2 1

Published by Allworth Press
An imprint of Allworth Communications, Inc.
10 East 23rd Street, New York, NY 10010

Cover design by Derek Bacchus

Interior Design by Sharp Designs, Inc.

Page composition/typography by Integra Software Services Private Limited, Pondicherry.

ISBN: 1-58115-350-3

LIBRARY OF CONGRESS CATALOGING-IN-PUBLICATION DATA
Weisgrau, Richard.
 The real business of photography/Richard Weisgrau.
 p. cm.
Includes index.
 ISBN 1-58115-350-3 (pbk.)
 I. Title.

TR690.W45 2004
770′.68—dc22

 2004005389

Printed in Canada

Contents

Introduction

Many professional photographers wish for help in the form of a studio or office manager, agent, representative, consultant, or some other guru who will offer them guidance as they try to navigate the rapids in the daily flow of their businesses. This is especially true of those who have no or only a few years of experience in the business. It is an understandable condition. Art and business require such different types of creativity and practice that they seem irreconcilably opposed. Still, many photographers find both artistic and financial success without being dependent upon others to handle their business affairs.

How is it that some are successful and others are not? Certainly, it is not because successful photographers have business degrees or a long history of business experience. Most successful photographers have no formal business training. Even if they did, it would be no guarantee of success. Some of the largest corporations in the world have proven to be unsuccessful while being run by MBAs from many of the world's best universities. In fact, people built many of the greatest business empires before business administration degrees existed. Bill Gates dropped out of college and then built Microsoft. This is not to make light of education, which is a true asset. All I intend to point out is that business success is not dependent upon business education.

So what is that makes some photographers successful in business while others flounder? Is it common sense? Is it experience? How about luck? Well, all three can be involved, but it is more likely that success is based upon other traits that help us develop common sense, gain positive experience, and make our own luck. Patience, perseverance, determination, dedication, thoroughness, thoughtfulness, and

other abstract qualities are what successful photographers have developed to allow them to succeed. They couple these traits with their ability to visualize a goal, just like they visualize a photograph. They work their way backward in planning to the first step required to make the picture. They apply the same technique to operate their business.

The one thing that most photographers have in common is the ability to visualize the outcome of their photographic effort. It is a simple leap from visualizing artistic outcomes to visualizing business outcomes. It is a bigger leap to apply the traits of patience, perseverance, determination, dedication, thoroughness, thoughtfulness, and other abstract qualities to achieve business outcomes because it requires a different mindset than that of the artist. The reason many photographers want managers, agents, and gurus is because they fear making the leap to acting on their business vision.

This book is intended to help photographers cross the divide between business and art. It does it without asking photographers to change their nature or to engage in rituals or exercises from Business 101. Instead, it offers insights, advice, and practical methods that any photographer ought to be able to follow. This book won't help you build a photographic empire, but it will help you achieve success in business.

What distinguishes this book from other business books for photographers is that it is not a rehash of textbook advice. Instead it is a guide to help you make sense of business and its processes while offering simple but reliable methods for planning and operating a profitable business. So, if you have the photographic skill and talent required to succeed in photography this book can be your personal guru, offering you guidance about how to succeed in business.

Strategic Visioning

WHETHER YOU ARE JUST STARTING OUT IN THE PHOtography business or remodeling your existing enterprise, the most important step that you take is the first one: developing a strategic vision of success. Strategy development begins with a mental picture of what you want your success in the photography business to look like as your future unfolds. Successful people have a vision of their success before they achieve it. Their vision is often fantasy based to some degree, but it is still one that is translatable into executable goals that can be achieved through a series of objectives. Strategic visioning is the process of getting from fantasy to the doorstep of planning concrete steps to turn your vision into reality.

Business achievement is dependent upon accomplishing defined objectives. The good businessperson sets objectives according to a predefined strategy, expressing a vision of what would constitute success. Visioning is a process of mentally picturing results, not of creating detailed plans: You can see the outcome of your efforts in your mind.

The secret to developing a strategy is having a vision of what your business will look like when it is successful, and what resources will be employed to gain that success. Once you can see that, you can begin the process of operational planning. Operational planning is the road map to making your vision a reality. A strategic plan is a topical map of the terrain through which the road has to be cut. The entire process from vision to reality is not much different than creating a photograph. First, you envision the result, then you plan for what you need to accomplish it, and then you create the envisioned

result. In photography it is called conceptualize, layout, and photograph. In business it is called envision, plan, and implement.

Self-Assessment

The pitfall in the visioning process is separating the reality from the fantasy. A person might envision him- or herself as a great architect who designs skyscrapers. But if that person has poor mathematical and drawing skills, it is unlikely that he or she will ever reach that dream. Neither an aspiring nor an experienced photographer who envisions himself as a sports photographer is likely to be successful if he has no interest in sports as sports rather than just as subjects of photographs. Likewise, the person who prefers to avoid contact with people is unlikely to be a good portrait photographer. A strategic vision has to be based upon realistic appraisals of oneself, one's assets, and one's opportunities, if the vision is to be developed into an executable plan. Self-assessment as part of a strategic visioning process is a relatively easy task, provided that commitment to and honesty within the process are maintained. Making a self assessment requires that the photographer answer the following questions:

1. What type of photography, in particular, am I drawn to?
2. What are the best photographs I have made?
3. What are my unique advantages and disadvantages?

What Appeals to You

Determining what kind of photography you are drawn to is actually an enjoyable process. If you have not had the experience of doing many different types of photography, one way to make such an assessment is to page through magazines, books, and annual reports, and peruse Web sites, making note of the specific images that you wish you had taken. Do this repeatedly over a period of time. Evaluate the consistency of your findings. You will most likely see a pattern emerge. Perhaps you have often centered on still life, or action and sports, or large-scale production advertising images. Perhaps candid documentary images appeal to you more than images of staged products or posed models. Be spontaneous

and don't let your selection be influenced by what you think you should be doing or by what others have told you. Your judgment should be visceral and uninhibited by practicality. You are making a judgment about your art, not your business. Business judgments are made after your artistic inclinations have been decided because the level of your success is dependent upon your passion for what you will be doing day-to-day. It is always easy to be passionate about what you love to do. Turning a passion into business success is easier than turning a boring pursuit into a successful enterprise.

Style, Not Markets

It is important that you make narrow choices based upon art and style, not market segments. Advertising, corporate-industrial, editorial, and stock photography are not photographic specialties. They are not based upon style or subject matter but are instead segments of the large marketplace. All photographic styles and specialties serve all segments of the business. In chapter four of this book you will read that as a photographer you can serve any or all of these market segments, and then it examines how you fit with the marketplace. Right now, in this specific part of the strategic visioning process, stay focused on the art and your personal resources for making the art. This process starts with knowing what you want to photograph and how.

Through the above process you will automatically answer the question of what type of photography you are not drawn to. Make note of it. It is almost unquestionably true that you will not be happy making photographs that fall into a class for which you have little artistic appreciation. Be true to yourself, and trust your instincts. Your observation and study should produce a continuum of information with likes and dislikes on either end and a middle ground of information about the kind of work that you should be doing or aspiring to do.

Your Best Work

Determining what kind of photography you do the best depends on your natural inclinations and experiences in education and work. Usually, those entering the profession from other professions have not had the opportunity to work with a variety of subjects. Those

who have had a smattering of the differences through education at least have some insights, while those who have worked as an assistant or photographer in a variety of situations usually have the greatest insights into the answer to the question. Those without good insight ought to try some self-assigned work, not aimed at commercial sale, but instead aimed at determining preferences. One can quickly discover whether studio or location work is his best niche, and more often than not, determining whether you are better at photographing people or things becomes quickly evident. The more exposure you have to different varieties of photographic image-making the easier it is for us to identify what you shoot best. Usually you find out that the photography you like best is the same as that which you do best.

Solicit Feedback

You should enlist the assistance of others. Photographers are notorious for admiring their photographs for all sorts of reasons other than their aesthetic impact. Clients, however, will choose the images that best fulfill their own criteria, including aesthetic impact. Feedback from other photographers, customers, art directors, editors, representatives, stock agents, and marketing consultants is indispensable. In the end it is your clients' opinions of what you do best that will be the final judgment of business success. This process has everything to do with the marketability of your work and nothing to do with your ego. If it becomes ego driven you will be an artist but not a businessperson.

After you complete the previous exercises be sure to compare the results. If you rejected every still-life photo you came across, and advisors tell you that you are a "natural" at still-life photography, you have an inconsistency that needs to be examined. You need to reconcile the difference, or you are likely to end up either in the wrong specialty and/or making images that you take no pride in. This latter pitfall is a sure way to get on the path to self-destruction. Unfortunately, many photographers have gone down that path because of a lack of self-awareness. If your photography is going to be great, it has to express you. It can't do that if you don't know who you are.

Personal Assets

Examine your range of interests, education, experience, location, material, and financial assets. Identify any unique advantages that you might have. You can also reflect on these to uncover any disadvantages. Here are some examples of the kind of analysis that you might do.

Did you have an area of study or special interest that lends itself to photography? For example, if you are a photographer who has studied the history of architecture and perhaps once gave consideration to a career as an architect, you would seem to be well suited for architectural and interior photography; you have an advantage. But you are at a disadvantage if you live in central Wyoming because the volume of work available is not going to support an architectural photography business. Likewise, if you are a knowledgeable sports enthusiast and understand the way certain sports are played, you have an advantage in sports photography. But again, if you are living in central Wyoming, you won't find enough assignment opportunities to keep your business running. You need to be in a locale where professional, semi-professional, college, and even high school sports are being played all year round. This is not meant to avoid a place like Wyoming. In fact, if you live in Wyoming, subjects like animal farming, outdoor recreation, landscape, and travel might offer opportunities, *if* you have the accompanying expertise. Likewise, if you live in an oil-drilling and/or refining area, you might find it advantageous to be a corporate-industrial photographer, *if* you have the insights to understand what goes on in those types of operations.

If you studied medicine or medical technology, maybe a medical-scientific specialty is for you. If you love to cook and make aesthetic presentations of your food, maybe food photography is for you. I know a photographer who thought she wanted to be a fashion designer because she loved clothes and the way they expressed the individual. After deeper examination she became a fashion photographer realizing that she had no real talent for *designing* the clothes, but that she had a real talent for *appreciating* the design of clothes.

Maybe you love children and enjoy getting down to floor level to play with them. You are a natural for child photography. If you can fly an airplane, the field of aerial photography might be for you. If you loved your course or experience in zoology, maybe wildlife photography is for you. Identify your non-photographic interests, knowledge, and experiences. Then focus on them as possible subjects and specialties presenting opportunities to exploit more than just your photographic skills alone.

In addition to your interests, knowledge, and experiences, your micro and macro location should also be considered. Property you own or have access to might allow lower-cost studio space. Your location might be subject- or specialty-oriented toward a particular kind of photography like surf or ski country, wildlife, or urban locales. You might live in the heart of a specific type of industrial or agricultural region. Almost every tangible item in the universe ends up being photographed for ads, corporate collateral, and/or editorial use. Lining up your strategic vision with a diversified marketplace is not as difficult as you think. Most importantly, you have to have a strategic vision before you can make a business plan with its marketing and financial components.

Avoid Delusion

I once met a photographer who sought my advice about breaking into fashion photography. He had been unsuccessfully trying to acquire editorial and commercial fashion assignments from mainstream fashion-related enterprises. He had above-average images in his book that were certainly adequate to qualify him for more than entry-level work. After listening and asking a few questions it became abundantly clear why he had had absolutely no success. The fellow lived in Wisconsin, and he was trying to get New York clients to assign him work that he could shoot in Wisconsin. Well, that was never going to happen. Art directors and editors want to be at the fashion shoots, and nobody was going to Wisconsin to do that. Maybe they would elect a trip to Madrid or Naples, but not Wisconsin. This talented photographer was committing a common mistake. He was trying to get a prospective client to change the preferred manner of doing business

rather than facilitating those preferences and making the prospect's life easier. His talent advantage was outweighed by his location disadvantage. My advice was simple; move your operation or learn to love agricultural and outdoor photography.

Commit Your Vision to Writing

Your strategic vision is a statement that blends what you like to do with what you are good at doing, in light of the assets available for implementation. When you are done with this exercise you ought to commit the vision to writing, and you should keep it as a guide in making decisions. Your vision is your future, as you want it to be. Once it is defined you will set goals in your other planning to turn your vision into reality. The more concretely you define the vision, the easier it will be to accomplish.

Sample Statements

Here are two samples of simple strategic visions of photography businesses.

1. As I am particularly drawn to photographs of the human condition, and because I recognize that my sense of adventure can be satisfied by challenging travel, photojournalism is particularly appealing to me. It will allow me to apply not only my photographic education but also my liberal arts education in subjects like sociology, psychology, anthropology, and history. I also have the advantage of being able to afford the range of equipment required for this type of work when compared to that needed for commercial illustration and other forms of photography. My location in the countryside will not be a disadvantage to doing my work, since my work will be done on location, but my location could be an obstacle to reaching a clientele. I can overcome that handicap by planned sales trips coupled with the use of the Internet and other communications tools. Because of the lower costs of entering this kind of business I will rely upon personal savings and credit for the cash flow until my earnings provide it.

2. I am particularly drawn to photographs that are meticulously constructed and perfect down to minute details. I enjoy working indoors and prefer not to have to engage people as subjects. While my fancy for cooking and the aesthetics of meal preparation have conditioned my eye for food photography, I also have the creative ability to do other types of still life. I will need to acquire substantial equipment and find studio space in or very near to the city. Recognizing this field to be highly competitive in urban environments, I understand that I will have to meet substantial marketing expenses in addition to studio and outside service provider expenses. To meet this cash flow need, I will rely upon the following sources: personal savings, second mortgage, loans from family members, and, hopefully, a bank line of credit.

Write It

In your own exercise you should strive to generate a longer statement for a start. You will be thinking out loud on paper. After you have written all you can think of, you can begin the process of editing into a concise statement that you can quickly access and read each time you have to make a major decision about some element of your business. The concise statement will help you keep on the right track to your goals. Every important decision you make about the direction of your business will be guided by this simple strategic vision. If what you are considering does not help you make your vision a reality, than you don't do it.

Flexible Vision

Your vision is not meant to limit what you can do. As a photographer you will have opportunities to make money by doing things that you would rather not. Do not reject assignments unless your talent, equipment, or experience does not add to successful completion of the work. The vision statement is meant to help you set goals and objectives, not to be a filter for deciding what jobs to take. But it can keep you from overextending yourself like I did once in my early career. I had little desire, skill, or equipment for catalog shooting. A good client that used me for my editorial style asked me if I would

be interested in shooting seventy or more still-life setups for a catalog it was producing. Seeing dollar signs, I agreed to do it. I had to rent some equipment that I didn't have, procure props, and stock up on a variety of seamless paper. The shoot went on for days and I hated every minute of it. Because I was not as skilled at it as other kinds of shooting, the results were mediocre but acceptable. The profit in the dollar signs that I had envisioned was eaten up with rentals, props, supplies, and the extra time it takes to do something I hadn't done before. It was a great learning experience. I learned to stick to what I enjoy and do best.

Inevitable Change

Sometimes your vision has to change, especially as conditions change. When I was starting out in photography in 1965 my dream was to be a photojournalist in the fullest sense of the word. I wanted to shoot photo stories and photo essays like those that had graced the pages of *Life*, *Look*, and other magazines. I worked diligently to develop the skills and insights necessary. I worked for the wire services to start, then secured assignments from small magazines, gradually working my way up to more important journals. In time, my skills and confidence grew, and I could feel myself being ready to shoot for the top level of magazines. Unfortunately, I had missed, ignored, or dismissed one significant development in the publication business. The major magazines were in trouble as people turned to TV for in-home entertainment. Advertising dollars left the magazines and went to TV networks. By 1970, some magazines had closed their doors and many more were clearly going to follow suit in short order. By 1972, the magazine world had changed forever. It would fight its way back in the form of a different model over the next decade, but the business that I had centered my strategic vision on was gone, and I was not prepared for it. I had to rethink everything and make major revisions to my plans for my future. Fortunately, the corporate communications world was beginning to find the photojournalistic style of shooting appealing. With careful research I was able to craft a new plan. It allowed me to capitalize on my style and experience.

That lesson taught me that, if I had been reading the *Wall Street Journal* in addition to the host of photography magazines I read and the copies of magazines that I wanted to shoot for, I'd have been able to see the problem coming, and I could have altered course gradually to avoid a last-minute transition. My experience was repeated by hundreds of photographers who didn't pay attention to what was going on in the business of which they were a part. We failed to recognize that our part of the photography business was part of the publication industry, and its trends governed the directions of our futures.

You can build your strategic vision from roots that are seated in a fantasy of your future, but you must be realistic about the probability, not the possibility, of successfully reaching your envisioned future. You must expect changes, often major changes. You must see them coming to stay ahead of the curve. You must revise your vision based upon emerging realities. That means you must monitor the business for those emerging realities.

Having learned that the forces around me did not respect my carefully designed strategic vision, and having now forged a new vision of my future, I soon found myself in the corporate photography business. I moved from one city to another because the new location offered more opportunity as it was rapidly transitioning from a manufacturing to a service economy. The *Wall Street Journal* indicated that many corporations had opened offices there, and many were planning to or considering it because the locale offered a low-cost urban setting. It was the correct decision. I moved to a city where business was growing and the number of photographers was static. Of greater advantage was the fact that most of the photographers were the fellows who shot annual reports on 4″ × 5″ cameras with flashbulbs. It is always easier to find new business in places where your competition is weak. It took about a year to establish a successful business. That business went almost unchallenged for a decade, when a new trend developed.

Corporations were cutting back on print publications because paper, printing, and mailing costs were growing rapidly. Clients began to give up their company magazines. As printed pages became more precious they began to use more creative illustration

than documentary-style images. They stopped telling stories and started creating illusions. Once again, external forces were threatening what I did as a photographer. But this time I knew it would happen before it could hurt me. I also knew that the corporate world had discovered the multi-image, audio-visual program as a tool for morale boosting and teaching employees, and for selling their services to others. Over another year, I added multi-image work to my line of services. It was a nice fit with my photojournalistic style. Multi-image programs became a rage in business. This, too, lasted for about a decade, until videotape programming took hold and began to rapidly replace it.

The lesson to be learned here is that things change, and, as a businessperson, you have to change with them. Evolution is inevitable. Adaptation is the key to surviving the evolutionary process and extinction is the end result of a failure to adapt. What is true in nature is true in business: There are forces that you can never control, so survival is dependent on fitness, adaptability, and the ability to recognize the dynamic changes underway.

When I was executive director of ASMP (American Society of Media Photographers, on the Web *www.asmp.org*), I learned that many photographers who pass the three-year mark in business stay in business for only seven to ten years. That most photographic businesses do not last longer than ten years can be statistically proven. There are no statistics that tell us *why* these photographers give up, but I believe they leave the business because they fail to adapt to the trends that shape the business they are in. If you are to succeed over the long run, you will have to plan a future and routinely revise that planning, sometimes in major ways. If you don't, it is unlikely that you will retire from the business of photography, or any other business for that matter. Some folks just were not meant to be in business.

Armed with a strategic vision statement, you have created a picture of your future business endeavor based upon your personal preferences and talents, and defined by an analysis of your advantages and disadvantages. While this strategic vision is critical to charting your course, never forget what the military often points out. A battle

plan changes as soon as the enemy is engaged because the other force does not care to follow your plan. Eventually, your strategic vision will have to change. The important thing is to be changing it in anticipation of counter-productive forces rather than in response to them. Stay informed and keep re-evaluating, and that way you will stay ahead of the curve.

Avoid Cynicism

Some photographers will disagree with my advice. But before you accept their criticism, consider their level of success. Have they achieved the kind of success that you seek? Then think about the highly successful photographers whom you want to emulate. Do they try to be generalists? Do they try to be all things to all clients? No—they situate themselves to serve niche markets and exploit their special talents and capabilities. Photography is used to communicate messages about an endless array of subject matter. You will always be more dedicated to the pursuit of what you enjoy doing more than doing that which you do not enjoy. Ignore the cynics. Do the exercise. Carefully consider your choices about stock and assignment photography. Develop a picture of your future. But don't do it until you have finished reading this book. It is better to have a fuller knowledge of how you will do business before you design your own.

Stock or Assignment?

A S YOU PLAN AND OPERATE YOUR BUSINESS YOU WILL HAVE TO decide whether to engage in stock or assignment photography, or both. The fundamental difference between stock and assignment photography is the existence of the photograph(s) relative to the time when a prospective client seeks to purchase. Stock photographs exist prior to the contact with the prospect. Assignment photographs are created after contact with the prospect. If you have an inventory (stock) of photographs on hand for fulfilling prospects' needs, you are engaged in stock photography. If your inventory of photographs is just being stored for possible re-ordering and re-use by the client who commissioned the creation of photographs in the inventory, you are not engaged in stock photography.

Understanding the Options

Some photographers exclusively produce either stock or assignment photography; some engage in both types of production; and many photographers produce assignments that also generate stock photographs for additional marketing as stock. Others do both separately; that is, they do assignments, but do not derive stock from them, and they also shoot stock that has no connection to their assignment work. The previous options are best compared in list form.

- Assignment: You produce work as ordered by paying clients for current sale.
- Stock Production: You produce work at your initiative and cost for future sale.

- Hybrid A: You produce both stock and assignment photographs.
- Hybrid B: You produce assignment photographs and reserve some as stock.
- Hybrid C: You produce stock, shoot assignments, and reserve some assignment photographs as stock.

Deciding which path(s) to follow is a matter of understanding the effective differences between stock and assignment photography as described in the above list.

Assignment photography is made-to-order work. You don't make photographs until someone orders them. Consequently, someone else pays for the photography work that you do within a short time after completion. The commissioning party pays all of the direct and indirect costs of production of the photographs.

Stock production photography is self-assigned work. You must cover the production costs in addition to the related overhead. This requires having enough capital on hand to meet those costs. The only way that you can recover your costs is by the future sale (if any) of your stock images. The images must sell at high enough fees to not only cover your costs but also to make a profit so you can stay in business. To be a successful stock producer you must have good insights into the future needs of the marketplace. You must produce images in advance of the need, in order to ensure that you have adequate time to have them visible in the marketplace when the actual need for such images arises. That is risky business. Very few photographers are successful in stock production businesses. Those who are successful are so because they understand the imaging needs that drive the market.

The photographers who engage in hybrid option (A) direct some effort at assignment production and some effort at stock production. The photographers who engage hybrid option (B) cull stock from assignments, adding it to an inventory of images that can be licensed by photography users. This may be the best option for the photographer who wants the additional revenues that stock could produce but does not want the risk that the stock producer has to take. The photographers who engage in hybrid option (C) are

doing it all: producing assignments on demand, creating stock at their own initiative, and culling stock from assignment photographs.

Retaining Rights

Obtaining stock images from assignment work is dependent upon two factors: the kind of assignments that you will shoot and the copyright you can retain to the work you create. The subject matter that you shoot will be most important. If an image is not suitable for stock, retaining the right to use that image as a stock photograph is meaningless. If your assignments will expose you to subject matter that will have stock value, then you must retain the rights you need to be able to market it. Your ability to retain rights will be dependent upon the policies of the assignment client and your ability to negotiate.

Your clients' policies will be varied. Advertising clients do not want their products and services identified with other companies or individuals. They do not want their photographs published without their approval, and they don't want to be bothered by giving approvals. Some will never give approval. Some will give approval to use images that do not show the advertiser's name, logo, or product, but they will sometimes allow the use of generic images taken on assignment for them. In today's stock market, generic images have little value. There may be exceptions to that statement, but good businesses are not built on exceptions to the rule. My advice is don't hassle your advertising clients for rights that you are unlikely to ever profit from. That is not to say that you should give away your rights without sufficient payment. It is saying that you should avoid risking the loss of profitable work in order to retain the rights to market unprofitable generic stock photography.

The corporate market offers more opportunity to shoot material that has stock value. While covering a corporation's equipment or personnel you can acquire many images that have value in other markets. I give an example of this in the chapter on networking. Most corporations like to keep all the rights to images that they commission for the same reason that advertising clients do: control.

The editorial market almost always presents the opportunity to acquire images that can be placed in your stock files. Most publications do not seek exclusive rights, and those that do want them for a limited time to protect their investment in the assignment images. The editorial assignment market pays less than other markets. One reason photographers shoot for the lower rates is because the potential for stock resale of their work is high, and it supplements the low rates paid by the publishers for assignments.

Continuous Production

Assignment photographers must produce a continuing stream of work to meet clients' demands. Stock photographers must continually add to their stock inventory. The average stock photo has a life of three to five years; clients want new images to assure that their advertising and promotional efforts look fresh. This means that you will have to continually update your stock files or they will become stale and unmarketable. Again, there are exceptions to the rule, but you already know what I have to say about building your business on deviations. Clients who commission the work finance the assignment photographer's production. The stock photographer must make a substantial financial commitment to finance production with the belief that future sales will eventually recover the cost of production. The photographer who culls stock from assignments has the advantage of the production being financed by clients, but as time goes by those images become outdated. Income from those outdated images will stop unless new assignments offer the opportunity to replace them with similar up-to-date images. All photographers are dependent upon continuous production. The important distinction is who is going to pay for it and when. You must take that distinction into consideration when planning the scope of your business.

Fees, Costs, and Risk

Since the client pays the fees and costs of assignment photography, the photographer's need for working capital can be less than the need of the stock production photographer. More capital needed to operate a business means more capital at risk. We can generalize that

stock production puts more of the photographer's capital at risk. Being in business means taking calculated risks. Let's look at the financial risks for assignment and stock photography producers.

Heavy production of an item makes it a commodity, and, as any player in the commodity futures market will tell you, commodities are risky business. If the statistic I most hear quoted is true, that only 2 percent of a stock file is actually ever licensed, stock production seems to be a highly risky enterprise. Indeed, banking on the fact that 100 percent of your production costs will have to be covered by 2 percent of your marketable images cannot be described as anything but risk.

For example, suppose the cost (direct and indirect) to produce 20,000 images is $60,000. Of the 20,000 shot, 10,000 are marketable. But, if only 2 percent of those 10,000 will ever be licensed, it means that 200 images will have to recover all production costs plus, in order to generate a profit. If you have an agent and an average 50 percent return on your share of your stock photography licensing fees, that means 200 images will have to earn $120,000 during their marketable life for you to break even. If inflation stays at 3 percent per year during a five-year period (the average life of a stock image) you will have earn an average of 7.5 percent more to replace your production costs with dollars having the same purchasing power as the one you spent.

Let's say that you spent a total of ten weeks producing the 10,000 images in stock. If you value your work at $1,000 per week, your images now have to earn another $10,000 for you to break even. If you want a return on investment of 8 percent, the images have to earn even more. When you total all the above factors, your images will have to earn $150,000 over five years. This means that each of the 200 transparencies that are likely to sell will have to earn $750 over five years. This is $150 per year, per image. If you are receiving less than 50 percent return on your sales the $150 is too low. If prices continue to drop, you either have to sell a higher percentage of images from your file, or sell the same images more times. Either way, you have committed a great deal of capital and staked its recovery and your profit from it on very few images is likely to be found desirable by clients.

Making the Decision

Stock photography production is a unique form of speculation. Can you afford to speculate? If you cannot, I'd suggest you stick to assignment photography and stay away from producing stock. The best solution is probably to mix your output. Shoot assignments, cull stock from those assignments that offer the opportunity, and produce stock when it is feasible and affordable to do so. That said, I think most photographers would be wise to maintain a healthy assignment business, and to continue to do so until they have a substantial understanding of the stock photography business.

Business Planning

T HE WORDS "BUSINESS PLAN" EVOKE A PARTICULAR IMAGE in the minds of most people who are exposed to the term. Among the reams of advice given to photographers who are starting or operating a business, one of the most repeated refrains is "you must have a business plan." This is usually followed by reference to or example of a traditional business plan outline, which might be as many as five pages long. These outlines are intimidating in themselves. The thought of actually trying to write a document that begins with five pages of outline is not very motivational. Having been involved in the creation of several business plans that were used to raise venture capital, I can tell you that the fifty-plus-page documents were prepared to make investors feel good. Once the money was obtained, the plan went into the file cabinet. Then the real work of running a real business got started.

Planning, Not Plan

A traditional business plan is worthless, unless you are trying to raise investment capital. However, business planning is an indispensable element of any business success. While the last two sentences might seem to be in conflict with each other, they are not. As I mentioned in chapter one, in the military, they tell you that a battle plan is useless as soon as the first shots are fired, because the enemy isn't following your plan. Likewise, there are forces in the business world that create obstacles to progress and success. While these forces are not enemies, they do have an impact on any plan that you might create.

A fifty-page business plan will not survive the first few months of business intact. What the successful businessperson learns is that plans become worthless, but that continual planning is an indispensable business process.

Business is like a long road trip. You have a starting point and destination, and you have to plan a route. Once you are on that route you might find obstacles that force or incentives that compel you to change the route or move faster or slower. Changing direction or speed is not the same as changing the destination. Altering the route that you take on a road trip according to changing circumstances is well advised. So is altering your business course as you encounter obstacles and incentives that warrant changes—and you will encounter them. A static business plan is a road map to a dead end. A dynamic business plan is the road map to success. A dynamic plan is changed periodically; that is, the planning never really ends. That is why I believe that a plan is useless and planning is indispensable.

Points of Focus

Your dynamic planning should be carefully focused on two major areas: finances and marketing. In small businesses, financial management is the key to financial planning. When you have acquired enough money that cash surpluses are more than adequate for operating your business, be smart and hire a good financial planner to help you plan what to do with your money. To get to that point you must manage your finances carefully. Routine financial management is the heart of your financial planning until you have the need for a real financial planner. Marketing plans are the catalyst to acquiring the clientele so you will have money to manage. Marketing consists of market/prospect research, promotion, and sales. These three processes are what keep you in business. They are the processes neglected most by unsuccessful photographers. You cannot succeed in business without them. Subsequent chapters in this book provide the basis for planning and conducting these operations in your business.

Step-by-Step Planning

There are six steps in dynamic business planning.

1. Research: getting the information you need.
2. Evaluate: determining what information to act upon.
3. Design: deciding how to carry out the required actions.
4. Implement: conducting operations to accomplish your plan.
5. Review: evaluating operational success and making changes as needed.
6. Adjust: redesigning operations to implement the changes needed.

Steps 5 and 6 are repeated periodically until either you reach your destination or you determine that the course is not going to get you there and you abandon the plan. Now, let's take a step-by-step look at the planning process.

Research

Research is a critical step in planning. Just imagine that you were traveling from downtown New York City to downtown Los Angeles by automobile. You would certainly review some kind of a road map and determine how many miles you had to drive and how much gasoline the drive would take. You would consider how many miles you could drive in a day so you could determine how many motel rooms you have to rent. You would calculate what the cost of those rooms and daily meals would be. You might consider different roads depending upon factors like speed versus enjoyable driving and sightseeing. You would create an itinerary based on your research.

Research is critical to your success in business planning. Market and prospect research are the subjects of subsequent chapters in this book. So you are going to learn the specifics of the research process as you read on.

Evaluate

Evaluating research is just a matter of applying common sense to sets of facts. Let's say that your research indicates that penetrating one

market you seek to enter will take a constant flow of promotion over six months while another market will only take occasional promotion over the same period. Your analysis of your financial condition indicates that you could not sustain a constant promotional effort without sacrificing other operations. At the same time you see that you can safely engage in occasional promotion without detriment. This is the process of evaluation, which leads you to select a specific path in your plan—the affordable and accomplishable one.

Design

Designing your course of action is a matter of determining what resources have to be applied and when to apply them to accomplish the tasks necessary to complete the plan. For example, the goal of business planning is to help you make sales that provide the necessary revenues to sustain the business and you as part of it. In order to make sales, you have to decide on specific markets and then select prospective clients as targets of promotion. You do that by deciding how you want to position yourself in the marketplace. Once that is done, promotional materials can be sent to prospects and the sales effort made to capitalize on the promotion. Other chapters in this book cover those processes.

Implement

Implementation is simply getting the work done. You might call it acting on tasking or getting the "to do" list accomplished. It doesn't require an extensive explanation. It is simply acting on the tasks to get things done. That being said, it is important to note that many businesses fail because of a failure to implement successfully. It is easy to have a to do list. It is quite another thing to accomplish the items on it. Many photographers never find success because they fail to implement one or more parts of their planning. This usually happens because the photographer does not like to do the chores involved and has a mindset against doing them. The most common occurrence of this is the sales effort. Most photographers will tell you that they hate to sell. Those that say this break into two major groups. The first group is composed of those that have tried selling and really feel uncomfortable with the

process. The second group is composed of those who have never tried it and are so afraid to do it that they never try it. Instead, they hope that their promotional efforts will cause clients to ring their phone, give them work, and make them successful. Well, it never happens that way to a degree that will sustain a business. Failure to implement part of a plan, no matter what the reason, is the kiss of death for the plan and the success that might flow from it. If you are not committed to implementation, then don't start. It will save you lots of time and grief, not to mention a bout with depression.

Review

Reviewing is a critical part of the planning process. Business planning is intended to produce results like finding prospects and converting them to clients to whom you make sales and from whom you earn revenues. A review might demonstrate that you have secured many prospects and that your promotional activity is on target, but it might also reveal that your sales are not being made to the degree that you projected, so revenues are off. Well, something is out of balance. You cannot continue the level of promotion indefinitely unless the sales are there to pay for it. You have to make changes. Review provides the opportunity to discover the need for and make timely changes in your planning.

Adjust

Adjusting the course and/or cost of action is the final step in the first round of planning. Your review has indicated that your projections are off target. You adjust the plan accordingly and implement the changes. Then, you periodically review and adjust your planning to insure that it is achieving the results you need to stay in business. If it does not produce satisfactory results, you have to go back to the research and evaluate it again; that is, start over. Intentionally starting over is always better than starting over because of a catastrophic failure.

Complexity

Your business plan's size and depth will be determined by the complexity of your strategic vision. If you see yourself opening a major catalog or assignment advertising studio, you will need a more

comprehensive plan than being an editorial assignment photographer requires. Regardless of the depth of the plan, the planning process is not as complex as those prefabricated outlines make it appear to be. If you can plan a photograph, you can plan a business.

Photographers and Planning

Many photographers seem inclined to believe that creative people are poor planners because planning is the antithesis of free thought. Fortunately, that is a myth. In fact, photographers are generally very good planners. They have to be because all but the simplest photography assignments, whether assigned by client or self, require planning to execute. Imagine yourself receiving an assignment from an editor or art director to create an illustration for an article or campaign called Circus Days. The theme requires a picture of a circus in action with all of its components: three rings, lions and tamer, acrobats, clowns, elephants, ringmaster, and even an excited crowd. Making that photograph requires planning. What does a circus consist of? Where does one get lions, elephants, and performers? How much do they cost to hire? Where can you stage it all? Do you need permits? How about special insurance? There are many questions to answer before you can begin to design the shot. That's research. You'll sift through your findings to select elements that will allow you to execute most efficiently and economically with the best possible result. That is evaluation. Finally, you begin to set up a to do list and timetable, or design the project, and then you get started doing the work. That is implementation. Who said photographers are poor planners?

The planning of a process is really very simple, if you consider that planning a project is not much different from planning a photograph. Both a project and process have major similarities. If you understand project planning, you will understand process planning. The difficulty for most photographers lies in the fact that they know how to plan a project but they don't understand how they did it. Once you understand the methodology, you will be able to plan any process.

A project consists of four elements: tasks, resources, dependencies, and timelines. These four elements are present in every process,

Figure 1

#	TASK	DEPENDENCY ON	RESOURCE	TIMELINE
1	Research prospects		WWW searches	3 days
2	Evaluate findings	#1		1 day
3	Categorize prospects	#2		1 day
4	Design promo materials	#3		1 day
5	Order packaging material		Art supply store	1 day
6	Create promo material	#4	Commercial lab	3 days
7	Assemble promo	#5 & #6		1 day
8	Ship promo	#7	Post office	
9	Follow-up calls	#8		5 days

whether brushing your teeth or conducting a promotional effort. Of the two examples in figure 1, let's look at the simpler one.

From this example, you can see that tasks are the steps you have to take, while dependencies are the steps you have to take before others can be taken. Resources are the means to completing the tasks, and the timeline is the targeted time for completion of the task. Timelines are not deadlines. Timelines are a guide to meeting deadlines.

Successive Planning

In the first chapter of this book we explored how you can create a personal strategy to guide you on your path to accomplishing your vision of your career as a photographer. Once you go through that process you are ready to begin the process of planning how to accomplish that vision by taking practical and tangible steps; that is, planning how to convert your strategy into a working business operation that gets you to your goal in a profitable fashion. In the next few chapters of this book you will successively learn approaches to planning your marketing, positioning, promotion, and sales efforts. In order to sustain these planned operations you will have to manage your finances. These are all core processes in the business planning function. One flows from the other, and so one is dependent upon the other. Fail to do one and your plan is

likely to fail. Do them all minimally, and you will survive; do them all well, and you will excel.

Hidden Value

There is a hidden value in planning before you start a venture. Good planning will help you realize your personal strengths and weaknesses, your preferences and your fears. Now, let's admit it—we are all afraid of something, and we ought to own up to it, because you cannot develop the courage to overcome a fear unless you admit to having the fear. For example, if you develop a plan that calls for an income level that requires shooting an average of two assignments a week at a certain rate, you know that you have to sell at least two clients on hiring you every week. Since no one bats 1,000 you realize that you will have to make more than two sales calls to meet your need. In fact, you will probably have to make eight to ten calls to meet your goal. If you are one of those who detest the thought of selling, are you going to be capable of implementing the plan? If not, why get started? Planning a certain failure is stupid. You either have to plan to overcome your aversion to selling or come up with a way to hire someone to sell for you. Investing your money in a self-defeating process makes no sense. It would be better to get a job and shoot photographs that you can try to sell or have an agent sell. Selling the existing photograph is easier than selling an assignment where you have to convince the prospect that the finished result will be the photograph that they want. Planning forces you to confront in privacy the things you fear most in your business life before you have to confront them publicly.

Self-Discipline

Another important asset to planning is self-discipline. It is a critical characteristic. You have to discipline yourself to be thorough in your planning. If you don't have the discipline to be thorough, will you have the discipline to complete the steps in the plan—especially the difficult ones, or the ones that you won't enjoy doing? Remember, business is not always fun. If it only involved making

photographs, then the world would be crowded with successful photographers. It is the business aspect that is the hard part. If successful photography requires some planning effort to achieve the results you want, you can only imagine that business planning requires even more because it has more facets than any photographic assignment.

Computer Assisted

If you purchased a project management software package you would see that it is based on the elements described above: tasks, resources, dependencies, and timelines. It would certainly have many bells and whistles that would enhance the process and make it more detailed and flexible, but it would still be processing data related to the four project elements. That being said, if you like working with computers, a project management software package can make your process planning easier. You can use it to plan a shoot or a marketing/promotion campaign, create a sales campaign, and brush your teeth. You do not need a five-hundred-dollar package. They are used for massive projects. A simple, inexpensive package will be adequate for your business. Of course, you can do it all on pieces of paper for a lot less. The advantage to the software is that it allows you to change sequences and timelines and add and subtract tasks and resources without rewriting everything. In short, it saves time; and saving time saves money.

Computer-assisted process and project planning allows you to be more dynamic in the planning process. You want a dynamic planning process underway because your situation as a small fish in a big sea is going to mean that you will have to cope with a continually changing environment. When the physical effort and time required to change a plan are reduced to a minimum, it allows more time for the creative mental work of planning, and that is the fun part. I do recommend project management software as a basic tool for the photographer. A Web search can lead you to sites of a variety of companies that offer inexpensive packages for both Mac and Windows operating systems.

Planning for Bad Times

Every photographer who stays in business long enough will eventually experience a period of time in which business slumps. The photographer must be prepared for such a contingency. I wrote the article below, which addresses this topic, for the *ASMP Bulletin* while serving as executive director of that organization. It is reprinted with permission of the ASMP and is as useful today as when originally written.

Surviving in Our Economic Climate

What can you do to cope with a business slump? How do you survive an economic blight that drives many out of business? What is the secret that the survivors know?

Is cutting expenses the answer? Cutting expenses is a logical choice when revenues are down. If you spend less, you can offset losses from lack of business. But you can only cut expenses to a certain degree. You can't cut so far that you decrease or damage capability. You can do deep cuts for a brief time or shallow cuts for a longer time. Either way, cost cuts are not an answer for the long term. Eventually costs will go up again, if not by design, then in the normal course of business.

Are large cash reserves the answer? Well, when you are in business it never hurts to have a lot of money in the bank. But how much is enough to outlast a recessive economy? Reserve capital can defray the effects of a slump for some time. The very purpose of reserves is to have capital for an emergency or sudden need, or for use to capitalize the business in times of growth. So even though reserves might cushion the fall in a recession, they are not the long-term answer because these funds should be kept available for expansion and other needs. If you deplete your reserves in bad times, you will not have them in good times when they can help you make more money.

Is a line of credit the answer? A line of credit is simply additional reserves that belong to other people. A loan can be used to offset losses brought on by a business slowdown. But remember, you have to pay it back. Borrowing should be used as a means to obtain income-producing assets or work, or to offset seasonal slumps, which are usually historical and quite predictable. No, a line of credit isn't the best answer.

Is raising prices the answer? Now that's novel thinking, or is it? Who would raise prices when business is bad and sales are off. Recently, I read in the *Wall Street Journal* that many advertising agencies, which have been hit particularly hard with economic woes, were raising prices. I also read in *Advertising Age* that many magazines were raising ad-page rates to compensate for revenue losses brought on by the advertising decline. That makes sense. If revenue minus expenses equals income, then it goes without saying that raising prices can increase revenues and prevent the possible erosion that comes with cutting expenses, meanwhile, providing income adequate to meet needs.

But did you ever notice that businesses don't raise prices in good times because everything is going well so why take chances on alienating or losing a customer by asking them to pay more for something when you aren't feeling pinched? And, did you ever notice that many businesses don't raise prices when things are slow or in recession? They don't want to lose business. The fear that a price raise in bad times is the kiss of death for the supplier is prevalent in the business community. Fear of losing a customer often overrides the need for more revenue through a price increase. It's a catch-22. You can suffer reductions in cash flow with either choice. Business is often a calculated risk.

So, we see that cutting expenses, using reserves, activating credit, and raising prices all fall short of being the solution to weathering a slump. Certainly it is obvious that all of these can be combined to cope with a recession, but will they be enough? Probably not.

Well then, what is the answer? The answer is simple. Let's look at the fundamental equation for income: revenue minus expense equals income. Income is what you need to stay in business in good times or bad. We already know that cutting expenses is only a partial solution and will not lead to a sustained gain in income. We know that increasing revenues is a better answer than cutting expenses. Raising prices can increase revenues, but that has its risks. Good clients can be alienated by price increases in bad times. But is that the only way that revenues can be raised? No, it is not.

Making more sales can increase revenues. That can be done by selling more to existing clients and by developing new clients. Making more sales means more revenues, which will have a great effect on business, especially if you are careful not to let expenses increase. More sales will mean that your client base will also be larger after the slump, making good times even better.

Opening new accounts will also have a special benefit if you want to raise prices. These new accounts will not be experiencing a price increase.

The fees you set will be their first exposure to your pricing and will not be seen as pressuring your client for more money in bad times. It is easy to see a recession as a poor selling environment. But the experienced businessperson knows that recessions can be a marvelous selling opportunity. Clients are looking for greater value. Many photographers respond by lowering prices, but other photographers realize that better value comes from giving more for the right money, not doing something for less money, which often reduces value.

More sales can also come from developing markets that you have never served before. Photographers tend to become specialized in their selling, even though they are not specialists in their shooting. Specialized sellers fail to see the diversity of markets. They continue to concentrate on ad agencies, even when they know the agency business is off, or they call on editorial accounts as ad-page losses cause a continuing decline in the editorial content and assignments. There is a better way.

Every photographer who is experiencing difficulty in a slump ought to go to the local library and take out a book on marketing and market research. With a little change in thinking you might find many insights into new places to sell your services. Remember, you're selling services and hopefully licensing rights. Many use photographic services and not all the users are publishing the end result in traditional ways. Some are not publishing at all. But when business is bad, the tear sheet shouldn't be your primary motivation; revenues should be. Don't hold onto any criteria that will diminish your position and ability to increase those revenues.

Finding people to sell to isn't all that difficult. Years ago, as a working professional photographer, I took a map and drew a circle with a 100 mile radius from my studio on it. I proceeded to identify all the potential users of commercial photography within that circle. From that I made a prospective client list. It was so long that I could never call on everyone in a lifetime. But I tried. That list was the best insurance I could ever get to protect against a slump, a seemingly endless source of sales. All it took to activate the insurance policy was a lot of work.

Professional Services

You are a professional photographer. You don't think highly of those who hire amateur photographers to do the work of professionals. You know that the word "professional" means a proven level of expertise. So when you need advice or service, practice what you preach by using a professional for the same reason that you believe your prospects should do so. There are a number of professional services that a photographer might need. I will only write about the most necessary.

Attorney

An attorney is an important asset to any business. Using an attorney as an advisor on legal matters costs money, but getting advice before you get yourself into legal trouble is much less expensive than using an attorney to get out of trouble.

I wouldn't hire a food photographer to shoot soccer. Likewise, I wouldn't hire a divorce or negligence attorney to handle my commercial affairs. I'd hire an attorney who had experience in business law. If I had a copyright infringement I'd hire a copyright attorney for the same reason that I would hire a brain surgeon rather than a general surgeon to operate on my head. Laws are usually very complex. No lawyer can know it all. Some act like they do. In my career I have seen many photographers who have lost cases and had serious troubles because they hired lawyers who did not have expertise in the area of law surrounding the case. So their lawyer did a poor job, while the opposing side's lawyer was an expert and made mincemeat out of his opponent. The best lawyers know what they can and can't do

well, and they don't take cases they can't handle, unless they can tap the expertise that they need by adding another lawyer to the case to provide the expertise. The worst lawyers also usually know what they can and can't do well, but they don't let that stop them. You have to qualify your lawyer before you hire your lawyer. You do that by asking about their experience and support systems for getting expert assistance when needed. If you are going to trial, you need a lawyer with litigation experience. This lawyer may be in addition to your attorney with the expertise needed in the law in question. You will want to know if they have won cases similar to yours and how many.

A lawyer that has experience representing photographers will most likely be better than one who represents singers or dentists because the lawyer will have some understanding of the practices of the photography trade, that is, how the business works. Practices of the trade are often taken into consideration by the courts in making decisions, especially when contracts and agreements are ambiguous or unwritten. An attorney with knowledge of these practices might save you a great deal of money and/or disappointment. An attorney without knowledge of the practices of the trade can cost you dearly because he is not armed with knowledge needed for some cases.

The ASMP and some other photographers' associations keep lists of qualified attorneys to refer photographers to, so they are a good place to start looking when the need arises. State bar associations usually make referrals. Good attorneys will make referrals when they can't handle a case. And there is always the Volunteer Lawyers for the Arts (VLA). Hopefully you are successful enough that you won't qualify for their free service. VLA provides pro bono services to artists who cannot afford the services of an attorney.

You can ask other photographers about their experience with and recommendation of attorneys. But you still must ascertain whether a recommended attorney is qualified to handle your matters. Having another photographer for a client does not mean that an attorney is suited to meet your specific needs.

You start looking for an attorney before you need one for routine business matters. Don't wait until you get sued, are

threatened to be sued, are threatened by a taxing authority, or have a contract to sign that you just don't understand. Find your attorney now.

One final piece of advice is this: Beware of lay lawyers. Over the years, I have seen numerous photographers dispensing legal advice at meetings and on the Internet. Some have a history of being involved in legal cases, others have read a book or know a lawyer. The bottom line is that they are not lawyers and they don't have to back up their advice in a courtroom. You are a professional—hire professionals.

Accountant

Another professional that you should have lined up is an accountant. You can do your own bookkeeping by hand or on a computer, but do you know your liability for local, state, and federal taxes? Do you know the Internal Revenue Service's equipment depreciation rules? Do you know if any of your income is passive, and subject to a different tax burden than your earned income? If you get audited, do you want to be able to say "my accountant will address your questions"? Accountants are very valuable when you need them and you need them at least once a year when you do your taxes. So my advice is to hire one and start building a relationship. Try to find an accountant that serves other photographers because the accountant will already have done the research to answer many of your questions. Again, asking other photographers might provide some good leads.

Consultants

Don't confuse the words professional and consultant. Both give advice, but the professional stands behind his advice. You can decide if you need marketing and promotion consultants, but read those chapters in this book before you contract with any of them. I am not implying that these consultants are ineffective. The good ones are quite effective, especially in helping you develop a strategic view based on your own talents, and where you are positioned in the marketplace. They are also excellent at helping you select your best work for promotion and developing promotional materials. But in the end, they won't sell your

services, so they won't be accountable if they are wrong. Be sure your consultants have the expertise to back up their claims to be experts. You need to know their work history, and how it helped them gain the expertise they claim to have. You also need to know the names of some photographers that they have serviced.

Finding competent photography business consultants is not always an easy task. Here are some suggestions about how to locate them. One good way is to ask for referrals on photographers' Internet bulletin boards and mail-list services. Another approach is to research the trade press and photography magazines for articles written by consultants. Some consultants have written books about various aspects of the photography business, so a trip to a book store can help. Finally, a search of the World Wide Web will also yield some results. I suggest that you keep a file of possible consultants as you come across their names in publications, at programs, or from other photographers. That way, you might have the appropriate consultant's name on hand when you have the need for one.

Equipment

Planning to acquire the equipment that you will need is important. Each photographic specialty presents its own set of equipment needs. The best way to determine what your equipment needs will be is by discussing the matter with photographers working in the particular specialties you seek to practice and by reading trade books and journals that offer such information. While it is important to have the basic equipment needed to do the work within a specialty, it is important that you do not go to excess by purchasing gear that you will rarely need, and which can be rented when needed. It is very easy to become equipment poor; that is, to be paying off equipment costs for gear that is not needed for most of your work. Remember, you can purchase equipment as you develop a need for it. Don't be extravagant. Most work can be done with very little equipment.

However, many photographers fail to recognize the need for equipment repair and replacement services before it is too late. Imagine that you are out on assignment in central Wyoming. You are shooting wild horses. You are very dependent on your 400mm lens.

Then you drop it, and the rock it hits, being harder than the lens, damages the focusing system, making sharp photographs impossible. There is no nearby store where you can buy another one. There are not a lot of professional photography equipment suppliers in central Wyoming. And the lens is expensive, so you'd rather fix the broken one than buy a new one. What do you do? I know what I'd do. I would use the nearest phone and call Nikon Professional Services (NPS) and ask them to loan me a 400mm lens and ship it FedEx to my hotel for arrival the next day. I'd pack my lens and ship it to NPS for a quick repair. The next day, when the loaner lens arrived, I'd continue working on the assignment.

Professionals, especially those doing rugged work, need quick repairs, temporary replacement equipment, and sometimes to borrow some piece of gear that they don't own and rarely need. You ought to have a means in place for meeting such needs before the needs arise. When I recently purchased digital camera bodies, I bought Nikons, because I know that my NPS membership will save my butt when I have my first inevitable and unfortunate experience with these cameras. I know other manufacturers provide special services for the professional photographer, but I only shoot with Nikons so I have no research on the other programs. But you ought to know how to get replacement equipment and quick repairs when you need them, especially if you use different formats and equipment by different manufacturers. Professional equipment service is invaluable when you need it; plan in advance to be prepared in the future.

Planning Beats Panicking

The simple message of this chapter is to be prepared. Panic is a reaction to surprise. The best way to avoid surprises is to be prepared. In business, you cannot avoid being surprised, but you can avoid panic responses to surprises by adequately planning for your future and your possible needs.

Financial Management

T HE FUNDAMENTAL PURPOSE OF THIS BOOK IS TO ASSIST photographers by providing easy-to-understand insights into operating their businesses and to debunk or simplify some of the convoluted and/or meaningless advice given to photographers. This is the chapter in which the information and advice can only be traditional, for there is no other way to handle your finances. The simple reason for that is that the basics of financial management have not changed since the first business transaction took place, however long ago that was. When you think about it, finances are simply mathematics, and math doesn't change. Two plus two has always, and always will, equal four. As a result, fundamental financial management will always be the same process of balancing an equation of income and expenses.

Overview

You become a photographer because you love to make photographs. You become a financial manager because you have to make money. You have to make photographs to make money, and you have to make money to make photographs. For professional photographers the inter-dependency of photography and business are inescapable unless you have the good fortune not to need to make money. Most of us are not independently wealthy or being supported by another, so we cannot escape the fact that we are in business—like it or not. Ignore the financial aspect of your business, and you soon won't have a business. That means that you will go from the ranks of professional to amateur because the only thing that separates the two is that the professional earns a living from photography. Notice I didn't say makes money.

Amateurs can make money from a photograph, but they do not earn a living that way. Professional photographers support themselves by means of the sale of their services, photographs, and the rights to use those photographs.

Success as a photographer is often indicated by recognition. When peers and colleagues, students and teachers, and clients and prospects recognize the quality of your photography, you will have achieved a level of success as a photographer. When you can not only show a profit repeatedly but also have increasing equity, you will have achieved a level of success in business. The photographer part of you has to manage your craft. The businessperson side of you has to manage the finances. These two skills are not mutually exclusive, but many photographers seem to think that they are.

There is a general impression that managing the finances of business is an esoteric skill. This impression probably flows from the way that the subject of financial management is presented to the inexperienced. We usually read about balance sheets, profit and loss statements, cash flow, depreciation, amortization, return on investment, and many more terms. Then we get a peek at a sample balance sheet and profit and loss statement. The result is that our eyes glaze over. The terminology seems comprehensible to accountants only. We see line after line of numbers and headings. However, it's really *not* terrifying. It's just boring and unaesthetic. It is also more complicated than need be. You are not going to become an accountant, not even a full-fledged bookkeeper. You are just going to manage your money with common sense, simple arithmetic, simple terminology, and with little understanding of the world of high finance, because you are not in that world, and you do not need to deal with the complexity of that world. Successfully managing your photography business can be done with a few hours of effort every month, using simple systems and tools and applying simple principles.

Financial Management Tools

The primary financial management tools that you will need are a forecast, a profit and loss (P&L) statement, and a balance sheet. A forecast is nothing more than an educated guess about what your

P&L will look like once the business is done. I prefer the word "forecast" to the word "budget" because budget is very formal and implies a rigidity that only an established business with a financial history can maintain. A manufacturer of widgets generally knows how many widgets they can sell in a period of time, and what the cost of those is likely to be, so it can set up a budget that details all these items. Start-up service businesses, and, to a lesser degree, even established service businesses, don't manufacture widgets. The scope of their work is less predictable. So, they must estimate revenues and expenses continually. This is planning. Forecasting is dynamic planning. A budget is a plan. Remember what I said about a plan versus planning in the previous chapter. Dynamic businesses require dynamic planning and adjustment.

Cash versus Accrual

There are two methods of accounting in use today. The simplest is the cash method. Under this method, revenues are recorded when received and expenses are recorded when paid. Under the accrual method, the invoices to be paid to you are recorded as revenues as soon as issued, and invoices to be paid by you are recorded as expenses when the invoices are received. Under the accrual method, both accounts receivable and payable are treated as if they had already been received or paid. Accrual accounting is more complicated than cash accounting. Most photographers use the cash method of accounting. The Internal Revenue Service (IRS) requires some businesses to use accrual accounting. You should check with your accountant or the IRS to see if you are required to use accrual accounting. Chances are that you will not have to use accrual unless you are making so much money that you are unlikely to be reading this book. In this chapter, I'll assume that you are or will be using the cash method of accounting.

The Profit and Loss Statement

In the paragraphs above I wrote: "When you can not only support yourself, but also have increasing equity, you have achieved a level of success in business." The easiest way to keep track of your equity is

through a balance sheet, and the easiest way to see if you are making a profit is through a profit and loss (P&L) statement. The P&L will track your profitability and the balance sheet will track the equity created by that profitability.

The P&L is the most essential tool for financial management. It is a way of keeping score of whether you are winning or losing in business. It is the manifestation of the one mathematical formula in business that you must understand for financial success: Income minus Expense equals Profit or Loss. Most photographers use a cash method of accounting. For them the P&L statement simply lists income received from all sources and paid expenses of all types. For those who use the more complicated accrual method, the P&L lists all accounts receivable and payable in addition to income and expenses. Whether using the cash or accrual method, the difference is either positive (a profit) or negative (a loss), hence the name Profit and Loss statement. It is a statement that can reflect a loss one month and profit the next. What is important is that it reflects an aggregated profit over the long run.

You have probably seen many examples of the categories on P&L statements. Let's take a look at one in its simplest form, that is, as a minimal expression of the basic formula for financial success (figure 2).

Figure 2

Income		
Assignment income	$173,400	
Stock income	38,400	
Interest and investment income	2,400	
Miscellaneous income	8,900	
Total income		$223,100
Expense		
Cost of product and service	$32,200	
Cost of overhead	112,300	
Total expense		$144,500
Profit (or Loss)		$78,600

You can see that the P&L is the total of revenues received minus the total of expenses. We can expand the simple P&L to include greater detail as in figure 3.

Figure 3

Income

Assignment income		
Studio	$128,000	
Location	45,400	
Stock income		
Agency	26,100	
Self-sold	12,300	
Business interest		
Savings account	700	
Certificates	1,700	
Miscellaneous income		
Photo	6,000	
Other	2,900	
Total income		$223,100

Expense

Cost of product and service		
Film & processing	$4,300	
Production costs	27,900	
Cost of overhead		
Salaries	42,000	
Taxes	6,800	
Facilities	21,600	
Consumables	6,900	
Professional service	4,800	
Support service	3,000	
Travel	11,700	
Insurance	11,900	
Depreciation	2,600	
Total expense		$144,500
Profit (or Loss)		$78,600

The simple fact is that your P&L can be as detailed or as general as you want it to be as long as it reflects all the income you receive and all the expenses that you pay so that you can track whether you are making a profit or taking a loss. One thing you should keep in mind is to be sure that your P&L contains at least the minimal information needed to complete your tax return. Remember, tracking and recording details takes valuable time. If the details you are accumulating are not being used to provide you with valuable information, then you are tracking too much detail. Keep your system lean. It is easier to expand the level of detail than to reduce it at a later date. In the end the system should be capable of telling you five things: what categories of work generated revenue, the total of your revenues, for what you paid expenses, the total of your expenses, and what was your profit or loss. These five categories of information will be the basis for forecasting your financial picture in the future.

Sample P&L

Now let's take a look at a basic P&L for an average photography business. Figure 4 presents a hypothetical P&L for a new studio belonging to Leslie Startup. Leslie started a photography business last year, and at the end of twelve months this is where the money came from and went. This end-of-year P&L is the total of twelve months of P&L statements.

The $78,600 profit on the bottom line of this P&L is the amount that the photographer receives as personal income. From this amount he or she will have to pay all personal expenses and taxes as well as provide a percentage for personal savings. The very wise photographer will also take a part of this profit and set it aside for business expansion or weathering bad times like recessions. If the photographer were to set aside 10 percent of expenses as a cash reserve, in three years' time Leslie could weather a period of time with no revenue coming in because the expenses of the business would substantially decrease for the period. Businesses have fixed and variable expenses. The fixed expenses are constant no

matter how much business you do. The variable expenses change with business volume. You don't have to pay production expenses with nothing to produce, but you still have to pay the rent. The important thing to understand is that you should set aside a portion of profits to guarantee that you will have money to operate when business is lean. The only way you can do that is to know what your profits are.

Figure 4

Leslie Startup's Photography Studio Profit and Loss Statement

CATEGORY		AMOUNT	BALANCE
Income			
Assignment			
	Advertising	$128,000	
	Corporate	42,500	
	Editorial	2,900	
Stock			
	Agency 1	16,300	
	Agency 2	9,800	
	Self-sold	12,300	
Miscellaneous			
	Studio rental	4,000	
	Print sales	2,000	
	Sales taxes	2,900	
	Interest	2,400	
Total income			$223,100
Expense			
Cost of goods			
	Film & processing	$4,300	
	Photo production	16,900	
	Independent contractors	8,000	
	Equipment/prop rentals	3,000	
Gross profit			$190,900

(continued)

Salaries

	Office staff	$9,000
	First assistant	33,000

Taxes

	Payroll taxes	3,700
	City mercantile	200
	Sales taxes paid out	2,900

Facilities

	Rent/mortgage	12,000
	Telephone	4,800
	Gas/electric	3,600
	Maintenance	1,200

Consumables

	Printing	4,000
	Postage	2,000
	Office supplies	300
	Stationery	600

Professional Services

	Legal	2,000
	Accounting	1,800
	Consultants	1,000

Support Services

	Messengers/couriers	1,000
	Web design	3,000

Travel

	Automobile	4,500
	Airfare	6,000
	Rooms and meals	1,200

Insurance

	Health	4,400
	Disability	1,600
	Commercial liability	1,900
	Premises/tenants	1,600
	Automobile	2,400

Depreciation

	Equipment	2,000
	Furniture/fixtures	600

Total expense $112,300

Profit (loss) $78,600

P&L Comparison Chart

The P&L in figure 5 is a yearly summary. In your business, you must generate a P&L each month. The year's result will be the total of the twelve months. Monthly P&L statements can help you monitor the financial condition of your business by doing more than just telling you whether your business is profitable. By charting your monthly P&L results you can see the profit/loss pattern that your business follows. The chart in figure 5 shows the hypothetical profit and loss of a business over three years.

Some interesting observations can be made from a brief analysis of the chart. The first one is that in year one you had a profit in January while in years two and three you had a loss in January. The question is, why? Was it a loss of a good account? Was the profit the result of a special promotion? Did you have a sudden and substantial increase in expenses? If you can identify why the changes occurred, you can focus on restoring the income that generated the profit. The changes were not inconsequential. The difference between years one and two is $5,300, and the difference between years one and three is $4,500. That means an average of $4,900 difference each year. It's worth looking at.

Figure 5

	YEAR 1	YEAR 2	YEAR 3
JAN.	2,100	−3,200	−2,400
FEB.	8,500	10,600	7,200
MAR.	7,600	8,400	9,300
APR.	5,400	6,200	6,800
MAY	12,700	13,300	12,900
JUN.	14,400	10,500	13,100
JUL.	−8,300	−9,100	−10,300
AUG.	−9,700	−10,200	−11,400
SEP.	14,500	15,600	17,400
OCT.	19,600	18,700	17,900
NOV.	22,200	24,000	26,000
DEC.	17,900	21,000	22,500
TOTAL	106,900	105,800	109,000

You can also see that in July and August the situation is bleak. In year three you needed $28,800 to pay for expenses that revenues didn't cover. Fortunately, you followed the advice in this book and set money aside as a reserve to cover loss cycles like these, didn't you? If you didn't, you may be going to the bank to borrow money.

Benefits of Comparisons

When you see loss months like those of July and August you have to explore the reason why. Probably it is because it is summer vacation time, and the studio business always drops off then. The bigger question is what can you do to reduce the losses. Maybe you should do some market research into what entities buy photography in the summer and try to sell them your services. Maybe amusement parks or outdoor recreation facilities or summer camps need photographs. Anything you can do to find business for these months will help stem the losses.

Another important benefit of the monthly profit and loss chart is the view it gives you of the progress of a year's business when compared to other years. For example, when you see a month like that of January above in year two you should immediately begin to question why. Businesses shut down from losses, not profits. Whenever you take a loss you have to examine why. The loss reported in January of year two in the chart, if researched early enough, would allow ample opportunity to reverse the condition so that there was no repeat of it in year three.

Hidden Benefit

A hidden benefit of the properly maintained P&L and comparison chart is its effect on a lender. When the day comes that you want to obtain a line of credit, lease expensive equipment, or even buy a property, the lending institution will carefully scrutinize your finances. Lenders know that self-employment is a temporary state for most people. Failure rates are high. The more your records show that you are in command of your business finances the more likely you are to be approved for a loan. Borrowing money is something that any business must do with great care. There are good reasons to borrow, but you have to convince the lender that there are good

reasons to lend. There is no substitute for monitoring your financial condition, if you want to stay in business and make a profit.

Monthly Revenue and Expense Comparison

You can also make a chart of comparing annual revenues and expenses across several years. The value of this information is usually found in the expense section. Spending money is easy, especially when you are making it. Sometimes we spend more than what we need. Always remember that every dollar you do not spend becomes a profit dollar in your bank account instead of a profit in someone else's bank account. The chart in figure 6 compares three years of expense information for three categories of expense.

Needless to say, costs increase over time as the prices we pay are increased. But when costs jump substantially they have to be examined. Above we see a 33 percent increase in messenger and courier fees, a 50 percent increase in postage, and a 50 percent increase in printing over a thirty-six month period. Unless there have been some catastrophic price increases these numbers indicate that you are spending more money at your initiative rather than at that of others. You have to ask yourself where the money went and why. Assume that your research indicates that you printed and mailed increasing amounts of promotional materials that account for two of the increased expense categories. Assume that the third, messengers and couriers, results from delivering more portfolios for review by buyers. It has increased as a direct result of the increased promotion. So, two increased expenses have led to a third increased expense. It proves one thing: your promotional effort worked, it helped to get your work in front of more buyers. That's a good reason to increase expenses.

Figure 6

	MESSENGERS/COURIERS	POSTAGE	PRINTING
Year 1	$3,000	$2,000	$4,000
Year 2	$3,600	$2,500	$5,000
Year 3	$4,000	$3,000	$6,000

Figure 7

	REVENUES	P OR L
Year 1	$162,200	$47,500
Year 2	$186,700	$56,200
Year 3	$185,400	$55,800

The bigger question is whether the increased expense was profitable. To answer that question, you have to make another chart like the one in figure 7.

This chart indicates that you increased your revenues and resulting profits in year two, so your promotion expense paid off. But in year three, your revenues dropped slightly, as did your profit. This means that the additional increases in promotion did not pay off. The question is why, and the answer is most likely one of two things: Either you reached a saturation point with the promotion and more was not effective, or your sales effort to close deals based upon those portfolio reviews was not as effective as it should have been. You'll have to check your sales call and closing records to determine the reason. In either event, you have to consider cutting back the promotion expense to a lower level until you figure out how to remedy the problem.

As you can see, the P&L is full of useful indicators for managing the control of your finances. It is a necessary tool for operating a profitable business. Like all tools, the more familiar you become with it, the better you can handle it, and the more benefit you can derive from it.

If you have only one financial control in your business, the P&L is the one you must have.

Forecasting Your Finances

Forecasting is a term that is often preceded by the word "weather." But, just like weather forecasting, financial forecasting is dependent on variables. Sometimes those variables are changing so rapidly that accurate forecasts are not possible, but most of the time the forecasts can be very close because the variables are predictable or controllable.

While weather forecasting requires a solid knowledge of meteorology, fortunately for photographers, business forecasting does not require as much expertise in economics. Business forecasting simply requires common sense, a bit of research, a bit of educated guessing, and a commitment to making the forecast come true by trying to control the variables. In the latter regard, the businessperson has an edge on the weather forecaster.

Forecasts are nothing more than educated guesses of what your P&L will look like at the end of a given period of time. Forecasts can be annual or monthly, even weekly, if you like to drive yourself to madness. If you have a year of business-financial history you can use it to help in preparing a current forecast. All you have to do is study the P&L from the previous time period and contemplate what will likely cause it to change. Maybe the economy is better or worse. Maybe you have enough cash to do more promotion and sales work that will lead to greater revenues and expenses. Possibly you have secured a new client that will increase your business volume and hopefully your profitability. A forecast can help you make the probability of profit more likely, because the forecast is really a combination of estimating future reality and goal setting.

Educated Estimating

If you have no history from which to derive a forecast, you have to make educated guesses about the line items. Some of your estimates can be right on target because the expense is fixed, such as rent and insurance. When it comes to revenues, you are effectively setting goals. Be realistic about it. How many assignments are you really likely to sell during the year and how much can you charge for them? Before you do your forecasting, you should do your marketing and sales planning. Those processes develop the basic information you'll need to forecast revenues. The volume of promotion and shooting that you do will also influence your variable expenses. So forecasts are a product of deliberation in a goal-setting process. You can get help with your forecasting from an experienced professional who might share their assessment of how many shooting days a photographer in a particular line of work might be able to book. Associations often have statistical information

on average business costs. The Small Business Administration (SBA, *www.sba.gov*) has useful instructional aides and offers a program, SCORE, in which retired executives voluntarily assist you in processes in which you have no experience. Information about SCORE is available at the SBA Web site or at *www.score.org*. Assistance is out there—you just have to go get it.

Use the statistical categories that appear on your P&L for forecasting your finances. These are the real core elements of your business finances. Follow the successful businessperson's forecasting rule: when forced to guess, estimate expenses high and revenues low. This is a safe track to follow. In the worst-case scenario your losses are not too shocking, in the best-case scenario you end up with more profits than you estimated. It is always better to be a bit negative in your forecast to assure that your P&L will be positive, that is, show a profit.

It is not hard to estimate your fixed expenses. The rent, car payment, equipment lease, electric bill, your salary, etc. are generally consistent from month to month. The expenses related to promotion and sales are variable but controllable by you. The expense to produce work for clients is billed to them, and those revenues will balance the corresponding expenses. Of course, there are unexpected expenses that every business has to deal with. That is why a healthy balance sheet is important. You can't avoid the unexpected, but you can prepare for it by stashing away some profits in the bank as cash assets.

Estimating revenues is harder than estimating expenses. Again, the established business has an advantage because of historical performance. But even the established business cannot predict the unexpected drop-off in sales and subsequent revenues. Revenues are always subject to greater variables than expenses. Forecasting revenues is really nothing more than setting sales goals. If you add up all your estimated expenses for a year, you know how much sales revenue you have to make in order to break even. Then you add a percentage for profit to be retained in the business so that your balance sheet's equity increases. The total of the two items is your estimated revenue. Estimating revenue is not earning it; to earn it, you have to make the sales. Your success at meeting your forecasted revenues will depend

upon the effectiveness of your marketing, research, and sales efforts. The next few chapters explain how to plan those activities.

Variance Reporting

Becoming efficient at forecasting finances is a matter of time and effort. You will be surprised at how good you can become at it with a reasonable effort. One tool that will allow you to perfect your estimating capability is the variance report. This report compares your forecast with your P&L. The difference, the amount they vary, is the variance report. The chart in figure 8 compares a few lines of forecasted revenues with a P&L for the same period.

These variances not only tell us just how accurate our forecasts are and how you should adjust future forecasts, but they also help you to see where you need to either work harder if sales are off, or tighten up if expenses are off. If the variance report indicates substantial differences, once again, you ought to understand what caused it. In the above example, how did you make stock sales that were so much higher than your estimate? Was it a couple of big sales the likes of which you rarely receive? Did you increase your average sale? The latter is reason to increase future forecasts, while the former deviation of a few sales from normal is not.

The variance report is an analysis tool. It helps you assess your ability to forecast, and at the same time it helps you learn to be a better forecaster. It is an early warning system alerting you to what you are doing right or could be doing better. Once you have a P&L and forecast, the variance report can be generated in a short time. If you are keeping records in a computer with accounting or bookkeeping software, or in

Figure 8

INCOME	CATEGORY	FORECAST	P&L	VARIANCE
Assignment	Advertising	$116,000	$122,400	+ 6,400
	Corporate	42,200	39,900	−2,300
Stock	Agency	$22,000	$18,500	−3,500
	Self	15,000	26,200	+10,800

a spreadsheet, the variance report can be created automatically. To not take advantage of an automatically produced, no-cost financial tool is simply foolish. Don't be foolish about finances.

The Balance Sheet

The balance sheet is an important tool for two reasons. It is how you know whether you are financially successful, and it is an important element in how any prospective lender or investor evaluates your business history and future potential. It is used for those purposes because a balance sheet simply tells the story of how much your business is worth at any given moment in time. If your balance sheet shows increasing equity over a period of time it indicates that you are successfully running your business. The greater the equity increases, the more financially successful you have been. The balance sheet is a scorecard in the game that we call "business."

Unlike the P&L, the balance sheet does not concern itself with revenues and expenses, or profit and loss. Instead, it compares assets with liabilities. The difference between the two is your net worth. The P&L also indicates the state of your solvency. If you own more than you owe you are in a state of solvency; that is, you own unencumbered assets that are cash or capable of being converted to cash, so you have money. If you owe more than you own, you are in a state of insolvency; that is, all your cash and cash value is owed to others, so you really have no money. If you are insolvent long enough, you won't be able to pay your bills. In that case you might find yourself in a state of bankruptcy. Creditors can force you into bankruptcy, or you can elect to declare bankruptcy. In either case, it means you are out of business, you cannot get credit for years, the court takes over the administration of your business, and you need to find a job.

The old adage that bankers only lend money to those that have it is true, and the bankers look at your balance sheet to see if you really have money and how much you have. Like the P&L, having a balance sheet tells a lender that you at least understand the fundamentals of financial management. If for no other reason, impressing lenders is a good reason to have a balance sheet.

Equity

In its simplest form, the balance sheet lists the assets that you own and compares this total to the total of the debts that you have accumulated. The rest is your business equity, sometimes called "net worth." Let's look at the categories of a very simple balance sheet in figure 9.

If your business has no equity, you have no business in the truest sense of the word. You are just doing day work for a living. You would be surprised to know how many photographers have no idea of what is the value of their business. This lack of knowledge is a primary cause of many photography business failures because revenues and expenses keep flowing and are tracked, but the difference

Figure 9

Assets
 Cash in banks
 Cash on hand
 Investment value
 Equipment value
 Property value
 Accounts receivable
 Loans receivable

Total assets

Liabilities
 Mortgages
 Rental/lease contracts
 Wages owed
 Loans payable
 Accounts payable
 Other debts

Total liabilities

Equity

Figure 10

Leslie Startup's Studio Balance Sheet

Assets			Amount
Cash in banks			
	Checking	$21,000	
	Savings	13,000	
Cash on hand			
	Petty cash	500	
	Travel fund	900	
Investments			
	Stocks	12,000	
	Bonds	4,000	
Equipment			
	Photographic	48,000	
	Office	6,000	
Accounts receivable		26,000	
Loans receivable		4,000	
Total assets			**$135,400**

Liabilities			
Leases			
	Studio	$12,700	
	Automobile	8,000	
	Copy machine	2,000	
Wages		3,500	
Loans payable			
	Bank	6,200	
	Credit cards	4,900	
Accounts payable		19,300	
Taxes payable		22,000	
Total			**$78,600**
Equity			**$56,800**
Total equity plus liability			**$135,400**

between debt and assets gets out of hand because it is not watched. Debt piles up faster than assets, and the photographers find themselves bankrupt with no reserve capital to weather a bad economic period. They are then forced to find work elsewhere to support themselves. As I said, the balance sheet is the indicator of your level of success in business, or it is the indicator that you are really no longer in business.

Figure 10 shows a simple balance sheet for a small business. Balance sheets can be much more complex, taking the age of receivables and the quickness of conversion of non-cash assets into cash, etc. But for our purposes, this simple example will suffice.

Looking at the last line you will see why it is called a balance sheet. To balance, your assets must always be equal to the sum of your liabilities and equity. In the example, your equity in your business (the business' net worth) is $56,800. The net worth is how much you would receive if you closed down the business. It's nice to know. Don't forget, the balance sheet is mathematical. It does not take into consideration things like the ability to collect receivables or convert assets at stated value. It is possible that your business will be worth more on paper than it would be if you actually shut it down, converting assets to cash.

Balance sheets can become more or less detailed depending on the complexity of your finances. Simple math is still used to calculate it, no matter how many line items it might have. Like the P&L, you do not need an advanced degree to maintain a balance sheet. In fact, you only need early elementary, school-level mathematics.

Your balance sheet can yield important information. There are ratio tests that auditors, accountants, and lenders can perform on a balance sheet to test the strength of the company's financial position. You can do the same tests. The word "current" reappears in these tests. Understand that current in accounting language basically means "cash" or "easily converted to cash."

The Working Capital Test compares current assets to current liabilities. Using the balance sheet in figure 10 the equation would be seen as in figure 11:

Figure 11

Cash in banks	34,000
Cash on hand	1,400
Accounts receivable	26,000
Total	61,400
Accounts Payable	19,300
Wages	3,500
Taxes	22,000
Total	44,800
Working Capital	$16,600

This means that you have $16,600 dollars to use if needed in your business since it is not needed to pay off currently occurring liabilities. The higher your working capital grows, the stronger your business is financially.

The Debt to Equity Test is a means of evaluating the risk that a potential investor is taking or that a lender will be incurring by lending you money. Using the example balance sheet in figure 10 the equation is:

Total Liabilities divided by Owner's Equity equals Debt to Equity, or $78,600 divided by $56,800 equals 1.38

A lower result means there is a better investment value in your business, making your business more credit worthy.

The balance sheet is like a heart monitor. It indicates the beat and rhythm—read that as strength—of your business. Once you understand the value of a balance sheet, you will understand why so may big corporations spend so much time and effort trying to keep theirs in shape; it is a financial management tool that you should not do without.

Record-Keeping Systems

Many photographers use computer programs to keep their financial records. This is a highly efficient method because it forces you to use a system, and with personal discipline, posting the system becomes routine. Financial management packages come in all sizes and con-

figurations. Some of the vertical, photography-business-management software on the market has built-in financial management tools. This software is a boon to those who are doing enough business that they need a highly efficient and integrated management tool. However, this type of software is usually expensive and has a lengthy learning curve. Many photographers abandon the use of all or parts of such packages after paying a lot of money for them. They find them to be more complicated than what they need to track the number of financial transactions that their businesses generate.

If you bill seventy-two jobs a year with an average of six per month, do you really need a computerized system to manage six invoices a month? No, you do not. You may want to use a computerized system to do it, but it's not necessary. That volume of business is manageable with a typewriter and file folder. On the expense side, you might be writing about twenty-five checks a month for business expenses. You don't need a computer to do that either, but it sure makes life simpler. The computer does not make math errors, and having a computerized checkbook certainly saves time when it comes to reconciling the account each month when the bank statement arrives. It also speeds up the check writing and bookkeeping processes: the system does the work for you after you indicate how much gets paid to whom. You can purchase check writing and/or check bookkeeping software for 10 percent of the cost of many business management software programs.

Perhaps the most affordable and efficient way to manage your finances is through the use of a software program like Intuit's Quicken or Microsoft's Money. These programs are low cost but highly flexible and usable financial-management tools. For those who have higher sales volumes that require accrual accounting, or for those who work with accountants and professional bookkeepers, programs like QuickBooks and MYOB offer a low cost but complete double-entry accounting suite. The simple fact remains that most photographers do not have to do accrual accounting, nor do they need to work with accountants on a monthly basis. For this majority, inexpensive and easy-to-learn software is the best choice. You can always upgrade when the business warrants it.

The Bad Economy

One contingency that you must plan for in business is the eventual recession. Recessions are a fact of business life. The only way to escape them is to go out of business before one happens. Since no one plans to do that, it is important that you plan for a future recession. Preparing for an eventual recessionary economy is wise because they are cyclical events. This is a topic I addressed in the *ASMP Bulletin*. The article is reproduced here by permission of the ASMP. Like most business advice the information is timeless.

Plan for Recession

Businesspeople often employ vision by forecasting future scenarios for their businesses. It is similar to dreaming about a photo essay or illustration and executing it or rejecting it after the exercise. Forecasting is like fortune telling; it is a best guess based upon vision. Vision and fortune telling are related. Vision and fortune telling are intrinsically entwined. Today, it is time for each of you to exercise some vision by forecasting future scenarios to improve your fortune. The following are some of my thoughts and direction on this theme.

Successful businesspeople and good photographers have one thing in common—vision. For the photographer, vision is the ability to interpret a scene to imagine how it will look when it is reduced to a two-dimensional photograph. Having vision is also the ability to imagine how a concept will look when it is translated into a scene and then into a two-dimensional image. For the businessperson, vision consists of seeing how a business will operate, grow, and deal with advancing its own goals and success. All vision comes from the same innate creativity. It is simply expressed in different terms and ways. Vision can be cultivated and improved. One thing for sure is that you, the photographer, have the vision to be both photographer and businessperson. You have to exercise it, and that will improve it and your fortune.

Here's a practical exercise for you. I am going to present you with a simple scenario based upon a business reality and will give you some tips on how to work with the data. The governing premise is

this: The economy is a cyclical landscape that has peaks and valleys with plateaus between. As you walk the landscape, you will travel up peaks, across plateaus, and down into valleys. The most dangerous spots are the peaks and the valleys. When you are on the peak you can fall, and when you enter the valley, you can go so deep that you can't get back out. In short, too much business can ruin you, as will not enough business.

You need a topographical economic map to be safe, but nobody makes one. You have to envision the landscape and plan how to deal with traversing the valleys and the peaks. The peaks are simple to deal with by a simple rule: Never overextend yourself. You can take on so much that you lose your quality of service or creativity, and that is a fall. The valleys are more complicated. How do you survive when you are in too deep and don't have a way to get through the valley? This is the exercise we will address.

Periodically, the country experiences a recessive economy—a valley. The valleys always end and rise back up to a plateau, leveling out to a middle ground. Then the economy grows. Growing is another term for reaching a peak. After any economy reaches a peak, it will turn down and eventually reach the plateau again. The danger lies in the fact that the valley comes after the plateau. You have to get ready to deal with the valley while you are on the peak and plateau. You do that by establishing what I call "recession insurance." No, you can't buy it; it is self-insurance.

When will the next recession come? Well, if anyone knew exactly when that would be, they wouldn't need to think about the problem. They would have the information needed to make them a billionaire overnight. But, we mere mortals have to do some fortune telling; perhaps the better word is fortune guessing. In the time I have been in the photography business I've seen severe recessions happening in the first years of each decade. Often there are minor recessions in between, but the ones that are more likely to be fatal have been within the first five years of a decade. Of course, no one can accurately predict the timing, but history is a good guide when vision is blurred.

Now for the exercise: Let's assume that you will be faced with a twelve-month recessionary period, and that you have had thirty-six

months to prepare for it. How should you proceed? First, make an assumption, based on a worst-case scenario. Let's assume that your business will drop by 50 percent during the recession and that you will not be able to cut expenses at all during that time.

While you might be tempted to do this, it often requires spending more money than warranted on promotion and sales to keep the reduced volume of business flowing during a recession. OK, the problem can be stated simply: if you need X dollars to run your business in the thirty-six months before the recession, and you won't be able to cut back during the recession, then you will need Y dollars to supplement your business during the twelve recessionary months.

Now if my college algebra course (in which I earned a D) taught me anything, it was that we may make an equation out of this information. Now remember, Y is 50 percent of the annual amount needed to weather the twelve-month recession. The formula is $Y = X/3 \times .5$, which reflects that the needed supplement is equal to 50 percent of one year's dollar needed in each of the preceding three years.

So, applying that formula to a business that is projected to gross $85,000, $75,000, and $65,000 in each of three consecutive years, we see that X = $225,000. That means that the supplement needed for the recession will be $Y = \$225,000/3 \times .5$, which in turn reduces to $\$75,000 \times .5$, which equals $37,500. You have thirty-six months to create a liquid reserve with a minimum of $37,500. If you have a normal reserve of $10,000, you will need to raise, save, or borrow $27,500 more to make it through the recession in good business health. That in turn is 12.2 percent of the $225,000 three-year total. This means making plans to take 12.2 percent of all revenues for increasing reserves, or building your borrowing power to 12.2 percent of revenues, or cutting back 12.2 percent, or a combination of any or all of these elements. Now for those of us who hate complex math, here's a simpler approach. Take the average of three years' revenue and divide it in half. That is how much you would need in reserves in the above scenario. You can save it, borrow it, or cut it from expenses, or combine these means. Whichever way you chose to do it, it is planning for the

eventual recession that will help to ensure that you will be in business when the recession is over.

It's Simple Math

This chapter has one message. Financial management is an exercise in simple mathematics and well within the capability of anyone smart enough to learn photographic technique. Managing finances are the crux of business success. If you can create, read, and understand a P&L and a balance sheet, you have the necessary financial skills to be successful. In the end, financial success requires that you make profits and retain enough of those profits to establish equity in your business. The forecast, P&L, variance report, and balance sheet are tools you must master to succeed in business.

Market Research

THE OBJECTIVE OF YOUR BUSINESS IS TO EARN A PROFIT from making and licensing photographs. As a photographer you have something to sell to generate the revenues needed to make a profit. Now all you have to do is sell it. The problem is that unless you approach the sale of your services correctly, you will not sell very much. Fortunately, you are already a bit ahead of the game because you read chapter one, and your strategic visioning statement has steered you in a specific direction.

Marketing is a combination of three processes: research, promotion, and sales. Since promotion and sales are critically important processes, separate chapters are devoted to the subjects. I'll refer to promotion in this chapter many times, but only to reemphasize its value. Right now we will focus on market research.

Picturing the Marketplace

Good marketing requires that you understand in what industry your marketplace is situated. The photography business serves the consumer services markets and the communication markets. Consumer services markets are weddings, portraits, events, groups, etc. Communications markets are publishing, entertainment, educational, etc. Each communications market can be illustrated as a circle divided into segments, as in figure 12.

For the most part, photographers who are making photographs for publication deal in any or all of three market segments: advertising, corporate, and editorial.

Some photographers refer to advertising, corporate, and editorial as specialties, but that is simply not the case. Specialties refer to subjects

Figure 12

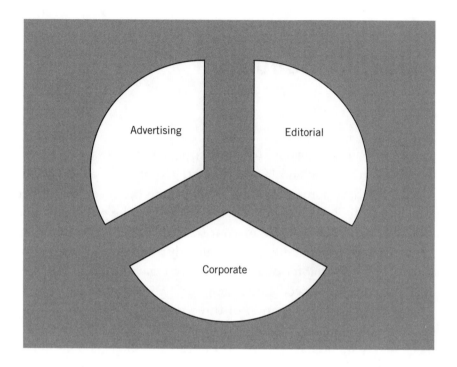

like sports, food, landscape, and wildlife. Any one of those subjects can be used to illustrate an ad, an annual report, a magazine, or in products like posters and wall art for the consumer market. Never pigeonhole yourself as only an advertising, an editorial, or a corporate photographer, unless you intend to give up opportunities in the other market segments. If you do that, be sure that you fully penetrate the one segment you have selected, because you are limiting your revenue-making possibilities.

You should also remember that both stock and assignment photography serve the needs of all three segments of the market. Stock and assignment photography are not specialties. Specialties describe what you shoot, not where it goes or how it came to be. Stock and assignment photography are only descriptive of the means of fulfilling the market's needs.

Mining for Business

The purpose of market research is to determine who is buying what and how much they are willing to pay for it. The marketplace is huge because there are millions of photography users. You have to pinpoint those to whom you are likely to be able to sell your services. These will be your prospective clients. Some of these prospects will eventually become your clients. Before you do any selling you have to do your prospecting.

There is an interesting analogy that can be drawn when thinking about market research and selling. The process is quite akin to mining. A mining company will do a geological survey of the land it suspects holds ore. That is like researching the market. After they identify the area in which there should be ore, they begin taking earth core samples to see if they really have good probability of finding ore in any quantity to make the effort worthwhile. That is prospecting. Once they see the odds are in favor of a productive mining operation, they begin the mining process. They dig into the ground until they hit a vein of ore, then they dig out the ore very systematically by following it until it runs out. When they are mining, they are harvesting the results of the prospecting. In your business, surveying is market research and mining is sales. In mining, the intermediate step is test drilling. In your business it is positioning, promoting, and networking.

Staying Focused

It is time to use some of the knowledge that you have already acquired from this book. Your prospecting efforts have to be focused in order to maintain some efficiency. As I mentioned above, the marketplace is huge. In the past few years, while doing research for a business plan I was helping develop, I learned the following:

Worldwide, there are about 2,260,000 businesses that buy photography. About 160,000 are classified as creative users, meaning that they usually have some level of art direction as part of their operations. These are the advertising agencies, design firms, magazine and book publishers, multi-media producers, etc. The larger group is the non-creative users of photography; that is, entities that do not have art direction but use photographs in self-produced materials. These are

the smaller businesses that dominate the business landscape world-wide. There are about 2.1 million of them. That is a lot of doors to knock on.

Depth and Width

The research I was involved in also estimated that the marketplace consumed about 3.5 billion dollars in stock photography (including royalty free) every year and about twice that amount in assignment photography. That would make the entire publication photography business a 10.5 billion dollar market. Research also indicated that the creative buyers spent about one-third of all dollars spent. This means that about 7 percent of all businesses buying photography are purchasing about 33 percent of all the photography bought. These creative businesses are called a vertical market. It is an inch wide and a mile deep. The non-creative businesses are called a horizontal market. It is a mile wide and an inch deep. The way you prospect and mine is different depending on whether you are working a vertical or horizontal market.

Finding Prospects

It is easy to see who the vertical prospects are. Magazines, book publishers, ad agencies, designers, etc., are readily identifiable and almost assuredly going to use photography. They are listed in creative directories, the yellow pages, and the trade associations that represent them and have membership listings that are available to the public. When prospects in a vertical, high-volume market are so easily located they attract a large number of prospectors. These entities have no problem finding photographers because most photographers spend a tremendous amount of time finding them. There are two ways to come up with your list of prospects. One is to research the many lists available. The other is to identify them through their product.

Finding prospect lists is relatively easy, especially since the World Wide Web has become so loaded with information. The one print publication that you will probably not have to go to the bookstore or library for is the yellow pages. The best yellow pages are those with

the Business-to-Business listings. They have become popular in many cities. You can look under headings like Advertising, Designers, Graphic Arts, and Publishers. The yellow pages for the telephone area I reside in covers one suburban Philadelphia county. It lists more than fifty advertising agencies that are within ten miles of my home office. That means fifty prospects for photography. Some of them are better prospects than others depending upon where you are positioned in your market segment. You'll learn about that in the next chapter.

There are a number of print publications full of lists of prospects. A visit to your public library's business reference section will usually be productive in this regard. Publications like "Redbook of Advertising Agencies" and the "Thomas Register" for a variety of industries are often found in large metropolitan libraries. However, many of these books are quickly being turned into Internet applications on the Web. Web sites like *Mediafinder.com*, *Ulrichsweb.com*, and *Redbooks.com* are examples of sites where you can look up agencies and publishers.

Trade associations often have searchable member rosters online. The Association of American Advertising Agencies will provide you with a list of its members by state via its Web site (*www.aaaa.com*). Your local art directors club might have a Web site listing the business contact information of its members. You can find all sorts of lists by visiting *www.knowthis.com*. The Internet is a veritable warehouse of lists of potential prospects for you.

Old Standby

Among its many market guides, Writer's Digest Books annually publishes *Photographer's Market*. The 2003 edition contains information on 680 magazines and newspapers, 124 book publishers, 66 greeting card/poster/calendar publishers, and 308 advertising agencies. While these listings cover less than 1 percent of entities in the marketplace, the value of the book comes from the fact that each listing has been fully researched. Who to contact, what they buy, how much they buy of it, when they buy it, and more. The book does a lot of homework for you. If you find a few listings that are a good fit for you it will save hours of search time. You'll see why as you read on.

Here's an example of how I used the 2003 issue of *Photographer's Market* for my own marketing research. A few months ago I re-entered the business world as a photographer/writer after spending years as executive director of ASMP. I had no clients, and I had to find prospects. In my strategic vision, I thought I would primarily shoot stock that I would market directly to prospects that bought what I like to shoot. So I had a categorical list of image types that I like to make and that I have access to making. Here's my actual list: adventure, agriculture, animals, architecture, automobile, business concepts, children, cities, couples, environment, families, fine art, fitness, historic places, industry, landscapes, pets, rural, seasonal, sports, travel, and wildlife; twenty-two categories in all. *Photographer's Market* lists sixty-six publishers of greeting cards, posters, and related products. Studying the listings, I found that forty-eight of them used photographs in the categories of my list. Forty-four of the forty-eight provide their Web site address. The Web sites provide catalogs of the company's products, so you can see if they buy what you shoot, or if you want to shoot what they buy. It was the easiest market research I ever did and I can do the same exercise with book and magazine publishers. In the end, I will end up with perhaps as many as 300 prospects this way. Now that might not seem like a lot, but it is because these prospects are hot, not just names on a list. I know who, what, when, where, why, and how from the book's listing. I'll take 300 prospects like these over 3,000 names of bona fide buyers on a mailing list. I have 300 hot contacts while some other photographers are still chasing down 3,000 names to see if they have any real potential for providing business.

Blind Mailings

There are going to be those who want to argue with my advice on qualifying prospects. They will argue that my advice to know what a prospect is buying in terms of photography is impractical, and that doing blind mailings of promotional material is a reasonable way to get clients because it works. They will point out that any photo buyer might be attracted to their work because either it impresses, or it eventually fits with a job to be done. To that I answer yes, it works, but is it efficient?

I want you to think about the direct mail you received over the last few months. How much of it do you remember today? Did you save the memorable material in case you want to buy it? If you want to buy it, are you going to buy it from the sender, or from someone from which you have been buying for years?

Suppose a Photoshop service provider knew that you had just landed a large contract for product illustrations and you were going to need substantial digital retouching services. If that provider promoted itself to you before you began the job, it would have a better shot at getting your business than if it promoted itself to you six months earlier when you were working on a job that required practically no computer enhancement. It is easier to sell your product to someone who needs what you offer in the immediate or short run.

Qualifying Prospects

Too few sources of prospects provide the qualifying details that you need. By "qualify" I mean to know the who, what, when, where, why, and how about their buying habits of photography. So, in many cases, you have to do that research. Unless you want to spend your life in the library to get maybe a 10-percent success rate, you better turn to the Internet. Photographers thought that the Web was going to provide a bonanza for them in image sales. Well, it hasn't because most Web site producers go for low-budget work, and royalty-free photography is usually more than adequate for their needs. It is time to wake up and smell the coffee. The Web does pay off in increasing sales, if the photographer uses it correctly. When it comes to market research, the Web is unbeatable for the solo practitioner (which most photographers are). You can get more information about a company on the Web in ten minutes than you can get in ten hours any other way.

I use *www.google.com* for market research. Its search engine is more intuitive than any others I have tried. It even corrects mistakes in your entry typing, and it asks you if you meant what you wrote, suggesting what it thinks you want to find. Pick an advertising agency for which you have a name and a location. Search under those terms in Google. Your query might look like this: "Funhouse Advertising" + New York.

It is important to learn how to use qualifiers to limit search results. Google and other search engines have online advice on how to use them. If Funhouse has a Web site, Google will find it. But it will find other things too. I have done this over and over again in my recent market research efforts, and here is the kind of information I am getting by doing so:

Good Information

From the prospect's Web site I can learn the proper name, address, and phone number of the agency. Many have the names of clients so you know if you are shooting the kind of subject matter those advertisers use. There are samples of ads they have produced so you can see the trends in the agency's work. Some sites are even kind enough to provide the names of art directors and art buyers in the agency, saving a lot of phone calls to find out whom you want to contact. I can also judge the stature of the agency by the quality of its Web site.

From other Web sites listed in the search I can find articles about the agency that can help me qualify the prospect. Press releases from companies that have recently hired the agency also show up. If a company hires a new agency that will be taking over future PR work, it can give me a jump on my sales effort. This means that I can get a portfolio together to show work that fits the advertiser's needs. For example, if I find that Bigfoot Shoes is going with Funhouse Advertising next month, I can promote myself to Funhouse with a great display of shoe and shoe-related photographs.

The Vertical Market

Just as the Web helps you get from prospect list to qualified prospects it can help you to identify and qualify prospects through their work product. In the vertical market you can work backwards from the advertiser's advertisements or other promotional materials to find out which advertising agency produced the work. You see ads and brochures every day. You probably can categorize them into two groups: the ones that you wished you had taken because you would be so good; and the one's that you wished you had taken because you would have done it so much better than the picture in the ad. Maybe

you even have samples of work that you did, and that is even better. You must show that work of yours to the agency. They may still be working with that advertiser, and there might be future work awaiting you. But to do that, you have to find out which advertising agency or design firm produced the ad. How can you do that? Well, get on the Web again. Enter the name of the advertiser in Google. If the company name isn't evident, you can enter the name of the advertised product or service. Either way, you are likely to end up at the Web site of the advertiser. The company might even list the name of its advertising agency at the site because it might have ads at its own site, or the agency might have even designed the site. If all else fails, there is still the old way. Look up the phone number on the site or use the "contact us" e-mail provision and ask someone who their advertising agency is and where it is located. You can even try to get the name of the account executive, who, in turn, might just tell the name of the art director or art buyer on the account. It is amazing what a Web search can provide or lead you to.

Quality, not Quantity

Remember this—it is the quality of your research that will pay off when it comes time to promote yourself efficiently and affordably. If you do the homework, you will get the grade you need in the test; that is, the test of any business—making sales. Many photographers think that they can avoid market research by purchasing mailing labels of photography buyers to whom they will mail some promotional material. The photographer might pay $250 to $500 for two thousand labels, depending on the quality of the list. They spend $2,000 to $4,000 on material and postage to send each name on the list some promo piece. In the end they have spent thousands of dollars to send their promotion to a prospect that they know nothing about. If your beautiful poster of a shoe gets to the spaghetti art director, it is likely to go into the trash can along with the other dozen pieces that the art director received that day. Sure, he keeps one, and he hangs it on his wall. Which one? The one that interests the art director personally because it is exceptional art or something the art director is really interested in. But if you only know the art director's

name, how can you know what his interests might be? You have to qualify your prospects if you want your promotions to pay off.

The Horizontal Market

The horizontal marketplace is much different than the vertical. It does not support many photographers who are primarily interested in the advertising or editorial market segments. But it is a great market for corporate/industrial and architectural photographers. Thousands of hospitals, universities, architectural firms, utilities, landscaping firms, construction contractors, equipment manufacturers, theater companies, orchestras, recreational facilities, hotels, and other types of businesses use photography periodically. These firms do not usually pay fees as high as the creative market for the same level of work, but they offer advantages. One big advantage is that they usually pay their bills on time; another is that it is possible to build a relationship that leads to substantial repeat business; and another is that since most photographers are looking for work in the vertical market, you face less competition.

Look Around You

I was once asked to deliver a talk to a small photographers' organization. It had about forty members. All were complaining that the business was terrible, and as a result competition was fierce. No, make that cutthroat. To prepare for the talk, I acquired some information about the area that those photographers serviced. What I saw was a fifty-mile radius in which there were a total of about sixty creative, market segment businesses. Now imagine forty photographers looking for business from the same sixty prospects. No wonder it was cutthroat business. There was not enough of a prospect base to support that many photographers. Then I researched how many non-creative businesses there were in the same area; the number was about two thousand.

In that market area maybe one business in ten uses photography. That's an educated guess, as I have no statistics but my own experience to support it. But if my guess is correct, you could go to an industrial park where a hundred businesses are located, and after you knocked on every door, you would find ten photography users.

Some of them will acquire their photography through the services of a creative business like an ad agency or design firm, and others will acquire it themselves. But if you could identify the 10 percent of the two thousand that used photography, you could potentially have another two hundred prospects to add to the sixty. Two hundred sixty prospects would support forty photographers better than sixty would.

The problem that you and those photographers face is the amount of time that it would take to identify the photography users, and then determine which ones acquire their work directly. If you can afford to make that effort, you probably don't need to work. That is the reason that most vendors of stock and assignment photography concentrate on the vertical market. It is less costly to mine in time and dollars, and the ratio of dollars spent on photography per prospect is much higher than in the horizontal market. But the competition is fierce, often cutthroat. However, there are ways to exploit the horizontal market, if your particular kind of photography, as reflected in your vision statement, fits that market.

The problem is finding the companies and qualifying them. Remember, there are two ways to come up with your list of prospects. One is to research the many lists available; the other is to identify them through their work product. Let's look at how to do each.

Use Membership Directories

When it comes to the larger corporate businesses and institutions like schools and hospitals, you can find lists of individuals that you can qualify as prospects but, it's more difficult than finding names in the vertical market. This is because the people you want to find are most often employees of businesses that do not want their names readily available primarily because they are trying to avoid being approached by salespersons. However, many of these people are members of organizations. So get the membership lists. Some organizations will sell copies of their membership directories; others will not. Popular organizations such as International Association of Business Communicators (IABC), Women In Communications, and American Society of Association Executives (ASAE, communications division)

all represent corporate communications workers. If you can get these or similar lists without too much trouble, you ought to. They can be helpful when you are trying to prospect.

Visual Sightings

Fortunately there is a more efficient way to find prospects in the horizontal market. The easiest way is to keep your eyes open and do what people pay you to do—see. Imagine that you are outside moving about town or the countryside. Take notice of possible prospects. You see a hospital. You can be sure that it uses photography in a variety of ways, with PR being one of them. If it is a large hospital it may have a staff photographer; if it is a smaller hospital the chances are that it does not. The same is true for educational institutions. Next, you pass an industrial park of small manufacturing and service businesses. You stop and copy down the names of the companies from the list so conveniently placed on the sign at the entrance. Chances are that some of these businesses use photography. You drive down that strip that leads out of town and you realize that along fifteen miles of that road you passed three oil refineries. Maybe their home offices need photographs at their plants. If you want to find prospects in the horizontal market, you can find them all around you. You just have to look for them.

Calling the main office and asking if there is a communications- or public relations–type department in the company can qualify these prospects that you found along your drive. You can get the name of the person who is in charge of the department and/or those who work in the department and hire photographers. It is amazing how much information you can get from a phone call if you just ask nicely. I always like to ask for "help." Most people like to help, if it isn't too much work. It makes them feel good, and I am happy to provide them with the opportunity to be helpful. You should also be on the lookout for materials published by them. Company newsletters, magazines, and brochures abound. They make press kits, use executive publicity photographs, record events, and more. Remember what you read above. This horizontal

market buys two billion dollars of photography a year. You can sell them some of it.

Needless to say, you should also visit these prospects' Web sites. Most likely it will give you a look at some of the ways that they use photography. If they do not use photography it is a signal that you ought to be selling them on the idea of doing so. It might have the information about the communications department that you need. Sometimes you can sign up for their promotional materials. If you can, you ought to, because when they arrive in your mail they are a messenger telling you what kind of images you have to show them when you promote yourself and make that inevitable sales call.

Here are two true examples of what I have been suggesting. In the course of driving around my region on location jobs I drove past a number of oil refineries. I never paid much attention to them until one day as I was driving by one of them there was a film crew outside taking some shots of the main gate. It was like lightening striking me. Companies use photographs of their oil refineries. It had never dawned on me. The next day I recalled all the regional refinery locations I could remember; there were seven prospects to qualify. Another day I was driving down the main avenue, which parallels the local port facilities near where I live. There was a large, new-looking ship being unloaded. Well the lightning bolt hit me again. I wondered what company built and/or owned the ship, and whether they ever photographed their ships in port. The next day I did some research and identified all the ship-building yards in the Unites States, of which there were very few. In a short time I had qualified the prospects in the oil and ship-building business. Then it was time to promote myself to them.

Scope of Effort

This leads me to the last thing that you have to consider in your efforts to find prospects through market research. Are you going to service a local, regional, or national clientele? The markets you serve will dictate that to some degree. Advertising studios are going to get most of their business locally and regionally. You can get accounts from other areas of the country, but it isn't easy because art directors often like to be on the set, and travel is an expense most businesses avoid unless it is

absolutely necessary. When it comes to corporate and editorial work you will most likely choose to be regional and national. Publishers and companies from around the country could need a photographer in your region. Keep your eye on the target (your region). You are more likely to be hired to shoot in your own backyard than to be sent to a far-off location. But you have a national market scope if your prospects are spread around the nation, even if all your work is done in your region. Of course, assignments that call for travel do exist, but it is unlikely that anyone is going to pay to send you on a trip until they have seen what you can do in your own locale.

By now you get the idea. Your business is going to be built on your marketing skills more than your photographic skills. Finding the prospective clients with whom you and your work fit best is the key to establishing a business that makes its phone ring instead of one that hopes it will ring. While it is an unending process, once you have established a good prospect list, keeping it updated and revised is not very difficult or time consuming. My advice to photographers who have time on their hands because they do not have much work is to spend that time laying the groundwork that will make you busy; that is, doing market research so you end up with a nice long list of qualified prospects.

Market Position

A S YOU DO YOUR MARKET RESEARCH YOU WILL QUICKLY understand that not all prospects have the same characteristics in terms of revenue-generation capability because the same day of work for one client can pay more or less than the same day of work for another. You have probably heard the expression "charge what the traffic will bear." It simply reflects that some customers can pay more than others. It is a fact that anyone in business comes to accept in short order. You already know that a day's work for an advertising-segment client will pay much more than it would for an editorial-segment client. But that cross-segment difference is not what I am talking about. I am referring to the fact that you could have two architects for clients and one could be paying double or more than the other. One of them could be a small, one-person architectural firm trying to become established in the community and the other might be world-class firm with a hundred architects on staff. For one you might be photographing a house for the architect to place in his portfolio; for the other you might be doing a shot of a thirty-story building used to promote the firm worldwide. It's all in a day's work. One job might sell for $300 and the other for $3,000. Or, you might be shooting a brochure for a national corporation on Monday and doing a couple of product shots for a local machine shop on Thursday. There are a number of market levels in the business. The question you have to think about, answer, and plan for is in which level should you be working.

Market Levels

A simple illustration of any marketplace is tiered with several levels like a traditional wedding cake. Each level represents a group of

buyers who have different needs in terms of volume, quality, and price of the photography they use. What is true for the entire marketplace holds true for each segment of the market. So, no matter where you end up marketing your services, the terrain follows the same patterns.

The graphic in figure 13 represents the marketplace in four tiers. It could be divided more depending upon the criteria for separation, but I have divided it into four tiers because my experience indicates that this number is realistic and manageable. Each level is really a set of characteristics that reflect the quality and volume of work and the fees paid.

Each segment of the market has these four levels:

A. Highest creativity, lowest volume, highest fees
B. Medium to high creativity, medium volume and fees
C. Medium to low creativity, medium volume and fees
D. Lowest creativity, highest volume, lowest fees

Because of the way the market is stacked up, the photographers that serve the markets fit into a tiered structure. The consumer-services side of photography offers us a good example of these tiers in the portrait specialty. The breakdown looks somewhat like this:

Figure 13

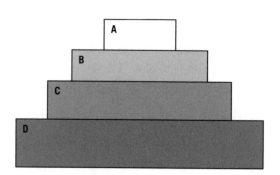

A. The finest, most talented portrait photographers
B. Very good portraiture artists
C. Good portraiture artists
D. Average portraiture artists

Reaching the Top

It is likely that most successful photographers, even those of great reknown, will have traversed at least a few of these tiers during their career. Arnold Newman, one of the world's greatest portrait photographers and a pioneer in environmental portraiture, reached levels of acclaim that most photographers will only fantasize about. What few people know about Arnold is that he started his career in portraiture by working in a department store photography studio where everything was done routinely and by formulas. Arnold went to the A tier from the D tier. It took years. That is probably why he stayed in the A tier and reached a level of fame. He worked at it slowly and surely, gradually establishing his credentials. Obviously, he was talented, but he was also very patient, and it paid off. He photographed many a common man before he aimed his camera at presidents of the United States.

Wonder Kids

Every established professional photographer who has been around for a decade or two can tell you about the "wonder kid" who was shooting for the top clients within a year of getting into the business. Any established pro could also probably tell you about how the "wonder kid" dropped from the spotlight as fast at he got into it. Everyone wondered what happened to him. No one is hot forever. The best way to become one of the photographers that stays in the A tier for a long time is to earn the position by a reputation that has been built over years. You should come to the A tier as a dignitary, not as a tourist. If you achieve the level by a reputation built over years, you will hold onto it. If you achieve it by a sudden burst of popularity, you will likely lose it. Too many photographers shoot for the top thinking that once they work at that level the fame will follow, and they will have it made. But it just doesn't happen that way. I like to advise young

photographers that they will be famous for as many years as it takes them to acquire fame. Reach the top in a year and you will probably be there for a year. Take twenty years like Arnold Newman did, and you will probably be there forever. In the photography profession, twenty years is forever.

More about Tiered Segments

We can look at any market segment and find the tiers. In the advertising marketplace we see levels of agencies doing local, regional, and national work. The D tier is filled with small agencies, sometimes with one or two people working, who do a host of small ads for small retail businesses. We see their ads in media such as weekly newspapers, on local cable TV, and local coverage magazines. In tier C we find regional ad producers who are working for small- to medium-size retailers producing a variety of promotional materials for regional advertising, brochures, sales fliers, etc. In the B tier we find agencies that do trade advertising. They produce material for manufacturers and wholesalers. Catalogs, product sheets, brochures, and trade magazine ads are their mainstay. In the A tier we find agencies that mostly do national advertising work for larger corporations. This is the top-of-the-line work for magazines, transit posters, billboards, elite catalogs, and the like.

The corporate-segments tiers are generally based on the size and reach of the corporations. They can be for-profit or not-for-profit corporations or they can be institutional like hospitals and universities. The world of corporations is packed at every level, and most of them use photography to one degree or another. There are local, regional, national, and international businesses, and these geographic levels best define the segment's four tiers.

The tiers of the editorial market are a bit more elusive. You cannot characterize them by geographic reach, size, audience, or other popular descriptors. The only way to categorize them is by what the publishers pay. Unlike other markets, publishers are not inclined to negotiate or entertain competitive bids. They simply set a fee and you can take it or leave it. Therefore, the best way to delineate levels is by the range of fees. The astounding thing about

the editorial market is that you can't make assumptions about who pays more. Here's an example, based on work I did for two different magazines in the past. One was *Success*, a magazine aimed at middle-level business executives; the other was for *Centaur*, a magazine with an audience of show- and race-horse owners. *Success* had the higher circulation and greater recognition, but *Centaur* paid a day rate that was 240 percent higher. Why? Because *Centaur* was directed at a narrow market of horse owners; it had to have top-notch work to attract subscribers; and the subscriber base was the key to selling lots of advertising at top rates. *Success*, on the other hand, had a mass market. It had to compete for advertising revenues by pricing competitively with the dozens of other magazines that *Success'* readers also read. The fees paid by publishers who narrow cast are usually going to be higher than those paid by those who broadcast. You can be sure that I was always much happier to hear from *Centaur* than *Success*.

The chart in figure 14 shows four different magazines and their rates. The information was taken from *Photographers' Market 2003*. This popular marketing guide for photographers lists magazines with one to four dollar signs in the listing to categorize them by rates paid. Here's an example of the tier structure.

You might look at this chart and wonder why it does not contain titles like *Time* and *National Geographic*. There are two reasons that it does not: First, these are not the mainstream of the editorial world; they are elite titles. If you hope to earn your living shooting only for elite titles, you will probably soon learn that it is nearly impossible to do unless you get a job on staff, on contract, or

Figure 14

TIER	MAGAZINE	CIRCULATION	COVER PHOTO FEE
$$$$	*Southwest Airlines Spirit*	350,000	$1,200
$$$	*Careers and Colleges*	100,000	$ 800
$$	*Junior Scholastic*	589,000	$ 350
$	*Fishing & Hunting News*	133,000	$ 50

become one of their regular freelancers, and those are very few. Second, the elite magazines do not usually pay elite rates. The fact is, the magazines that have the biggest names often pay average fees because so many photographers want to be published in them; there is an unending supply of people who will accept less for the prestige of being in those magazines.

Diversify

As you read on you will learn about ways to identify prospective clients in the market segments that you will select for servicing. Before we get to the specifics of how to do that, it is important that you have an understanding of diversification, which is a popular word in business. In a nutshell, diversifying is the process of positioning yourself to service more than one segment of the marketplace and more than one tier of a segment. To market your wares successfully, i.e., profitably, you have to understand that you are in the photography business and that you must not confine your market potential. There was—and I mean was—a day when a photographer could focus on a tight niche of clients and work. Those days are gone for the average photographer. Today, the successful photographer seeks and finds business in different segments and in different tiers of those segments. It is important to keep that fact in mind as you do your market research. The series of illustrations in figures 15 through 18 show how your market share, the pyramid within the illustration, might change as you go from novice to seasoned pro.

The inexperienced photographer is most likely to have all of his or her business in the D tier. This is the level where the pay is the lowest and the jobs are plentiful but uninspiring. It is a place to hone both business and photography skills. This is not where you build a reputation. It is where you *learn* to build a reputation. It is a level in which a creative or business mistake will not come back to haunt you for the rest of your career. For the editorially inclined it might be the local and regional newspapers and trade magazines. For the corporate/industrial shooter it might be the small businesses of the industrial and office parks in your region. For the advertising shooter

Figure 15

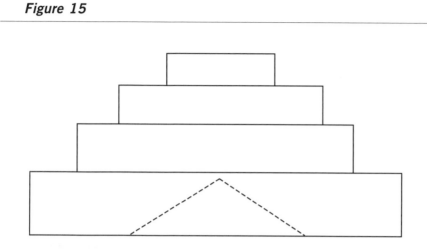

it might be the smallest agencies dealing with small retail merchants and similar local advertising accounts.

Over time, as experience is gained, marketing is aimed at new and better prospects as the photographer penetrates the C market, establishing some clients while dropping some but not all clients in the D tier. This is the beginning of upward movement and the first steps in creating a reputation. The work is more substantial and the clients are

Figure 16

Figure 17

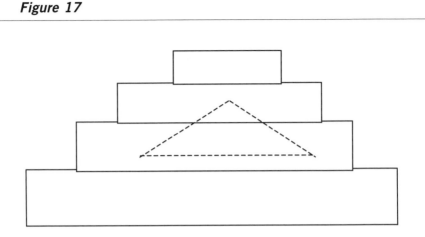

more discriminating about the photography they use. There is a higher quality of work demanded, but the fees are accordingly higher.

This upward movement is continued until the next tier is penetrated, and the photographer has replaced the dollar volume of the lowest tier with fees earned from the one immediately above. The photographer is now in a three-level market, and not dependent upon the lowest-end work to pay the bills. Every job is important

Figure 18

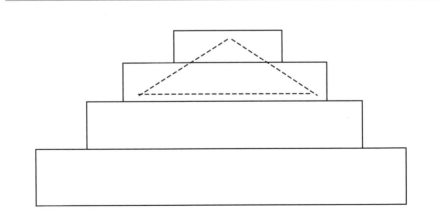

to reputation and future advancement. Effectively, this is the entry level of the major leagues of photography. Now there is a chance to advance to national prominence. This is the beginning of building a reputation.

Eventually, the photographer reaches a peak, which may be in the A tier, or a different tier. Now the photographer is in final position with two levels of clients. Some are in the top tier and others in the next tier. The lower tiers are forgotten. The photographer sells quality and performance, not price. The volume of work has been reduced, and the fees have grown substantially. Now the photographer has a reputation to protect.

The most important thing to notice and remember is that the base of the triangle does not rest in the same tier as the apex. This assures that the photographer has a more stable footing when entering the uncertain world at the top of the profession. Remember that no one is on top forever. It is wise to position yourself so there will always be business to fall back on. That can mean the difference between success and failure in the long run.

Try to imagine your market penetration as if it were a building. The higher you go, the more substantial your foundation has to be if you don't want to risk structural collapse or being toppled in a severe storm. How you spread out that triangle is up to you. I would advise you to keep the base broad and not let the apex get higher than the next tier above. In that way your growth will be deliberate and well supported. It may take more time to get to the top, but, once there, you are more likely to stay.

Your Success Zone

The location of the triangle is your position in what I like to call the *creatonomic* structure. It is the relationship of creativity to the economic return. The level of creativity and the rewards for it increase or decrease as you go up and down within the tiered structure. Where you position yourself initially should be calculated carefully. Are you creative enough to skip the lowest level and start one tier above? If you guess wrong you may find yourself wondering why business is so bad while other photographers are getting the work. It could be

because you are outclassed by your competition. If that happens to you, there is a way to save the day. Step down a notch!

Years ago, a book titled *The Peter Principle*, written by Dr. Lawrence J. Peter, was a rage in the business world. The book's premise was that business philosophy was self-defeating when it came to positioning some employees in the workplace. In its simplest terms the concept was presented along these lines: When an employee is noticed for doing a particular job well, the employee is often promoted to the next higher level because people with demonstrable records of achievement are the ones that seem best suited for new challenges. If the promoted employee performs with noticeable skill, additional promotions follow, and so on, and so on. At some point the demands of the work exceed the performance capability of the employee. He or she is no longer delivering noticeably finer work than expected. That employee has now reached the highest level he or she will reach in the company. The problem is that the employee has also probably reached the level at which performance is adequate but mediocre. Effectively, the person has been promoted to a point where maximum performance is no longer likely. The business has assured mediocrity at a higher level in the company. Dr. Peter's postulate was that this was a very important flaw in human resource evaluation and that it hurt the companies that allowed it.

Dr. Peter gets no argument from me. We have all had the experience of wondering how someone in business got to the position that he or she is in. There is a high probability that we are experiencing the effects of the practice of promoting a person to the point of incompetence. Dr. Peter pointed out that the negative impact of failed job promotions could be avoided. The simple answer, he said, was to simply move that now-mediocre employee down a notch to the last level where the employee did fine work. In that way the company would have fine workers throughout its ranks. Of course, what happens in reality is that the employee gets fired and ends up with no job.

You can create a "Peter Principle" for yourself in the photography business by positioning yourself in the wrong *creatonomic* tier of the business. If you do it, your work, income, reputation, and self-respect

are likely to slide downward. When a photographer is consistently not being hired and other photographers are, there is a reason for it. While not the only reason, one that is often the cause is that the photographer is in a tier of the business for which the photographer is ill prepared. If that photographer is you, the answer is to step down a tier. There you can meet your needs and feel good about yourself. You can work at your deficiencies until you are ready to try to move up. You can move up gradually and test the waters. In that process you will also be establishing a footing at a higher level, or you will be finding out that you better stay where you are; that is, in your success zone.

Ground Positioning

Positioning yourself in the proper *creatonomic* zone is not the only positioning concern that you have to deal with. You also have to be concerned with your geographic location, which has something to do with identifying your marketplace. So does your more immediate location—your exact position on the ground. I don't know a better way to illuminate this than with an old precept from the real estate business. In real estate they say that the sale of a property is primarily dependent upon three factors: location, location, and location. Well, in some ways, that precept holds true for a photography business. Where you are located is important. This can best be explained by several examples.

In the early seventies when the magazine marketplace was dying at the top and bottom ends and changing in the middle, photographers who had serviced that market were scurrying to find new business. Many went into the corporate segment of the market since it was adapting an editorial look as the price of color printing went down rapidly. Many photographers repositioned themselves from New York City, the publishing capital of the day, to other locales, both to cut expenses and find local and regional corporate clients. One photographer I knew moved to Portland, Maine. He loved Maine, the cost of living was low, and Portland had an airport from which he could easily get anywhere in the country. This was a day when clients actually sent you places to do their work. What he did

not anticipate was the fact that the price of flying out of the Portland airport was astronomical when compared to the price of flying out of a large city hub airport. It cost him as much to fly from Portland to New York as it cost to fly from New York to San Francisco. That irregularity in pricing was, and still is, due to the lack of competition in smaller airports since not as many airlines operate out of them.

He also didn't take into account that Maine, with its cold and snowy winters, was not a place that was going to attract a lot of new corporate commerce. Maine had a tourism-, fishing-, and agriculture-driven economy. This photographer was known for his ability to do beautifully lit, eye appealing, facilities shots. He was what you might call a corporate/industrial–focused architecture and interiors specialist. But he had vacationed in Maine in winter and summer, and he loved it. Unfortunately, his prospects did not like the fact that his estimates were very high when it came to travel expenses because of the higher flight prices and because he most often had to go through two airports— Portland and a hub—to get to his shooting location. His new home was in an area where the cost of living was generally lower; however, he failed to realize that the cost of doing business was often higher. He often had to purchase supplies and services from Boston where the prices reflected the higher cost of living in a larger city. Fortunately, he was resourceful enough to survive his losses as he adapted to the marketplace that existed in Maine and surrounding areas. You can make money shooting for the tourism, fishing, and agricultural markets, and he eventually did.

Another photographer I knew had a reputation for capturing action and emotion on film. He was a very good sports shooter, and he could use his photojournalistic eye to make boring scenes look interesting. He went to Atlanta, which was developing one of the largest airport hubs on the east coast. It had a reasonable cost of living, lower than many cities. It had all the services he needed: Atlanta was the home of professional sport teams; it was the business center of the southeast so it was chock full of corporate offices; and it had a company headquartered there that had and still has worldwide facilities, the Coca-Cola Company. His move to Atlanta was well decided and his fit with Atlanta was a good one. He was well

positioned geographically. Such positioning makes it easier to find your position in the tiers of the market segments that you serve.

Pinpoint Your Location

You will recall that I advised that you consider where you are located when formulating your strategic vision. Now you see some of the factors that have to be considered in doing that. But there is more to positioning than picking a region or city. You have to consider how your location within that region or city will affect your business. Again, examples are the best way to shed light on this. Let's look at two advertising photographers who work in a major metropolitan area. Both of them take on big production jobs. They have to be able to shoot a tractor-trailer or to build a set that looks like the inside of a ski lodge. That means having a big studio space. Affordable space of that size is hard to find in a city. Each photographer solved his problem differently. One set up in a suburban area about fifteen miles out of the center of the city. He picked the location because he could buy an empty movie theater. It had a stage, balcony, and huge floor space. The stage itself was big; a studio within a studio. The balcony presented a high shooting platform. Opening the wall of the theater and installing a door big enough to drive a truck through was not too expensive. The space could be rented out and produce extra income. Because of the acoustics, the space was suitable as a recording sound stage, and the space would appeal to visiting filmmakers as a sound stage. The prospect of the additional income helped him sell the bank on a mortgage and improvement loan. In short order, he had the largest studio space in the region. It was rented often, and he photographed in it often.

The other photographer moved about thirty miles out of town. He bought a small farm complete with a barn. The barn was revamped into a modern shooting space. In addition, his property had some natural settings, which lent themselves to outdoor shooting. He added a tree here and bush there and even rerouted a small stream. He couldn't rent the place too easily because it was far enough out of town to be inconvenient when there were closer

studios to rent. It was not big enough to build a ski lodge inside it, nor would a tractor-trailer be easy to photograph in the barn. But he didn't care. His shooting was centered on people doing things with personal products: people on phones, at a computer, riding bikes, walking on a treadmill, etc. His barn was plenty big enough for that. He produced a lot of model-released, stock photography. He could build his own sets in the barn, and he had beautiful outdoor settings to work in. He, too, found his place to have a very successful business, but like all successful photographers he based his location on what and how he was going to photograph, in addition to the location of his client base.

Put It All Together

By this time you have begun to see how the various threads come together to make the fabric of business management. Exercising common sense when considering information that is readily available to you is the key to planning and managing your business. However, you have to understand the concept of tiered market segments and of positioning yourself in a sea of prospects before you can really develop a strategic view of your business. Think of your current market position as a starting point from which you are headed to a new position: your goal. Remember that you cannot get to a destination until you chart the point from where you are starting.

You can't begin to assess your business financial needs until you have a strategic view and general view of your markets, prospects, and position in the market. This is all very much like a photograph. You see it in your mind first then you build it or discover it. You cannot see your whole business close up. You can see only a tiny part of it. You have to step back and take a wider view. If you adopt a position farther from any problem or situation, you will be able to see solutions. There is a lot of truth in the saying that sometimes you cannot see the forest because of the trees. If you step back you can see the forest, and maybe, if you get above it all and look down, you will see the path through it. Like your market and geographic positions, the position from which you oversee your business is something you must be aware of all the time.

Productive Promotion

I MAGINE THAT YOU ARE AN ART DIRECTOR WORKING ON SEVERAL campaigns in different stages. For the past few weeks you have been concentrating on how to make motorcycles, surfboards, and sunglasses look so good that people will want to buy them. Your weeks have been full of long hours and high pressure as you conceptualize, design, select photographers, and supervise photo shoots while keeping up with your mail, phone calls, and e-mail. You are feeling exactly what you are; that is, harried.

In this morning's mail you received fourteen postcard promos from photographers, one stock catalog, six stock agency promos, two posters, a tube with a filmstrip in it, two CD-ROM promos, and several invoices. And you have to interview three photographers to prepare them to bid on approaching jobs, look over the photos from yesterday's shoot and fit them to layouts, and come up with a few sketches for an account exec who is putting together a pitch for a prospective client.

If you were this person, how much time do you think you are going to spend mulling over the promotional materials in today's mail? Not much. Unless one of them jumps up and bites you, you probably will toss the pile of them into the circular file. My point is simply this: busy people don't stop to look at the ordinary. Even very good photography is ordinary to an art director. If you want to get the art director's attention you will have to do something extraordinary. This also applies to editors and communications directors. Fortunately, there are ways to do it.

Quality versus Quantity

The term "information overload" was coined in the past decade because we are all swamped with more to see, read, know, and use than we can manage in our minds. A decade ago, I would have advised you to send a repetitive stream of communication to a prospect so that your name would be associated with photography in his mind when he needed to hire a photographer. Today, loading a person up with more and more information is akin to harassment. To be retained as a good potential source of supply you have to send the prospect something he or she can immediately relate to. That means it has to have direct, not indirect, meaning. A fine picture of a pony displayed on a promotional piece is not going to have an immediate effect on an art director who is working on a motorcycle or surfboard campaign. What would have an immediate effect is a picture of a motorcycle or surfboard, because those are directly on his or her mind right then.

Targeted Promotion

As I stressed in chapter 5, Market Research, you have to know what your prospect is doing. Sometimes it is easy. We know what kind of pictures the editor of *Baseball News* is looking for. We know that the communications director of a machine manufacturing company wants to see machinery of a size and type comparable to that which the company makes. Art directors are a different story, unless they or their agency is very specialized. Art directors have diversified and changing photo needs, so it is harder to know how to have that direct effect. But it is possible. Depending upon how much research you have done in your marketing effort and how deep you have dug for information while prospecting you can find out both the past accounts and the current accounts an art director is working on. Armed with that information you can scour your files for images of the same subject matter, or maybe even create it. If you don't have it and can't create it, you might have images that are similar in concept. I'd bet an art director could make the association between the conceptual similarities of a snowmobile and a motorcycle. Once you have a match or close match you are on the way to reaching that art director in a memorable way.

Use Your Craft

Make a beautiful but small print. Mount it with your contact information on the back. Put a letter with it that is written something like this:

Dear Ms. Buyer:

Recently I discovered that you art directed last year's Maniac Motorcycle campaign. It was an impressive bit of work. I find myself wishing I had done it.

The print that I have enclosed is from my work on the Downy Snowmobile campaign of two years ago. I think snowmobiles and motorcycles create the same sense of freedom in their rides. I don't know whether you will be awarded the Maniac campaign again, but if you are, I hope that you allow me to offer my services. Of course, I'd be happy to work with you on any other projects.

My contact information is on the back of the print and my card is enclosed. My Web site, *www.happyshooter.com,* has a good representation of my work, if you have the time to look at it. Speaking of time, I don't want to waste yours. Thank you for keeping me in mind.

Sincerely,

(your name)

The letter takes about thirty seconds to read. Your name is on the envelope and the letterhead. It is likely in the URL of your Web site. It is on the signature line of the letter and on the back of the print. This art director read your name five times in less than a minute. It could be that she'll remember it when she hears it again, or when you make a follow-up call to see if you can get an appointment to show your work. Moreover, she sees that you have done some homework. Art directors like thorough photographers. You have shown her that you understand conceptual relationships with the comparison of riders of motorcycles and snowmobiles. Her work is translating a concept into an imagined reality, and you speak her language. Finally, it calls up

the past for her. If she likes your photograph better than that used in last year's campaign, she is even more likely to remember you. You have made a bigger impression on her than that which a photographer will make who sends her a 24″ × 36″ poster of shoes.

The next step is to find out what her current or approaching campaigns will be. Repeat the process above using photography with the same or similar subject matter on which she will be working. She will not only get to know your name better, but she will also see that you are really serious about getting the business and working hard at it. Hard work impresses people; reinforcing a message convinces people; and treating people as individuals rather than one of the crowd is likely to get you treated the same way. If it sounds like hard and time-consuming work, it is. But you can do it while you are sitting around waiting for the phone to ring, and then you will have a reason to make the prospect's phone ring.

Repeat Performance

You are not finished. You just created the basis of your own advertising campaign. Your next step is more market research. You identify all the motorcycle manufacturers that you can, and using the techniques you read about in the previous chapter you find out which agencies are handling their advertising. Then you are ready to make up a few packages like the one above in an effort to make the prospects believe that you are the photographer they need to hire. In the end, you may have mailed out ten packages. That is micro-niche marketing.

The ten individuals who received your mailing will certainly take some notice of your promotion because they are paid to be interested in motorcycles and pictures of them. You have struck a chord close to their hearts, maybe more a chord near their cash register. You have their attention—now what do you do? Give each of them a call. Don't worry about bothering them; people in business get phone calls all day long. Introduce yourself as the photographer who sent the photographs of the Maniac motorcycles a week or so ago. If you have to leave a message, identify yourself by a reference to motorcycle photos. You want the prospect to connect your name with photographs of motorcycles, because that is what the prospect buys.

Wider Audience

You do not stop at the advertising agencies. You have researched who makes motorcycles. Each of the companies is likely to have a communications director and/or an executive in charge of advertising and sales. A few sample photographs to these folks won't hurt. The communications director might be looking for someone to shoot for the annual report, and your work might get his attention. The advertising/sales executive could be impressed enough to call the agency's account executive to suggest that the agency look at your work. Nothing will get an ad agency to review your work faster than a call from a client suggesting that they do so.

Promotional Publicity

It was probably a publicist who coined the expression that there is no such thing as bad PR. The appearance of your name in an article of a trade journal or paper can be beneficial. Being mentioned in a photography trade paper might make you the envy of your peers, but it won't do much for you in the eyes of a prospective client because prospects are unlikely to be reading the photo media. But, if the art director or buyer for Rolling Bike motorcycles reads that you are working on the Maniac account with a competitive agency in an advertising journal, it might help you get the opportunity to show your work. Let's say that the Maniac account is a prestigious one. If you get to do the work on its account, you become prestigious. People remember prestigious people.

Press releases should be sent to media outlets whenever you are awarded an important job or secure a new client. The media to which you send them should be the media that photography buyers, art directors, communications directors, and editors read. It can be national, regional, or local. The important thing is to get your name out wherever, whenever, and however you can.

A strong PR effort can have a direct and/or indirect impact on your business. The direct benefit is when a prospective client calls you because the prospect read about you in the trade press. An example of an indirect benefit is something that happened to me.

For several years running I sent press releases to a local advertising/communications trade paper. Every new client I got, every campaign I was hired to shoot, every time new work of mine appeared anywhere, the paper received a press release. They received at least two a month from me for two years. About 10 percent of them were published or otherwise reported in the paper because it was local news. Out of those published releases I acquired two new clients. Over the next few years those two clients purchased thousands of dollars in services from me. Was it worth it? Indeed it was. Writing and submitting a press release is simple and fast work. And when published these releases reinforce your name in prospects' minds. That leads to prospects calling you instead of you calling them.

In my case there was also an unusual indirect benefit. Like most local publications, a small team of people produced the trade paper. Over the two years that the releases flowed in regularly, that team became very aware of who I was and what I was doing. When the day came that they decided to do an extensive piece on commercial photography in the local area, guess who they called for the article to interview and photograph in his very busy studio? That's right, I became a very recognizable photographer. Almost every editor, communications director, art director, account executive, PR agent, and others, not only learned my name, but they learned what I looked like. They also learned that based upon the trade paper's research I was one of the busiest photographers in Philadelphia. What was that research? It was the many press releases I had sent. During the same period they had received only few similar press releases from other photographers.

Promotional publicity requires a consistent and sustained effort if it is going to work for you. Press releases are used to fill a void when editorial content slacks off. The law of averages says that your releases will get published sometimes, if you send them enough times. There are inexpensive computer programs that will help you write good press releases. Once you get the format down the way you want it, you just use it over and over again. The names and dates change, but almost everything else remains the same.

A sample press release has been included below. It contains all the components necessary to be acceptable to media outlets.

Sample Press Release Announcing a Newly Awarded Assignment

(On Letterhead)

(Insert Date)

For Immediate Release:

For more information contact:

Pat Photographer
510/555-1234
510/555-9876 FAX
Pat@email.com

Pat Photographer awarded General Hospital Advertising Photography Contract by ABC Advertising, Inc.

ANYTOWN, USA—(insert Month/Day/Year)

Pat Photographer, one of our region's most prominent professional photographers announced that she has been awarded the contract to do the photography work for General Hospital's new advertising campaign aimed at promoting its extensive services and fine reputation as one of the areas best teaching hospitals. The advertising campaign will be directed by ABC Advertising, Inc., which is the largest advertising agency in the state.

"We have a record of providing top quality service to our customers. That reputation certainly had a lot to do with our being awarded this contract," said Pat Photographer, the sole proprietor of the business. Pat went on to say that she was excited to be part of

this effort to distinguish General Hospital as the best such facility in the region.

Founded in 19__, Pat Photography Studio has been serving regional and national advertising clients needs for more __ years.

World Wide Web Promotion

Today, one of the best promotional tools for photographers is a Web site. Of course, there are so many photography Web sites that yours will likely go unnoticed unless you differentiate it in some manner. So you have to do yours in a way that stands out. Professional design is good if you can afford it; if not, and you are forced to design your own, first do a little reading on the topic of Web site design, and take some time to understand that a good Web site has two interrelated elements: form and function. A Web site with exquisite photography is not going to be studied by a prospect who finds that it takes too long to roll from page to page or link to page. You should also keep in mind that the viewer is not looking at your site to hire a Web designer. Concentrate on the content of the site, your photographs. Do not get hung up on the design. Clean, neat, and attractive design without lots of bells and whistles is best. The factors that go into proper design of a Web site are not within the scope of this book, but bookstores have more than ample offerings to choose from.

Inform the Buyer

The average buyer wants to know three things: What your photographs look like, who you are and what kind of experience you have, and the level of your clientele. Therefore, your Web site should have at least three parts: photographic samples, client/publication information, and biographical information. The photographic samples demonstrate the diversity of your work, but you should also have a section or sections devoted to images that are part of your targeted marketing effort. You will read an example of that subsequently. The client section should contain a list of some of your clients, and it should indicate that the information is a partial listing. No one needs to know all of your clients

or exactly how many you have. You list the most recognizable names of companies that you have worked for in the past. It doesn't matter if you worked for them three years ago or three weeks ago. As long as your list is factual, it is OK. You do not have to be specific about the exact jobs that you did for a client, the client's name is enough. If you have the rights to display tear sheets of your prior work, and if they are top-notch samples, you should use them. This client portion could also contain copies of those press releases you read about earlier.

The biographical data should provide a brief glimpse into your history in the business. It does not have to be long. It has to be appealing. Here is a sample of a bio I used on my own Web site, created upon my re-entry into the photography business,

> This site is owned and operated by Richard (Dick) Weisgrau. From 1965 through 1987 he was a professional photographer. He joined ASMP, American Society of Media Photographers in 1973, and became the founding president of ASMP's Philadelphia Chapter in 1975. He was elected to its national board in 1978, serving through 1982, and again in 1985 through 1987.
>
> He served as the executive director of ASMP from 1988 through 2002. In that position he was heavily involved in all major creators' issues, as he managed ASMP's entry into and travel through the first decade of the digital age. He has written and lectured on a wide range of topics and issues of concern to creators. Today Dick is back to his roots, making photographs and also writing.

You must have a Web site. The simple fact is that no one is going to think that you are a professional unless you have a Web site. The Web site is the least expensive way that you can get an ever-changing portfolio of your images in front of your prospects. But having a Web site and getting a buyer to visit it are two very different things. Buyers have better things to do than browse the Web looking for talent. The Web is an evaluation tool for them, not a scouting tool. You are going to have to do what every other business with a successful sales-oriented Web site has had to do; that is, you are going to have to drive

traffic to your site. There are three ways to drive traffic to your Web site. E-mail, metadata, and direct mail all can be used separately or in combination to drive people to your Web site for a look. Effectively, you can use one promotional tool to lead your prospect to another.

E-mail Promotion

E-mail, which once seemed to be a logical and effective means of promoting your business, is now a hazardous method. The increasing amount of "spam" being e-mailed to businesses and individuals has become a substantial nuisance. The novelty of e-mail wore off years ago. Today, as an effective high speed means of worldwide communication, it is a valued tool. When a person's valued tool is turned into a nuisance, the offenders are not well regarded. Unlike postal mail, e-mail arrives in our personal computer. That word "personal" has a territorial connotation, unlike an office mailbox or in basket. This means that you must be very careful when using e-mail to promote yourself to clients. It does not mean that you cannot use e-mail. It means you must use it intelligently and selectively.

Intelligent use of e-mail boils down to two factors: One, keep your e-mail brief and to the point. Do not add images, logos, html, or other elements that will slow down the reception and display on the recipient's screen. Two, make your message immediately understandable. Do not try to disguise the promotional e-mail as anything but what it is: an attempt to get the buyer's attention.

Selective use of e-mail once again goes to the idea of targeting the recipient so that you are not sending the person the equivalent of bulk mail. Put the intended receiver's name, as well as her e-mail address, into the "to recipient" line. An e-mail to *<pbuyer@bigads.com>* is not as effective as one sent to Pat Buyer*<pbuyer@bigads.com>*. Promotion is a prelude to sales, and sales work is a personal undertaking. You sell to individuals, not e-mail addresses. You also have to make sure that the e-mail is relevant to the recipient's needs. The medium you choose to communicate with does not alter the buyer's perception of the usefulness of the message that you send. Make sure that your e-mail states why it is relevant. Here's an example:

Dear Pat Buyer:

Your work on Skyways Airline has attracted my attention because of my substantial experience photographing aviation travel, including work for White Cloud Airlines. Please take a moment to visit my Web site (*www.happyshooter.com*). You will find enough examples of my work there to know that you will want to see more.

Thank you for your time,

(followed by your contact information)

Pat Buyer can read the above e-mail in about thirty seconds. It has a hyperlink in case Pat has the urge to see your work as she reads your e-mail. It has your name and contact information in case Pat wants to get in touch with you and it associates your name with the subject matter that Pat is working with. It makes it easy for Pat to get to your Web site and pretends to be nothing more than what it is, that is; a promotion to get Pat's attention. Pat doesn't mind receiving promotional material; it is simply a way to find needed talent. Play it straight with Pat, and Pat will play it straight with you.

Metadata Promotion

Metadata is nothing more than a hidden message in the form of words that Internet search engines read as they scan the Web for content. Careful selection of metadata will make your Web site visible to more photography users within a certain market segment. What should your metadata tags be? They should be the same terms that the people will type into their search engines to find you. You create metadata tags such as photography, advertising, advertising photography, stock photography, studio photography, magazine photography, editorial photography, etc. These hidden messages can bring more prospects to your doorstep.

Direct-Mail Promotion

Direct mail can be targeted to a niche or broadcasted to a wide range of possible prospects. There are consultants who urge photographers to do promotional mailings to buyers. Mailing labels for the buyers

can be purchased through a variety of sources. What you need to know before you purchase such a product is how often the list is updated. Turnover in the creative professions can be heavy at times, and a six-month-old list can have many names on it of people who moved to other positions or companies. From my perspective, these lists are not very valuable because the prospects are not qualified. Yes, they may buy photography, but what kind and for what purpose?

I have heard photographers proclaim how well a list worked for them. One photographer bought a list of 1,000 names. He systematically mailed out one hundred promotional mailers a week for ten weeks. He followed up each mailer the week after being mailed with a phone call to the person on the list, making twenty calls a day. The final result was that he was invited by forty-four art directors to send or drop off his portfolio. Tracking those portfolio placements he was invited to bid on eighteen jobs. That's a result of 1.8 percent, which is very consistent with good direct-mail result averages. If he had not made the phone calls, his returns would likely have been between 1 and 1.5 percent, which is the range of response to most direct mail. The law of averages says that you will have some level of success as a result of any reasonable promotional attempt. So mailers produce some results. Mailers with telephone follow-up calls get better results because you have made two contacts instead of one, the second contact being more personal. Regardless of what you do, you should track the results. If you are spending money on printing and postage and phone calls, you ought to be sure that the business it is generating is paying for the effort.

What you mail has a direct effect on the response rate. Photo postcards, letters with sample images, posters, and other traditional photo-bearing promotions come across the desk of buyers every day. As I mentioned before, many of them go right into the trashcan. Some get pinned to the wall for a week, until the buyer gets one he or she likes more to replace yours. Your promotion will survive longer if it is useful and beautiful and a calendar is the perfect example. A beautiful photo calendar for wall or desk is a winner. Unfortunately, quality calendars are expensive to produce. One way to create a promotional calendar is to create a calendar for a calendar producer from your stock of

photography. Ask for a contract provision that allows you to purchase the calendars at wholesale, usually a 40 percent or 50 percent discount from the retail price. If you intend to buy a large quantity, a thousand or more, you should try to negotiate a higher discount. Now your promotional calendar is also earning royalties for you, helping to defray your promotional expense.

Innovation

Obviously, a consumer calendar producer is not going to sell your commercial message with its product so you will have to attach your own promotional message. One photographer I know had Post-It Notes printed saying "Call Pat Photographer at (phone number)" and he carefully placed one on each new page of the calendar. As the buyers turned the page each month they found this same prompt. The photographer told me that it was the most successful promotion he ever did, with 30 percent of the recipients calling him during the course of the year. The photographer never called the recipients. He let the Post-It Notes do the work.

Novelty promotions can be good ways to attract attention, particularly if the novelty is useful. By novelty I do not mean a sending a thermometer or pencil with your name on it. I am speaking of sending the prospect something that he has never received before, so it's novel. You have to be creative to come up with an effective novelty promotion. An example of a successful novelty promotion was a photographer who went to her local art supplier and purchased a hundred very nice presentation boxes. They were of a size that could fit into a desk drawer, on a desktop or bookshelf, and useful for storing things that art directors use like tape, pencils, erasers, etc. Inside each box she placed a short note: "If you always wish you had something to hold all those loose items in and on your desk, this box might be just the thing for the job. I hope it works for you."

The photographer also pasted a card on the inside of the top of the box with a photograph and her contact information. Each time the prospect opened the box he was reminded about the photographer. She told me that that one promotion produced

phone calls for years, as buyers used the boxes. It was a novel idea that paid off. You are in a creative business, and creative promotions have value.

Prospecting by Referrals

Do you know any other photographers? I'll bet you do. If I sold you a great service or product that you felt you could recommend to other photographers, I'll bet that you would give me the names of a few photographers who you thought could use what I had to offer. In other words, you would give me a referral. This is an old practice in business. People know others who do what they do, and who need what they need. A client can identify a new prospect for you in seconds. All you have to do is know when and how to ask for the referral.

I made it a practice of never asking for a referral until I was certain that I had a good relationship with the client. That could take months or even years to build. But once I felt that we had established a business friendship, I was inclined to ask this question.

"Pat, we've done some fine work together on projects. I think we communicate very well. I want to ask you for something, and I'll understand if you cannot help me. I want to build up my clientele. It's difficult to do because it's getting harder and harder to see potential new clients (never call them prospects in this scenario). You must know at least one other editor (or other job title) who could benefit from working with a photographer like me. Can I ask you for the name of anybody you think I might have a good fit with?"

More often than not, I would end up with two or three names to contact. Once given a name or two, I would ask if it was OK to mention her name when I contacted the potential new clients. I can only remember one time that a person said no and I never called the referrals received from him. A referral is only good if you cite the credible source whom referred you.

My next step was to send the referral a letter telling him that Pat had provided me with his name. The letter promised a phone call in the near future with the hopes that we could set up an appointment. Like all good letters it was brief and easy to understand.

Dear Lou:

Last week, I met with a mutual acquaintance of ours, Pat Buyer. I have been working with Pat for a year. We have done some impressive work together, including the Maniac Motorcycle ad campaign.

Pat suggested your name as a fellow art director that might appreciate my work and service. She is always so right in my dealings with her that I felt compelled to write to you to introduce myself. If you have some time, I hope you will visit my Web site: www.happyshooter.com. I think you'll be pleased. I'll give you a call next week, with the hope that a quick look at the site will make you want to see more of my work.

Thanks for your time,
(Your name)

The letter does not try to disguise itself. It is promotional in nature, and buyers need suppliers so promotion is OK with them. The value of this promotion is that a person who knows the recipient endorsed it. Credibility is hard to build in business. Borrowing credibility from one relationship to build another is a classic tool in getting new clients.

Promotion's Proper Place

Promotion has to be followed up with good sales work to be effective. Promotion doesn't sell jobs. It only gets you the opportunity to sell jobs. It is the second step in the marketing, promotion, and selling process. Too many photographers expect that a promotional campaign will result in phone calls from people who are ready to buy. That might happen some of the time, but you will never build a business on the number of calls you will receive. Promotion is like the seeds the farmer planted. Before they were planted, the farmer prepared the field; that's market research. Then the seeds were sowed; that's promotion. Then the crop had to be harvested; that's sales. Promotion is wasted effort and money unless you have done the market research (so you promote yourself to the

right people for the right purpose) and if you fail to follow up on that promotion with good sales work. Priming the pump is not the same thing as getting water into the bucket. Understanding that the three-part process of market research, promotion, and sales must be done in that order, consistently, is the key to building business success to complement your success as a photographer.

Networking Markets

ETWORKING IS NOTHING MORE THAN AN EXCHANGE of information among individuals who are tied together by some similarity. It is a highly overused word in professional circles where people "network" to get ahead. These professionals believe that *who* you know is of similar value to *what* you know in advancing your interests. They are correct. Knowing the right person at the right time can be very rewarding. Unfortunately, networking has become a tainted word because some people are using personal networks to exploit contacts, rather than help them. This view of networking is becoming more pervasive, so I suggest that you refrain from using the word in day-to-day business. But I suggest that you employ networking as a means of reaching your market.

Years ago, a marketing consultant advised me to join the local art directors club so I could get to know my prospective clients. This is one way to network. I didn't do it; I thought that any art director would simply see me as being there to get his business through my membership, and I am not the kind of fellow who chats up prospects. I had a very good friend who did join. He said it helped his business. I have to a take his word for it. He was bit chattier than I was, and he was very comfortable in that role. I was not. I never defy personal traits. Forcing yourself to be what you are not in terms of your personality doesn't seem wise to me. There are many successful photographers who never joined an art directors club. I chose to network a different way.

Networks Start Anywhere

I lived a few miles away from a major horse show venue in Devon, Pennsylvania. The only horses that I had ever photographed were

ponies that my kids had ridden. But every time I passed the Devon show grounds I was reminded that the horse world had to be a fertile market for photography. I decided to penetrate that market. Research told me that Devon had three types of events: horse shows where the animals are judged as animals; equestrian riding competitions where the rider and horse are judged as a team doing difficult maneuvers; and jumping competitions where the horse's and rider's skills are matched to a course of obstacles.

The next event was a horse show. I bought a ticket and went in with my cameras and lenses, looking quite professional. There were lots of places to roam about and take photographs. The actual scenes of the horses being judged are so boring as to be painful. I photographed horses being groomed, fed, put through their paces in practice. I took photos of people with horses. Horses with horses, people with people. Whenever someone asked who I was working for, I'd respond with the truth: no one. I was just trying to learn more about the horse world so I could eventually get paid to photograph such events. The people were amazing. They loved helping me learn all about their world. The most important thing I learned was the names of the six most popularly read and respected horse magazines. These magazines ran horse-related advertising and editorial content. They could be a gold mine, if prospected well. (I also learned what magazines were considered to be sleazy and disreputable, and that was valuable, too.)

Ask for A Referral

I was networking. I met a lot of people with similar interests with whom I exchanged information. That fits the classic definition of the word "networking." Some of those people were very helpful; one person even knew the editor-in-chief of one of the magazines. I asked her if I could mention the fact that we had met at the Devon Horse Show, and that she had been kind enough to give me his name and she agreed. I made some warm and fuzzy photos of her with her horse and sent them to her a few days later. I also sent one to the editor she knew along with a letter introducing myself. There were no misrepresentations in the letter; I explained that I was an experienced

photographer in many other areas, but not horses, and that I was trying to develop some credentials in the field. I also suggested that he might consider giving me a letter of credentials so I could get a press pass to photograph the Carte Blanche Silver Cup Olympic Jumping Contest that was about two months away. I sent along some sports photography samples that showed I had a knack for catching peak action. I then offered to cover the event and give him first refusal right to the images and brief story that I would write about the event.

What did he have to lose? Nothing. What did I have to gain? Everything. In short order he called me, and after a brief conversation he agreed to send the letter for press credentials. We agreed that he would pay no expenses or fees for the work, but would pay standard stock photo and writing fees, if he used any of my work product. In the end, he used three inside photos and the five-hundred-word article I wrote. I also sold the magazine the cover photo of that issue.

Expand the Network

The next step in building the network was to expand it. I asked for ten copies of the magazine. I mailed five of them to the editors of the other five highly respected horse magazines along with letters of introduction proclaiming my availability to do assignments. I also sent copies of the magazine to Carte Blanche's advertising agency and corporate communications director. Each of them licensed some photos from me for other uses. The communications director hired me to shoot the same event for them the following two years.

Then it was time to try to get work from those other magazine editors. I looked up past editions of the magazines and saw what kind of material they ran. One did a photo feature in each issue. The subjects were a horse, a person, or both. In a different magazine I saw an article on the hard lives of "catch riders." I learned that catch riders were jockeys who worked the same track "catching" rides on visiting horse owners' steeds, if the horse had no accompanying jockey. I proposed that the feature-using magazine hire me to do a story on the day-to-day life of a catch rider. I sent its editor action and human-interest photos and copies of a few photo stories I had done in the past. I was awarded the job a week later. I spent five days with the jockey from

early morning until the track closed. I photographed him cutting the lawn of his trailer home, sweating off pounds in the sauna to make weight, riding in races, and more. The magazine ran thirty color photos of the jockey with my captions. An assigned writer did the text. It was an impressive photo/text piece.

I mailed copies of the story to the five other editors on my horse magazine list. I got more assignments and requests for stock. One stock request was for a picture of a teenage girl with her horse. It was to be used for the cover of the premier issue of a new magazine aimed at adolescent horse owners and riders. The cover image would be the heart of the direct mail promotion used to sell the magazine. I had the very photo they needed. I had taken it on that first day when I was trying to establish the first ties in a network at the Devon Horse Show. Fortunately, I had a release to go with it. My network

Figure 19

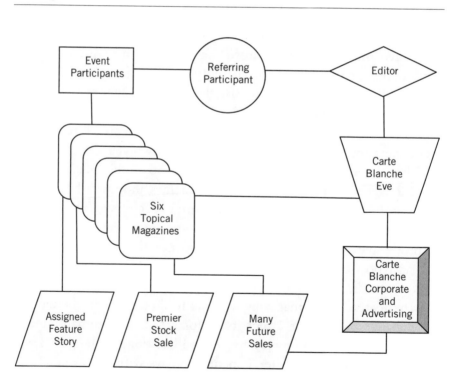

was producing good revenues, and I wasn't schmoozing art directors at social events for some work.

Figure 19 shows what my horse network looked like at that point.

The diagram shows a revenue-producing network. It portrays what I mean when I use the term "networking." It is nothing more than passing information among individuals with a common interest.

Repeat the Process

Revenue-producing networks can be developed in a variety of situations. They don't have to start with a referral. Here's another example: I did a great deal of photography for a major teaching hospital's communications department. This institution has had one of the first helicopter-serviced trauma units in the country. Wanting to toot its own horn, the hospital planned to release a publicity kit complete with photographs on the first occasion of a helicopter delivery of a trauma patient. I was on the top of the list of photographers to call because I was half a block away from the helipad. That positioned me better than any other photographer doing work for the hospital. Fortunately, on the day of first use of the helipad, I was available. From the time I got the call to the time the patient was delivered and the helicopter whisked away, only fifteen minutes elapsed. Once the copter was on the pad the whole sequence of events unfolded in a minute. I had seventeen shots covering the landing, patient removal, and the rush to the hospital's door. Over the next weeks the best photograph of the series was published more than seventy-five times.

That would have normally been the end of the useful life of the image, but I decided to use it to network for prospects and revenues. I sent the image to the helicopter manufacturer, which bought rights to use it. I sent it to the state police since it was their helicopter, and they bought rights to use it. I then solicited the helicopter's manufacturer for a special assignment to cover emergency helicopters that they had manufactured in action. I was given the assignment. That series of photographs was quite complete, as it was an accumulation of many days of shooting in different parts of the country. The images were used in an annual report and a variety of ads and sales brochures.

I also researched magazines to identify possible users of a story to be made from the commercial job. I found several aviation magazines and several medical trade journals. I sold the story I developed to one of each since they did not compete. Using the published story as a sample, I solicited a magazine that published information on military

Figure 20

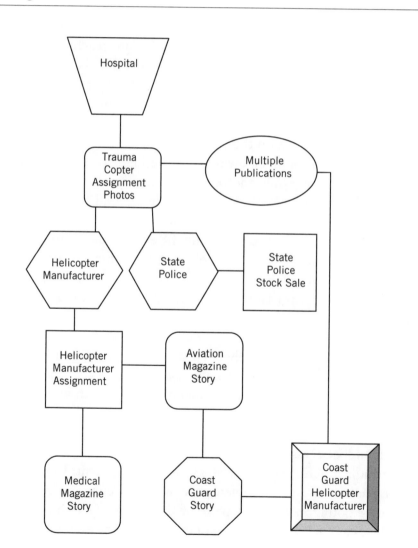

helicopter use to give me an assignment to cover the Coast Guard's use of helicopters in rescue operations. I got the assignment. A few months after it was published I sent copies of it to the communications department of the manufacturer of the helicopters that the Coast Guard was using. This resulted in more licensing sales. I also sent copies to the company that made the hoist and cable that is used to haul people out of the water and into the copter. They also licensed some photos. Figure 20 shows what that network looked like.

That revenue network was developed over about eighteen months time. It generated about fifteen shooting days and thousands of dollars in licensing fees. It took only simple research and a few letters with sample photographs and copies of previously published photos. It all started with one published photo of a helicopter delivering an accident victim to a hospital's helipad.

Employ Technology

Using the Internet for e-mail and World Wide Web research and sample presentation, the above process could be carried out with ease compared with the labor it required years ago. The principal behind it is that there is more than one user for any photograph, and many photographs have a message that multiple parties can exploit. This common interest is the basis of the network that is developed to produce prospects and revenues.

To reap the rewards of this kind of networking, the photographer has to retain the rights to images that he or she shoots, or at least enough rights to be able to approach multiple markets. If I had sold all rights to the hospital in the above network, I would not have been able to build the network. Retaining rights flexibility is critical to networking images and subject matter. Licensing non-exclusive usage rights is the key to maintaining rights flexibility. The final factor to building a revenue network is working smart. By that I mean seeing the relationship between the three market segments and any single subject. Earlier in the book I advised you not to see yourself as an advertising, editorial, or corporate photographer, but to see yourself as serving all those segments. Now you can see how to turn editorial work into corporate bookings and advertising sales. Today,

with a word processor, a Web browser, an image-editing program, and e-mail you can build revenue-generating networks while sitting at your desk waiting for the phone to ring. Better yet, do it on days when you are not shooting or making sales calls.

As you can readily see, the networking I am writing about is really a combination of promotion and sales work. Those two efforts are carefully linked together within a web of businesses in different market segments but dealing with the same subject matter. It is the softer kind of selling that can be done in the editorial and corporate markets where your familiarity with the subject matter to be photographed pays off in spades. Unlike advertising clients, corporate and editorial clients are focused on very specific genres of subject matter, and it doesn't change from week to week. Networked promotion and sales is a winning combination when you can identify the network of prospects that will be interested in the photographs that you can make.

Sales Management

THE FUNDAMENTAL SELLING PROCESS REMAINS THE SAME regardless of whether you are selling your services to an art director, corporate photography buyer, or a picture editor. In this chapter I have chosen to use the advertising agency as an example because it represents the more common selling experience, and the greater challenge. Agencies are continually interviewing photographers because their needs change with every advertising client they represent. Editorial or corporate photography users usually have a consistent need so they tend to develop a stable of photographers who meet those needs. Additionally, the fees for the work are not subject to the changes from assignment to assignment as they are in the advertising world. The examples provided are intended to give you an insight into the process and dialogue of selling. As such, they are adaptable to any selling situation because photography buyers need and want the same things from photographers. The sample dialogues have been developed to demonstrate how you can persuade the buyer that you will be able to fulfill his or her needs and wants.

Revenues Are the Goal

The sales department is the most important part of any company. There is a simple reason for this. Without sales there is no work. Without work there is no billing. Without billing there is no revenue. Without revenue there is no business. You become a photographer to make photographs. You run a business to make money. And that means you must have a revenue stream. So get this into your head right now: You have to have sales, and that means that you or someone else has to do some selling. Unless you are already good enough

to command a rep, and can find one, you will most likely be doing the selling yourself. Many photographers fail in business because they cannot bring themselves to do the sales work required. Nor can they find a rep, because a rep is usually looking for a successful photographer whose existing sales can be increased. Some reps take on start-ups, but they are usually inexperienced reps who are not proven sales closers. You need to be able to count on your sales department, and that is why you have to learn to do it yourself. Fortunately, approached with the right frame of mind, sales is well within the photographer's capabilities.

Focus on Your Market

Since you have read this far, you know that your sales effort is going to be directed at prospects within certain markets based upon your skills and preferences and your market research. It is going to be preceded by an effort to promote your name and services to the targets of your sales efforts. Selling is a contact sport. You must make personal contact, one on one, with a prospect to make a sale. And it is a simple task as long as you do not panic. Panic sets in when photographers allow their fear of rejection to take over their business sense. Most photographers want to be known for their photography. It's natural. When a client decides to use another photographer instead of you, it is often taken as a personal rejection or rejection of the photographer's work. While this is possible, it is more probable that the decision to use another photographer is based upon costs or style, not talent or personality. You can be sure of this if the prospect asks you to bid on a subsequent job. If they didn't like you and/or your work, they would never call you back. If you are never given another chance, you may have a problem with that prospect, or you are really slacking off in terms of your sales effort.

The Selling Process

Like every other operation in business, selling can be reduced to a series of steps. These are:

- Setting a sales goal
- Setting up quotas

116

- Promoting by quota
- Following up on promotions
- Presenting to the prospect
- Offering your fee and services
- Closing the sale

To successfully complete these steps you will have to use the knowledge that you have gained in every chapter of this book. Selling is the quintessential business operation, and, as the business depends on it, it depends on other operations in the business.

Sales Goal

Determining the amount of revenue that you have to earn through your sales is not very difficult. All you have to do is look at your financial forecast. Most businesses run on a fiscal year that corresponds with the calendar year. Your financial projection indicates that you need a certain amount of revenue to cover the expenses and generate a profit through the course of a year. As an example, let's say that you need $100,000 in revenues to pay all your business and personal expenses and have an end-of-year profit of 4 percent so you can add $4,000 into your business capital reserve. Now let's also assume that no substantial interest will be earned on your existing bank accounts, and you have no passive revenues like rents or royalties from a patent. In other words, 100 percent of your revenues come from the sale of your photography and related services. You now know what your sales goal is. You have to sell $100,000 worth of work in the form of services to create and licenses to use your photographs. If you had rental, royalty, or interest income, you would deduct it from the $100,000 to determine what you have to earn, which means what you have to sell.

As you can see, your sales goal is determined by the total of your needs (expenses) and your wants (profits). This is why businesses try to keep expenses down. Lower expenses mean bigger profits or a need for fewer sales. In a highly competitive business sales are more difficult to make, so keeping expenses in check makes sense. If you can sell more than you forecast, and you keep the expenses lower

than projected, you have greater profits and more capital to use to benefit yourself or your business.

Quotas

Once you decide on the sales goal of $100,000, your next step is to decide from what segment(s) of the market you are going to secure these sales. If you only do advertising work you are going to have to sell to clients in that sector only. If you service all three segments of the business, you will have to proportion your sales accordingly. This is more complex than it might seem at first, but it is not very difficult. Like most complex things (a photograph for instance), it just takes a bit of visual planning. One manner of approaching the task is to make a list in a spreadsheet or on a piece of paper, depending upon how complicated your business is.

Taking a simple example first, let's assume that you only do editorial photography, and that 20 percent of routine revenues come from stock sales by a stock agency. Your calculations are as simple as the list in figure 21 shows.

Basically, this list indicates you have to be shooting two assignments every week on average. This means you have a sales quota of at least selling two assignments every week on average. As a result,

Figure 21

Total revenues:		$100,000
	Minus	
20% from stock:		20,000
	Equals	
80% from assignments		80,000
	Divided by	
Average day rate		500
	Equals	
Required shooting days		160
	Divided by	
Average # of days per job		1.5
	Equals	
Number of assignments to be sold		106.7

you will have to promote yourself to enough prospects to get enough clients to make the quota. We'll explore that process shortly. First, let's look at the more complicated business that most photographers face.

Complex Quotas

Happy Shooter is a photographer who services all three market segments and has a stock agent selling his stock. He has a revenue projection of $100,000 and 10 percent of his revenues come from stock sales. Happy has a more complex (not difficult) list to prepare, so he uses a spreadsheet to do it. This gives Happy an advantage because he can calculate "what if" scenarios just by changing a number in the spreadsheet. This also means that he can make automated midstream adjustments during the course of a year, if his original projections are not turning out the way he thought they would. Happy's initial spreadsheet is a template of labeled rows and columns of cells. Some are blank, and some have formulas in them to instruct the spreadsheet on how to make the required calculations. We will look at creating this template first, and then we can fill in some numbers. The template is created with the following assumptions based upon Happy Shooter's experience. First, his assignment revenues consist of about 60 percent advertising, 20 percent corporate, and 20 percent editorial. His rates are based upon the lowest fee he will accept, a $500 editorial day rate. He doubles his editorial day rate for corporate work, and he triples it for advertising work. Understand that Happy doesn't always quote a day rate, but he has to perform his sales calculations on some value basis, so he uses what he is primarily selling; that is, services, and that means time. His day rate includes non-exclusive usage rights. Depending on the segment of the industry served he will adjust his rates upward from this base. That will be explained in this chapter.

By comparing the template in figure 22 with the subsequent spreadsheet in figure 23 you can see the benefit of the template. All Happy has to do is enter the "projected revenue" amount, and the spreadsheet calculates all the other information. If you set up your system to work this way, you can change the formulas at any time, so if the percentage of segment assignments change, or you want to see

Figure 22

	Template		
Happy Shooter projected revenue	0		
Revenues from stock agent	0		
Assignment revenues to be raised	0		
	Advertising	Corporate	Editorial
Assignment revenue percentage by segment	60	20	20
Assignment revenues required by segment	0	0	0
Average assignment day rate by segment	1,500	1,000	500
Shooting days required by segment	0	0	0

what the outcome would be if it changed, you can tell in a flash. A look at Sales Call Needed (figure 24) demonstrates a change in the projected sales and the segment percentages.

There are still two more steps that have to be taken to convert these sales quotas into a plan of action. Happy has to factor the number of shooting days by the average number of days billed on a job to determine how many assignments he must book to meet his projections. Happy's records indicate that the average advertising job has three billable days from prep through post-production. His average corporate job is 1.5 days, while his average editorial job is 1 day. That information is added to the spreadsheet in figure 24.

Figure 23

	Spreadsheet		
Happy Shooter projected revenue	100,000		
Revenues from stock agent	10,000		
Assignment revenues to be raised	90,000		
	Advertising	Corporate	Editorial
Assignment revenues percentage by segment	60	20	20
Assignment revenues required by segment	54,000	18,000	18,000
Average assignment day rate by segment	1,500	1,000	500
Shooting days required by segment	36	18	36

Figure 24

Sales Calls Needed

		Advertising	Corporate	Editorial
Happy Shooter projected revenue	100,000			
Revenues from stock agent	10,000			
Assignment revenues to be raised	90,000			
Assignment revenue percentage by segment		50	30	20
Assignment revenues required by segment		45,000	27,000	18,000
Average assignment day rate by segment		1,500	1,000	500
Shooting days required by segment		30	27	36
Average billable days per assignment		3	1.5	1
Total assignments required		10	18	36
Percentage of sales calls sold		30	50	70
Number of sales calls needed to achieve goal		33	36	51

Happy has to sell ten advertising jobs, eighteen corporate jobs, and thirty-six editorial jobs to achieve his sales goal. If he manages to sell more than that, he is going to have a better profit at the end of the year. If he sells less, he will have a revenue shortfall and that means a possible loss unless he cuts expenses. If he sells more jobs in one category he can cut back sales in another category. For example, one advertising job with three billable days equals $4,500 in revenues. That is equivalent to nine editorial assignment days.

How Many Sales Calls

The last thing that Happy has to determine before he can plan his sales campaign is how many sales calls he has to make in order to secure the number of assignments needed to meet his sales goal. The photographer with some years of experience is going to have a better handle on this step than the less-experienced photographer. But experienced or not, this is a critical step, as you will see. So, no matter what your level of experience, you have to make reasonable assumptions about how many sales presentations you have

to make to sell a job; that is, what percentage of sales calls will end up with you receiving an assignment. If you have no experience to base your assumptions on 20 percent, but you are confident about your sales ability, use 30 percent or higher. In figure 24 we'll use the 30-percent factor for advertising, a 50-percent factor for corporate, and a 70-percent factor for editorial. These factors reflect that some sales are easier for an established pro to sell than for a novice, and that it is easier to sell in some segments of the market than others.

So Happy has to make thirty-three presentations to advertising agencies, thirty-six to corporate communications departments, and fifty-one to magazine editors to sell enough jobs to meet his sales goal. Now Happy is ready to plan his promotional efforts.

Promotional Volume

How many prospects do you require in order to make presentations for thirty-three advertising jobs, thirty-six corporate jobs, and fifty-one magazine jobs from which you will receive the number of assignments required to meet your goals? Again, history will serve your informational needs best, but most photographers don't keep good historical records, so we need a new basis for assumption. The basis for assumption has to take two things into consideration. Are you doing blanket, broadcast promotion or niche-targeted promotion, and how many repeat jobs can you get from a client once you sell one assignment? The answer to that question depends upon the segment of the industry that you are serving. In advertising, you have to sell each job. No photographer gets hired because he has worked for the agency before. In editorial work, you can expect to be hired repeatedly once you establish your credentials as a reliable supplier. Of course, the magazine's editorial calendar has something to do with what kind of photographer they need for any job by virtue of style, experience, and location. Corporate accounts are the most likely to use your services repeatedly. Of course, some corporations shoot one job a year and some shoot five a month. Let's make the assumptions in the charts below. One covers blanket/broadcast promotion, the other covers targeted/niche promotion like that described earlier in the book.

Figure 25

Targeted/Niche

	# OF SALES CALLS REQUIRED	REPEAT JOB FACTOR	# OF CLIENTS NEEDED	RESPONSE FACTOR	# OF PROSPECTS NEEDED
Advertising	33	1	33	10%	330
Corporate	36	4	9	20%	45
Editorial	51	6	9	30%	30

In the targeted/niche chart (figure 25) the response factor is much higher than in the blanket/broadcast chart (figure 26). That is because quality, novel, targeted promotion has proven to be about ten times more effective than blanket/broadcast. In one scenario you have to send out more than four thousand promotional pieces a year. In the other you have to send out just over four hundred. Can you follow up on four thousand promotional mailers? Yes, but it is a lot easier to follow up on four hundred. And, if you send a memorable promotion, the prospect is likely to associate your name with it when you call. That is like getting two feet in the door.

You also have to keep in mind that these charts do not reflect existing accounts. If you have existing accounts that can be relied upon to generate a predictable volume of revenues, then you can deduct those revenues from the sales goal. You don't need to sell them; they are already sold. There is the reward for servicing clients

Figure 26

Blanket/Broadcast

	# OF SALES CALLS REQUIRED	REPEAT JOB FACTOR	# OF CLIENTS NEEDED	RESPONSE FACTOR	# OF PROSPECTS NEEDED
Advertising	33	1	33	1%	3300
Corporate	36	4	9	2%	450
Editorial	51	6	9	3%	300

well enough to keep them on board. You do not have to work as hard, or your hard work provides more revenues than you need. The later scenario provides the money you need to expand, own more, do more, etc.

Critical to Success

Sales are critical to the survival of your business and the advancement of your interests. Like any business operation, the sales effort requires management. Sales management starts with setting a sales goal and subsequent quotas. Then comes the hard work of promotion, soliciting presentations, and making offers to service prospects needs. It ends with carefully directing your effort to close individual sales. Sales work requires the discipline to stay on track even though many sales attempts will be unsuccessful, especially in the beginning of your career or new initiative. Sales success comes over time if you have the dedication and perseverance. The sales effort will make or break your business. That means it will be the most important factor in determining whether you are going to be a professional photographer or not. Recognize the importance of your sales effort; act on it, and you will find the success you seek.

Sales Technique

I T SURE WOULD BE NICE IF PROSPECTS RECEIVED OUR PROMOTIONAL material and immediately telephoned us to set up an appointment. Maybe it will happen to you every now and then, but if you are counting on getting your business that way, you ought to close up shop now before your losses get any greater. Right now almost all of your prospects are thinking about the job(s) they are currently working on, not on the next one(s) that they have to do. They start thinking about the next ones after the current job is done or nearly done. That is why they often call you a day or two before the work is needed instead of a week or two before. You will not stop that behavior. It is the way humans work, and, if you think about it, that includes you.

Getting an Appointment

What you have to do is get the prospect to think about the next job. That process starts with a phone call to follow up a promotion, and it ends in getting the appointment needed to sell your services to the prospect. Most companies with sales forces have a routine sales process. The reason for that is to guide the salesperson through the process as thoroughly as possible. You should have guidelines too. Those guidelines should be developed with common sense at their core, and based upon an understanding of these simple facts about peoples' buying habits.

Prospects tend to buy from someone they know. They feel that they know you when they remember your name. They prefer to buy from someone who is likeable, and buy more quickly from a helpful person. So you want to make prospects familiar with your name. Your

promotional material was the first exposure that they had to your name. The more memorable it was the more likely they are to remember your name. But they will forget your name quickly if you do not reinforce it. You can do that in a methodical way. The following list is a series of steps that you can take to get them to remember you.

Step 1, usually taken about one week after they should have received your promotional material, is to make a phone call to the prospect. There are two possibilities on that call. Either the prospect is unavailable, or you actually connect. If the prospect is unavailable, you should leave a message. A message has your name in it, and that helps establish name recognition and recall. Never leave a message that says you will call back. A prospect has no reason to remember a message to which no one has to respond. It is OK if the person calls back and you are not there to take the call. It tells you that they are interested, and it reinforces your name in their mind because your answering machine or office worker announces the name of your studio upon answering. If you answer your phone "Studio" or you have a machine that answers "You have reached 555-555-1212," then stop reading and go change the message right now. You are selling yourself, not a studio or a phone number. Keeping your identity a secret is not a good sales technique.

You can make up to three calls that go unreturned without being a pest. Wait a day between calls. That allows a person who was out of the office to catch up. If you do not get a returned call after three attempts, send the prospect a note by e-mail or postal mail. It should be brief and to the point. Here's an example:

Dear Pat:

I attempted to reach you by telephone last week without success after several tries. Understanding how busy you must be, I thought I should send this note to follow up on my promotion materials—you'll probably recall receiving the cigar box with the picture of the motorcycle on a pop-up spring like a jack-in-the-box.

You know that I hope to set up a meeting to show you a bit more of my work, and hopefully secure an invitation to bid for

a future assignment. I know that I can meet your needs for a top-notch, reliable, and creative photographer. I want you to know it.

I'll call you again in a few days.

Regards,

(Your name)

The next step is to wait a week for the letter to reach the prospect and then begin the three-call cycle over again. If you do not connect with the prospect, you should reschedule the process for a month later. Do not assume the person is avoiding you. Maybe the prospect had personal problems or illness. Maybe a work emergency totally distracted him for several days. You just never know why the prospect didn't respond, so don't assume the worst. Assume the best.

The best situation is that you connect with the prospect on one of the first calls. If you do you must be prepared to take control of the situation. You have to have your pitch ready to go. Here's an example of how such a conversation might go between Pat Buyer and Happy Shooter:

HAPPY: Thank you for taking (or returning) my call. You'll probably recall receiving the promotion that I sent to you. It was the cigar box with the picture of the motorcycle on a pop-up spring like a jack-in-the-box.
PAT: Yes, the damn thing really startled me when I opened it.
HAPPY: Sorry about that. I was hoping to get your attention, not startle you.
PAT: You got my attention.
HAPPY: Well I guess it helped you remember me. You know that I am calling to try and set up a meeting to show you a bit more of my work, and hopefully secure an invitation to bid for a future assignment. I know that I can meet your needs for a top-notch, reliable, and creative photographer. I want you to know it. When can we get together for a few minutes?

If Pat says OK to the meeting, all you have to do is work out a mutually convenient date and time. If Pat says no, you have to listen to her answer and determine her reason. If she is too busy, offer to call back in a week to see if she will be available then. If she says she has no work available, you can say that you'd still like to come, especially because she will not be under a lot of pressure if work has slackened a bit. You can say that you really want to be considered for future work, even if the work is not immediate. A salesperson has to have an answer for every excuse or objection. You can develop those responses over time by anticipating what you might hear or by reconsidering your reply to a response that didn't help you get a meeting. Sales work is like any other. It takes a bit of practice and experience to become good at it.

If you are granted the meeting, immediately send out a confirming thank you letter. If you fail to get the meeting, wait a few weeks and send Pat another promo package. This one does not have to be as novel as the first. Some excellent copies of your work will do. Then begin the process all over. If the prospect fails to respond to that attempt, you ought to consider pursuing her by phone just to ask why she doesn't respond. Once it is unlikely that you have motivated the prospect to see you, you can stop worrying about alienating her. She already told you that she is not interested by her refusals. The reason I suggest trying to find out why she doesn't respond is because you might learn something that you did wrong, or you might actually move the person to give in and see you. Either way, you have little to lose with the prospect.

You are going to keep after prospects until you secure enough presentations to make enough sales presentations to meet your sales goal.

Presentation

With consistent effort you will secure many opportunities to present yourself as a candidate for assignments from prospects. Depending on your locale and the specific client you may be doing this in one or two steps. Sometimes prospects want to see your portfolio first and then meet with you when they have a specific assignment to offer.

Other times the prospect will do both in a single meeting. There is one time when it is always a two-part process. This is when the client is out of town and you will be handling all discussions via telephone and e-mail. In these cases you will almost assuredly have proven your photographic capability to the prospect by having sent a portfolio in some form, or by maintaining enough work at your Web site to allow the prospect to make the appropriate judgment. While each situation is different, the process is the same. You have to show the client work that is similar to the work that she is in need of for the assignment that you are being considered for, and you have to have a thorough communication about the assignment with a persuasive slant aimed at making the prospect use you for the job.

Regardless of the method, the presentation of your portfolio should help you persuade the prospect that you are the photographer for the available assignment. To assure the proper effect, you have to be sure that the images that you will show are related to the kind of work required on the assignment. Again, art directors who want photographs of motorcycles are not very interested in pictures of food, unless it is connected in some way to motorcycles. Magazines that cover snow sports are not interested in tropical island scenes. Corporations doing an annual report are unlikely to be interested in product advertising, unless the annual report is going to feature still lifes of products. The display of photographs must send the message that you are a proud professional. Your images, regardless of presentation format or medium, must reflect your insistence on photographic excellence. Saving money or time at the expense of quality in the preparation of presentation images is foolish.

Do not show too few or too many images. Assume that a prospect will look at each photograph for an average of thirty seconds. If you have a thirty-minute appointment, you want to leave time to speak with the client without rushing. It will take ten minutes for the person to see twenty photographs, which is a good number for a portfolio. Twenty images allows the prospect to see enough, but with the option of stopping. When a prospect stops looking at your samples before the end of the pile it is because they are convinced that you are either

suitable or unsuitable for the job. Until you hear otherwise, always assume that you are suitable. Busy people are usually quite able to tell you that you don't fit the job to be done, and they don't waste time getting to the point and ending the presentation. Some people are very kind and they will continue the presentation, even if you do not have a chance of getting the job. If they stopped short in the portfolio review, and they have not expressed an opinion of your work, it is incumbent on you to ask them their opinion. A simple question like "Well Pat, I noticed that you didn't take a long look at my work. Does that mean it does or doesn't meet your needs?"

Do not talk while your photographs are being reviewed unless asked to. Photography is a visual art. Let the client's eyes receive the message without interference in the form of voice communications. If you feel that any photograph needs a commentary, then put it on the top of the pile and explain it before the process of review starts. If you have several photographs that require an explanation, you have too many. The review process is about art and technique. It is not about the deeper meanings of the images or educating the viewer about the subject matter.

Look Good

Just as important as how you present your photographs is how you present yourself. You are part of the service that you deliver. Look like and act like a quality-driven professional. Research studies have shown that when meeting a person for the first time that person is going to form 80 percent of his or her initial opinion of you in the first thirty seconds. The other 20 percent might take thirty years. You must make a good impression at the instant of initial contact. It is not difficult to do that. In fact it is very easy to do, if you concentrate on the factors that your counterpart is subconsciously evaluating in that first thirty seconds of contact.

Your prospect is going to scan you from head to toe about three times in the first few seconds. Then he or she is going to look at your hands (a primitive instinct related to self preservation), followed by a more focused look at your face, so he or she can remember you. That is why you should speak your name to prospects almost

immediately upon first meeting. They are registering your face in their minds, and that is the best time to have them simultaneously register your name along with it. You can do it this way. As soon as you are within reasonable speaking distance to the person, in a solid, even-toned voice say something like "Good morning. I'm Happy Shooter. Thanks for sparing some time for this meeting." Then continue to approach them and move close enough to offer your hand in a handshake, which is carefully controlled to neither break their hand nor make them feel like your hand is made of foam rubber. You will have subtly taken control of the first thirty seconds of the meeting, and that leaves the subliminal impression that you are confident and adept in life's daily routines. That is exactly what you want them to think, because that is exactly what they want in their professional providers.

The next step is to get to the heart of the matter. Again, taking control, you say: "I'd like to show you the work that I brought with me today, so you can evaluate when and where I might fit into your future plans. Is that OK with you?" A prospect will almost always defer to that request because he or she really doesn't want to waste time talking if your work is in line with what is needed. By your initiative, you have taken the burden off the prospect to stop the small talk and get to the images.

Needless to say, the images better be able to speak to the client through his or her eyes. The work has to be impressive in its quality, both aesthetically and in terms of its materials. Presenting worn prints, scratched transparencies, or cracked or dirty mounting boards are like saying "I do sloppy work." That in turn kills your chances of being taken seriously. If you went to the shoe store and the sales clerk brought out a pair of scuffed shoes for you to try on, what kind of impression would it make on you? Most likely a bad one. But with shoes you get to see the actual pair you are going to buy before you commit to paying for them. In assignment photography prospects commit to pay before they see the results. They need to be convinced by some evidence that you will deliver a quality job to make that commitment.

After the prospect looks at your portfolio he or she will most likely take over the conversation. You can expect to hear that your

work is great or good, or maybe that it is nice work but not exactly what the prospect is looking for. If you don't get a comment, ask: "How does my work fit your needs?" The answer is a key to the next step. If you get a negative response, you should ask what might make it better fit the prospect's needs. Then indicate that you would like to show her some additional work since you apparently should have brought different material. If you get some good suggestions from the prospect, you still have a chance, if you can put together what he or she wants to see. If you get an inadequate answer, it usually means you are wasting your time. It is time to understand that there are many prospects out there, and each one of them will see your work differently. Move on to the next one. Don't take the brush-off personally; you cannot be everyone's photographer.

If you get any kind of positive response, you have entered what I call the green zone. I picked "green" because you have received the "go" light that allows you to travel to the money-making (also green) opportunity. The prospect is satisfied with your work. Now you have to convert the prospect to a client. To make that conversion you have to remember what the client is buying in addition to photographs and convincingly sell the prospect on your ability to deliver those things. The prospect has already accepted you as a photographer. You have to become accepted as a businessperson and supplier. It is time to stop thinking about photography and start thinking about your client's non-photographic needs.

The Client's Needs

The prospect's obvious need is for photography. When you got past the portfolio review intact, you qualified as a person who could meet that need. But that qualification only gets you the opportunity to actually solicit work from the prospect. It doesn't guarantee you any work. To obtain the work you need, you have more to do in the selling process.

The prospect's needs break down into two types: concrete and abstract. The concrete need is for photography, and thus, a supply source. In the simplest terms you are in the prospect's office to offer

yourself as a source of supply. Once you pass the portfolio screening, your next step is to find out what the prospect needs supplied in the immediate future. It is not difficult to do that. The secret to finding out is to ask. I have been amazed at the reluctance of some photographers to ask what work might soon be available. These reluctant photographers seem to feel that it is either beneath them, or that it will put the prospect on the spot. Certainly it is not beneath you to ask what work will be available, since you and the prospect know you are there to get some of that work. For the same reason, it is not putting the prospect on the spot. In fact, it is best to get to the heart of the matter without a lot of wasted time. Prospects like direct and open communication. They are busy people and, as such, they do not want to play games. They simply want to get business done as efficiently as possible.

Every prospective client will consistently share a few needs in common. These needs are the abstract features of any service. My experience has been that staying within budget, delivering ahead of or on time, meeting the quality standard, and no hassle are universal desires of any prospect. The prospect will rarely mention these intangible needs to you, but they are at work in her subconscious mind all the time. Cost overruns, missed deadlines, and inadequate quality are the hidden worries that all your prospects have. The mere possibility of these things happening causes stress. That is why a no-hassle relationship is important to the client. The worries are enough to bear without worrying that the supplier is going to have a tantrum during a job. Tantrums increase everyone's stress. Understanding these hidden concerns can help you make sales.

The best way to present the selling process, and how it should encompass the points made in the last two paragraphs, is through a mock dialogue. In the dialogue I have made a few comments on the choice of words in parentheses. Let's set the scene for the dialogue below. Pat Buyer and Happy Shooter are meeting for the first time. Happy has taken care to make a good initial impression, and he has placed his portfolio in Pat's hands, just as he should. She has just finished looking at the portfolio, but remains silent.

HAPPY: Well Pat, what's the verdict? Will my work meet your future needs? (Never ask if your work is good enough; of course it is.)

PAT: Yes, it's good work. I think you could do a good job on some of our assignments.

HAPPY: Any of those "some jobs" coming up? I'd love to have the opportunity to estimate a job for you soon. I want you to see how I deliver quality at competitive prices. (You have just rung Pat's subconscious bell on two points: quality and cost overrun. Pat is subconsciously pleased to know that you are aware of two of his constant concerns.)

PAT: You know that we have a photographer working on the Maniac Motorcycle account, so that's off the table.

HAPPY: Certainly, I wouldn't want anyone to pull a job that I was working on out from under me. But, you know that I can do a good job on a variety of subjects.

PAT: Yes, I like the way you work with vehicles. Your book shows you really capture a sense of motion. We are waiting for a go-ahead from Slippery Snowmobiles to get started on the basic work of a new campaign for them. I hope to have something specific in the next few days. I'll give you a call when I have an approved concept and the budget. What's your day rate?

HAPPY: It depends on the nature of the job and the rights you need. I wish I could charge every job at a single fee, and a high one, but I have to price based upon the resources, talent, skill level, etc., that each specific job requires. Frankly, if I am the perfect person for the job, I charge more than when there are ten perfect people for the job. I can tell you that I just can't afford to take jobs that are under $1,500 per day no matter what because to keep an operation like mine going requires some serious overhead. But that is also why I don't have cost overruns, missed deadlines, or quality lapses. I stay on top of everything. (You just rang Pat's bell again.)

PAT: Well, $1,500 is within an acceptable range in light of the competition, which you will have because the agency has

a three-bid policy. (Pat just told you what fee she is always pleased to hear. She also gave you a clue about the fee by using the word "range." She is indicating some flexibility. You will want to bid at a higher point than $1,500 in anticipation of that fact.)

HAPPY: I love competition. It's so much more satisfying to get the job when you know you had to win to do it.

PAT: OK, I'll be in touch with you.

HAPPY: Let me give you a list of contacts and phone numbers at my recent clients' offices. If it will make you feel more secure, please feel free to call them. They will all tell you that I deliver on time, quality work within budget, and that I don't hassle them, even if things get confused, as we both know can happen. I want you to know that I am the right person to meet your needs. By the way, is it OK if I call you next week? I know how busy you must be, and I can take the burden off of you in terms of calling me. (Once again you have reassured Pat that you know what is important, and you have signaled that you are serious because you offered a means of easy confirmation. Pat is not very likely to call anyone, but, just in case, be sure that she will get the right answers from anyone on the list.)

PAT: Sure. Call me Tuesday or Wednesday.

HAPPY: Great. Will do. Thanks for your time today.

You can leave Pat's office with the good feeling that you are going to get an opportunity to engage in stage two of the selling process: estimating or bidding on a job and trying to close the sale and book the work.

It is often the case that stage two occurs as a continuation of the initial dialogue because Pat has the clearance required to start on the Snowmobile job. But when that does not happen you have to schedule and make the phone call to Pat to set up a date to engage in stage two.

In stage two you will almost undoubtedly be presented with sketches from Pat, who will want you to provide an estimate or bid for doing the photography that fulfills the concept in the sketch.

Depending upon complexity, you will need more or less time to work up a price for your services. Before you can calculate a fee you will need to get a good bit of information from Pat. Two important dates that you must find out are when can shooting begin and when must the finished work be delivered. The other important information you must have is the extent to which the images will be used, so you can issue the proper usage license to your new client. Obviously, you get that information by asking the prospect.

Checklists

You will also need to do a mental run-through of the entire job so you can analyze the production requirements. You should have checklists to help you be thorough. The first checklist should be of services for which you have to obtain a price from another party before you can complete your estimate. Do not guess what fees you will have to pay others for services. Here is a sample checklist.

Assistants
Casting
Equipment rental
Home economist
Insurance riders
Location research
Location scouting
Location permits or fees
Models
Production coordinator
Props
Security
Set construction and strike
Stylists
Trainer/animals
Travel
Wardrobe
Wardrobe dresser

You will want to tailor the checklist to your needs depending upon the kind of work you do. That means you will want to delete some items and add some items. Always begin gathering the information that you need from others as quickly as you can to avoid delays caused by tardy replies to your requests for prices or proposals.

You also need a full production checklist of all the possible materials and resources that you will need to do the job in order to calculate a price. The pricing chapter of *ASMP Professional Business Practices in Photography* offers excellent tools for checking the details of the assignment and for pricing them.

Preparing the Estimate

A VERY IMPORTANT PART OF THE SELLING PROCESS IS demonstrating your professionalism to the prospect. Professionalism extends beyond the scope of the photography and into the administrative work that you do and present. The appearance of your estimate and your ability to quickly present the details that went into making it are signs of professionalism. To assure a professional look, you should have consistent methods for doing the administrative work that your prospect is likely to see either because you sent it to him or because you will be referencing your own copy while in his presence. If you are discussing an estimate that you have given the prospect and you are asked how you arrived at a certain figure, you will have to refer to your planning and calculations. When you refer to these, they should be neat, organized, and professional looking. By being so, it will help reinforce the impression on the prospect that you are a top-notch professional who does things right. A client will be much more impressed by a photographer who brings a laptop computer full of the details when meeting to review an estimate than he or she will be if the photographer has a pile of disorganized paper.

The process of preparing an estimate for your client is an important part of the selling process. It not only needs to be thoroughly done to ensure that all required expenses are taken into account, but it also needs to be developed in such a way that it does not bog down the process of securing the job. Personally, I think that providing too much detail in an estimate is unwise. It can result in making the details of the expenses more important than the details of the photography. In the end, the prospect is

buying a photograph, and the estimate is the price sticker. It is the bottom line of the price sticker that counts. Think about it this way. When you are purchasing a car do you really care about the cost of the components on the price list? Do you care whether Ford's automatic transmission costs more than Plymouth's? No, you care about the price of the car, not one of its components. Estimates run the risk of making component prices an issue when they are too detailed. However, prospects determine how much information we have to give.

Buyers form a continuum between two extreme types. On one end of the continuum is the buyer who wants great detail, and on the other is the buyer who really only cares about the total price. The detail person probably does wonder why Ford's automatic transmission costs more than Plymouth's. It is even possible that the detail-obsessed buyer will mention it in negotiation in an effort to lower the price, citing that Ford has overpriced its car by the amount of the difference. Our other buyer will simply get the best price on the car from a few different dealers and play one against the other until all of them say they can't come down any more. Personally, I prefer the latter. Dealing with compulsive number crunchers line by line is time consuming, and it rarely leads to a different result than simply negotiating the price based upon competition.

You must always remember that pricing is part of the sales process. Your price can make or break a deal. Your pricing must be done in a manner that you can sell it to the prospect. One way to make that easier is to impress upon the prospect that the price you have presented has been carefully considered in light of the work to be done. By demonstrating that you have calculated your price carefully, you instill some confidence in the prospect that you know what you are doing, which, in turn, makes her less likely to pick your price apart.

As I have mentioned before, this book does not rehash what you can find in other books, so rather than restate what has already been well written and presented in another of Allworth's publications, *ASMP Professional Business Practices in Photography*, I will just refer you to chapter three of that book for your lesson in pricing and estimating.

Presenting the Estimate

When you are finished calculating the price for the prospect's proposed work, you will have to present it. You might be able to present the estimate in person, which is the best way to make the sale, if you can manage it. More often than not, you will have to send the estimate to the prospect and discuss it on the telephone. This means that your estimate has to be very understandable. An easily understood estimate will have four parts: a job description, the price of the major components, usage rights being granted, and some terms and conditions that govern the sale.

I have long been convinced that, after the quality of your images, the estimate is the key to getting work. I also believe that most estimates are either woefully lacking information or overloaded with information. Each has its damaging effect. Too little information makes you look incompetent. Too much information makes you look inflexible. This is especially true when it comes to the terms and conditions of the sale. As executive director of ASMP I presided over the creation and publication of terms and conditions of sale that would scare most good-intentioned people away. Trade associations are duty bound to protect their members' interests to the fullest extent possible. As a result, they create ironclad terms and conditions to recommend to their members. Most buyers ignore those terms, or they assert that the terms of their purchase order or their buying policies prevail over the photographer's terms and conditions. The better situation to be in is one in which you present the client with acceptable terms and conditions.

Below is a sample of an estimate that is intended to do two things: impress the prospect, and protect the interests of both parties. You will see that it is not a form agreement as offered by most trade associations, or in other books. The word processor allows us to customize our documents. You want to make the prospect feel special with personalized service. A form agreement will never do that. The word-processed document does look like it was specially prepared for the prospect. It is simple to do since its main components never change. Only a few details change according to the details of the job.

(On Letterhead)

(Date)

To: Ms. Pat Buyer
Art Director/Buyer
Amiable Advertising

Subject: Slippery Snowmobile Photography Assignment

Dear Pat:

Thank you for the opportunity allowing me to present my estimate for the Slippery Snowmobile job. I am looking forward to finishing this part of our business together quickly so we can get on to the creative work. If you have any questions, please give me a call.

The assignment requires the creation of three photographs. One is an unmanned snowmobile in a snow-covered outdoor setting. The second is a snowmobile manned by two people being driven along a tree-lined and snow-covered path. The third is a single-manned snowmobile crashing through a small snowbank with snow flying through the air. Copies of the sketches supplied by you have been attached for reference.

The location for the work is to be in Colorado during the week of January 20 to 25. The deadline for delivery of finished images is no later than January 29. You require digital files of all images according to the specifications attached.

The usage rights required by the advertiser have been expressed as a "buyout." Understanding that this term can mean different things to different people I have provided pricing that accommodates different usage scenarios, one of which will certainly meet your client's needs. These options are offered subsequently.

The expenses that will be incurred include:

Assistants & stylist	$1,750.00
Location scouting	1,200.00
Location permits or fees	600.00
Casting & models	4,000.00
Travel	2,900.00
Wardrobe	900.00
Film/processing/digital services	1,621.00
Total	$12,971.00

Production fees are based upon eight days for preparation, travel, shooting, and post-production work plus the usage of the photographs.

Option 1: Transfer of full title to copyright allowing unlimited use for the duration of the copyright for a fee of $45,000.

Option 2: Exclusive rights for three years allowing unlimited use for a period of three years from the date of first publication for a fee of $30,000.

Option 3: Exclusive rights for one year allowing unlimited use for a period of one year from the date of first publication for a fee of $15,000. One additional year of usage would increase the fee to $25,000.

The total price of the assignment will be the total of the expenses plus the amount quoted in the option selected from the above list plus any applicable taxes.

Being fully insured, I am responsible for any liability incurred through my errors, omissions, and/or negligence. Likewise, Amiable Advertising is also responsible for any claims arising from its actions or failure to act.

Should there be weather delays on the assignment, my fee for such days will be $800 for each day plus all expenses incurred including crew and model expenses. Any additional production days required to complete the assignment will be invoiced at $1,600 per day plus all expenses incurred including crew and model expenses.

Invoices must be paid within thirty days of the invoice date. Unpaid invoices are re-billed after thirty days, and a $50 rebilling

fee applies. Payment is the responsibility of Amiable Advertising as the purchasing party. If Amiable Advertising's policy is to make its payments contingent on payment from Slippery Snowmobiles, then I require a purchase order to me from Slippery Snowmobiles so I can bill them directly, if need be.

All original film and images produced remain my property. In the unlikely event that the original images from this assignment are lost or damaged by any party after delivery to Amiable Advertising, the full extent of liability shall be the amount of the invoice for the above selected option.

Model releases will be secured from each person in the images. Copies of the model release to be used are attached. If a different model release is required, please notify me and provide a copy of the release with the acceptance of this estimate. A copy of the attached independent contractor agreement will be obtained from all service providers including models and assistants.

Any alterations, whether additions, subtractions or otherwise, made to the images after delivery by me are the responsibility of Amiable Advertising and its client. Should a release acquired from a model fail to cover such alterations, it shall be the sole responsibility of the party authorizing such alterations.

Ordering any services to be rendered under this estimate is agreeing to its specifications, terms, and conditions, which become binding on both parties.

Once again, thank you for the opportunity to present this estimate. I will call you in a couple of days to follow up.

Warm Regards,
Happy Shooter

The Estimate's Parts

This estimate letter serves the same purpose as an estimate form, but in a friendlier manner. Remember that prospects would rather buy from a person they like. Most estimates received by buyers have the same worn-out look. Form agreements say "you were not worth too much of my time." Letters say "I took the time to create

this estimate just for you." Ask yourself, which you would prefer receiving?

The estimate letter contains the four parts previously mentioned: a job description, the price of the major components, usage rights being granted, and some terms and conditions that govern the sale. Let's examine them one by one.

The description of the assignment speaks for itself in enough detail to make clear what the prospect is ordering. By attaching copies of sketches and/or providing thorough verbal descriptions of the photographs to be taken you are doing two things. First, you are demonstrating to the client that you have the finished result in mind all the time. This is like saying I know what you want, and I am going to deliver it. Second, it protects you from the infrequent but nightmarish scenario in which the client complains that your images are not what they wanted, and they are now forced to use them but are unwilling to pay the full price for the inadequate job. Adding the location and the deadline to the description simply ensures that there are no misunderstandings about either of these two important details.

The usage rights section anticipates the unending contest of rights versus fees. This section asserts that there are defined rights being licensed, and then refers the party to the subsequent options. The usage options are presented in the section on fees. By doing this, the rights become connected to the fee. This has an advantage for you when it comes time to negotiate.

The billable expenses are presented in a summary fashion. This saves the prospect time by not having to sort through line after line of data. If the prospect is the kind of person who wants the details, you can provide the breakdown on request. You could state that in the letter, but my feeling is why should you offer an invitation to ask for more detail. If you have worked with this prospect before, and you know that more details will be requested, you can provide the breakdown of each category in a list accompanying the estimate.

The estimate does not list any markup of expenses. Some photographers add a percentage to the actual cost of expense items. They justify this by claiming that the markup covers their cost of procurement, which is usually for time spent. Many prospects balk at this

145

practice, seeing it as an unjustified fee. I recommend that you include the costs that would otherwise be covered by a markup of expenses in the pre-production fee that you will assess for the preparations necessary to do the assignment. Prospects do not see pre-production costs as an additional assessment, which is how they see marking up of expenses.

The section presenting the fees has three options regarding rights. You are probably wondering why, since this is not customary in the business. It is more customary to give the prospect an estimate, which addresses only the specific rights (in this case, a buyout). I'll address the reasoning behind this approach subsequently. But let's first continue with an understanding of the estimate's structure. The first usage option is the most expensive. In this case it is the prospect's requested rights. The second option is a less-expensive alternative aimed at providing the rights the prospect wants but for a limited period of time. The third option presents the base-level pricing and usage term, the least expensive alternative. It is the base on which the other two options are constructed.

The base option in the example has been calculated in a very simple, traditional manner. Happy Shooter previously cited that his "day rate" was at least $1,500 a day, but that it was dependent upon the skill and other factors, like usage, required for the job. That means that he understands that on some jobs he has more competition than others. Let's face it: There are many photographers who can shoot a snowmobile in a studio up against a cyclorama. Capturing the essence of snowmobiling is a different story. This is not a simple product shot. It is a product-in-action shot that requires skill, planning, and maybe even physical risk. So Happy is pleased to have the opportunity to charge more than the average fees of photographers in his area charge. In this case he decides on $3,000 as a basic daily fee. It also includes one year of exclusive and unlimited use.

That means that he calculates his fees on the basis of a production day with that value. Here is the breakdown of his time/fee details in the estimate.

2 preproduction days:	$ 3,000 (1/2 the shooting rate)
2 travel days:	3,000 (1/2 the shooting rate)
2 shooting days:	6,000
2 postproduction days:	3,000 (1/2 the shooting rate)
Total base fee:	$15,000

In advertising work, clients usually demand exclusivity. They do not want their photographs used by other people. It destroys the impact and the value of the advertisement if its image is seen elsewhere. So Happy's base fee includes one year of exclusive use. Additional years will cost more. Perpetual exclusivity (a copyright transfer) costs the most. Happy must be able to explain this to the prospect in logical manner. That means that there has to be a rational basis for the increases. So it's a simple matter for Happy. Two years is double the time so it should be double the value. Three years is triple. Obviously there has to be a limit, so he sees a copyright transfer as the equivalent of about five years usage because very few photographs have a marketable life of more than five years. Business decisions have to be based on averages, not exceptions. He might lose on the one in a thousand images that gets used for a decade, but he will make it up on the averages since most advertising images won't be used for more than a year or two, regardless of the level of rights that the client purchases.

Creative Deal Making

Happy's estimate reflects the concept that the more extensive the usage, the higher the cost. It also sets up a negotiating range based upon usage. This is a departure from the normal process followed by many photographers, but remember that most photographers do not reach their sales potential. Could it be because they never break out of the mold that puts them at a disadvantage in making deals with their prospects? I think so. Good businesspeople are creative at differentiating themselves from the pack. Do you know any photographers who seem to always be able to make a good deal for themselves? They didn't do it by sticking to some sales format that boxes them in. They are creative deal makers.

In today's photography business the opportunity to sit down with the prospect and negotiate a deal has all but gone away. Most deals are made over the telephone or by e-mail. The prospect describes the photographic needs and the photographer offers a price. Years ago, when a prospect asked for a buyout, the photographer had the option to say that he or she didn't do buyouts and then swing the prospect into a negotiation for limited rights. Over the years many photographers have caved into the demands for buyouts. So, buyouts have become commonplace in advertising and corporate assignments. While editorial assignments often call for more than one-time rights, the buyout has not yet become prevalent in editorial photography. The problem this change has created is that the photographer is pigeonholed because the photographer has no way to adjust price up or down based upon the value of the purchase. Lowering price is therefore only a way of saying that your initial price offering was inflated, or that you are ready to work for less than you are worth, even at a possible loss. That scenario is not a confidence builder in the prospect's mind. By placing options into the estimate you create a range of fees that you can bargain over on a use-related basis. In the end, if you do the buyout, you have shown your client its relative value compared to less-expensive options.

A Photograph's Value

The photography business revolves around a fact that is a blessing to some and a curse others. That fact is that there is not and never has been an established means of determining the value of a photograph in terms of its use. It is quite simple to determine the production cost of an image. It is quite another thing to determine the value of creativity and the use of that creativity by others who seek to advance their commercial interests. As a professional photographer you will hear your share of theories and stories about how the value of creativity and usage should be determined. All of them are opinion, not rules or practices of the trade. In the end there is only one truth: the client determines the value of your photography by his willingness to pay. If you understand that, you understand that the

fees for photography are most often determined by the client setting a fee, as in editorial photography, or by the mutual agreement of the parties, as in corporate and advertising photography. In the latter group the principle of pricing according to "what the traffic will bear" is the norm. For the good salesperson and negotiator this can present the opportunity to make greater revenues than an ineffective salesperson. If you are waiting for the industry to adopt some kind of value formula, please practice your sales and negotiating skills while doing so. Some day you will realize that the formula is never going to exist. Then, if you studied and practiced, you will be ready to engage in the business like a businessperson. Then you can start on the path to making more money by working the business rather than having it work you.

Agreement by Conduct

You will also notice that the estimate has no acceptance and signature lines that you are used to seeing on form agreements. I have avoided that approach. It is so difficult to get a signed acceptance that pursuing it can often cause your relationship with the client to deteriorate. I know that some may argue with my approach. They will cite the fact that contractors and rental car companies require signatures on their agreements, so why shouldn't photographers? Well, fifteen years ago I would have agreed with them, but the fact is that most photography work is done without such signature-sealed agreements, because generations of photographers have not insisted upon them. If signed agreements mean more to you than the photography work itself, maybe you ought to consider going into the contracting business. The photography business is what it is.

Instead of requiring a signature, the estimate relies upon a principle in contract law known as a "contract by conduct." One of the estimate's term states: "Ordering any services to be rendered under this estimate is agreeing to all of the estimate's specifications, terms, and conditions, which become binding on both parties." That condition sets up a situation in which the ordering of any services constitutes an acceptance of your offer.

For those who don't understand basic, contract-law concepts, a contract consists of three parts: an offer, an acceptance, and consideration, that is, something of value received by each party from the other. The estimate is an offer (to do work). Acceptance would best be in the form of a signature approving the estimate, but that is not likely to happen. So the "Conduct" term makes the "Conduct" of the prospect an "Acceptance" when he or she orders you to start the work. That inhibits any future attempt to say that the estimate was not fully agreed to before the work was started. Why? Because assignments are often set up in a rush, and sometimes you can be two days into the job when you receive a purchase order that demands more than you promised in your estimate. The "Conduct" simply makes that purchase order a moot point by making the fact that you were started on the job under the estimate's terms before receiving the purchase order the basis of a contract by conduct.

Conflicting Offers, Forms, and Agreements

Sometimes clients issue purchase orders with some terms that are in direct conflict with those of your estimate. While a contract by conduct is a practical tool and is likely to be upheld by a court, the fact remains that it is not guaranteed. Any lawyer will tell you that you can never be certain of the outcome of any legal action. If you want to be in the best possible position, you should insist upon a signature accepting your estimate. A signature is not a guarantee, but it is as close to one as you can come that your offer will prevail as the document that governs the transaction in question.

The decision you have to make is whether you want to push a prospect who is not accustomed to approving an estimate with a signature of acceptance. In making that decision, remember that most assignments do not result in disputes of any kind. Having a contract by conduct is like wearing a belt to assure that your pants stay up. Having a signature is like wearing a belt and suspenders at the same time. It's a choice. The choice ought to be made based upon probability of your pants actually falling. If you suspect that a prospect might be a collection problem or will argue about the

extent of the agreement in the future, then insisting on a signed contract is probably a wise thing to do.

Terms and Conditions

The other terms and conditions of the estimate reflect the reality of doing business. Don't put terms on an estimate that you don't intend to enforce. An example is insisting on a credit line accompanying an advertising image. Except in the rare case, you will not get it, and you are not going to sue a client over it. So why use it? The same is true for other terms that you are not prepared to enforce. Here's a brief explanation of the other terms and conditions.

"Being fully insured, I am responsible for any liability incurred through my errors, omissions, and/or negligence. Likewise, Amiable Advertising is also responsible for any claims arising from its actions or failure to act."

This simply acknowledges the fact that each of you is responsible for your own negligence. That is likely to be what any court is going to decide in a legal case. It is softer language than some forms employ in attempting to make the prospect responsible for everything and than some prospects employ in reverse on their purchase orders. In effect it is a reasonable compromise for each party to be responsible for its own actions.

"Should there be weather delays on the assignment, my fee for such days will be $800 for each day plus all expenses incurred including crew and model expenses."

You are going to Colorado's snowmobile country in the winter. It is very possible that you could be delayed by a storm. You cannot sit and wait for better weather without being paid. Time is money. If the assignment calls for working inside an office or factory for two days you probably can simply eliminate the weather clause.

"Invoices must be paid within thirty days of the invoice date. Unpaid invoices are re-billed after thirty days, and a $50 rebilling fee applies. Payment is the responsibility of Amiable Advertising as the purchasing party. If Amiable Advertising's policy is to make its

payments contingent on payment from Slippery Snowmobiles, then I require a purchase order to me from Slippery Snowmobiles so I can bill them directly, if need be."

This term simply says that you expect to be paid on time, just as the prospect expects to receive the images on time and, for the work it takes to send out additional invoices, you get paid. It also hedges against the excuse that some agencies use when they fail to pay because they say that their client hasn't paid them yet. You will be providing services to the prospect with whom you have a contract. You have no contract with their client. If they want to hold their client responsible for payment to you, then you need a contract with their client.

"All original film and images produced remain my property. In the unlikely event that the original images from this assignment are lost or damaged by any party after delivery to Amiable Advertising, the full extent of liability shall be the amount of the invoice for the above selected option." The invoice amount would include all fees and expenses for the work done.

The idea that lost original assignment photographs have value beyond the fees and expenses incurred to create them is one that is going to be hard to prove in a courtroom, where it is likely you are headed if the assignment photographs are lost and you want substantial compensation for them. Most advertising assignment images are too specific to have added value for other users. The exclusivity means you can't market them anyway. The choice is between making a beneficial deal with the client and trying to make a threatening deal; it's easier to sell benefit than threats. In the end, I'd rather have a long-term client than a legal settlement with an ex-client. If you are being asked to produce some unique set of images that have good value in the open market, then you can consider setting a fair amount of compensation in this clause. Since that is rarely the case, the norm is to get paid for the job, and if it gets lost too bad.

"Model releases will be secured from each person in the images. Copies of the model release to be used are attached. If a different model release is required, please notify me and provide a copy of the

release with the acceptance of this estimate. A copy of the attached independent contractor agreement will be obtained from all service providers including models and assistants."

A model release isn't important until you need it. And if you need it, it better be adequate to protect you, your client, and the advertiser. Show them your release form so they cannot accuse you of using an inadequate release for their purposes. Releases come in a variety of forms and wording. I suggest that you consult an attorney about which one to use. In a pinch, use one of the ASMP release forms. Which one? Use the most protective one that you can get away with, but never use one that fails to offer protection comparable to the needs of the assignment. Model release terms in the estimate makes the prospect responsible for deciding if the release is adequate. That might not save you from being sued, but it will help in transferring liability from your shoulders to others.

"Any alterations, whether additions, subtractions, or otherwise, made to the images after delivery by me are the responsibility of Amiable Advertising and its client. Should a release acquired from a model fail to cover such alterations, it shall be the sole responsibility of the party authorizing such alterations. This also applies to any violation of the terms of a release."

Model releases can become very complex when you have to accept a modeling agency's release. These often condition the release on the usage. If your client exceeds the allowed usage or otherwise ignores the terms of the release, then the client ought to be responsible. If the client makes alterations to your images and the model sues because the release failed to cover that point, then your client ought to be responsible, because it made the alterations. If the alterations are not in good taste, and the model sues because she claims that the alterations were defamatory, then you want the client to be responsible, again because it made the alterations.

Presenting the Estimate

The estimate letter is ready to go. In the best of all situations you would hand deliver it to the prospect and take some time to discuss it, modify it if necessary, and close the deal. In the real world

of the day-to-day photography business you are probably going to fax, e-mail, mail, or send it by courier or messenger to the prospect. Whatever means employed to get it to the prospect, be certain that it is in the prospect's hands before you accept an order to do any work on the potential assignment. That makes the estimate's "Conduct" clause effective.

Always remember that presentation is as important to acceptance as is content. Prepare your estimate letter in the finest fashion you can. Set your printer for its highest quality printing. Use good business paper and envelopes. Look like a success, and you will be perceived as a success until you prove otherwise. If you are faxing the estimate, set the fax on fine quality. If you are e-mailing it, it is better to attach it as a PDF file so that the formatting remains intact. I have my letterhead set up in my word processor, so it prints out on correspondence, estimates, and other documents. This allows me to convert my letterhead documents to PDF files. When you fax or e-mail an estimate always send a follow-up copy by mail. Print a notice on it saying "previously sent by fax (or e-mail)" to avoid confusion on the part of the recipient. Getting your fine-quality correspondence in your prospect's hands reinforces your value. Modern technology has replaced tangible quality with intangible speed. Speed is critical in today's hurry-up world. But there is a good reason to follow up with quality.

Keep a copy of the estimate in easy reach so that it can be quickly retrieved for any subsequent discussion. Print up a few tracking slips and attach one copy of the estimate. A tracking slip allows you to know what to do next in the process. When you are estimating a number of jobs these devices will help you stay on a methodical course in making sales. After you send the estimate, check to be sure it was received. You can do that with a messenger, courier, posted mail, or fax delivery confirmation. With e-mail you can request a receipt through your e-mail service provider. Since you are going to be placing a hard copy in your prospect's hands, originally or by follow-up, you can rely on a delivery receipt from that action. By the way, if you mail the estimate, do it by Priority or Express Mail. It makes the contents more important. Then keep a record like that in figure 27.

Figure 27

Estimate Tracking Form

Date sent:

Date received:

Call prospect to discuss on (date):

Discussion conducted on (date):

Discussion notes:

Next action required:

Date next action taken:

Follow required:

You have now presented the estimate to the client, and you have confirmed that it was received. You are now entering stage three of the selling process—closing the deal. This is the moment, often a very long moment, of truth. This is the stage when you either convert the prospect to a client, or end up in need of another selling opportunity to replace this one. This is also the stage of the process that distinguishes the very successful photographer from the pack. The higher percentage of sales you can close, the higher your revenue stream. It is time to close the deal. That means it is time to read the next chapter.

Closing the Deal

LOSING THE DEAL—THAT IS, GETTING THE JOB—IS STAGE three of the selling process. Success in this stage requires an understanding of three things: negotiating principles and techniques, the reality of your prospect's situation, and the reality of your situation. These three elements are intrinsically tied together in a web of related dependencies. You cannot negotiate in a vacuum of information. The most important information is what your needs and your prospect's needs are, where they conflict, and how you might remedy the conflicts. Since these elements exist together, this chapter will deal with all of them as they are related.

The best situation you can be in is when the prospect receives your estimate and immediately calls you and tells you that you have the job. You will get to do the work to generate the revenues you need to maintain your professional status without a contest. The thing that always haunted me when that happened was this: did I underprice the job? Was the quick acceptance a sign that I could have gotten a higher fee? I'll admit that the comfort of having the job was enough to keep me from losing sleep, but I always felt better if the client told me my price was too high—I know how to deal with that. I priced higher than I might have had I not had the confidence in my ability to negotiate. Of course the tradeoff is that there were probably times that my estimate didn't make the cut because my estimated fee was perceived as too much. Business is a calculated risk. When you are making money you can afford more risk than when you are not. Understanding that, when my sales goals were achieved I usually estimated higher than I might normally have because I could afford to lose the job.

The reality of the business world is that the prospect is unlikely to accept an estimate on its face unless it a deal that is too good to refuse. Everyone wants to save money. You want to save it because it makes you more profitable. That's good business. Your prospect is no different than you. Always expect to have your estimate questioned and negotiated.

Wants and Needs

Your prospect has certain realities that restrict his or her ability to make a deal. Maybe it is a boss who limits his or her authority to sign off on a deal without approval from above. An advertising or design client that demands certain rights or sets tight budget limits can be restrictive. You, on the other hand, have a reality of your own. You require a certain fee level to stay in business. You need to protect the value of your service, so you cannot just drop your prices on demand.

You and your prospect each have separate needs and wants. You want money so you can take vacations or pay for college. Your prospect's business owner also likes vacations, has college to pay for, and wants to save money. The simple fact of negotiating is that it cannot resolve differing wants. It can only resolve differences over needs. To be a successful negotiator you have to focus on needs, and you have to keep your client focused on needs, particularly the needs related to the one thing you have in common—the assignment that you have estimated.

When your needs are so pressing that you cannot stay in business without getting the job that you are estimating you are not in a position to negotiate. Likewise, if a dozen different photographers could do the assignment acceptably, you are not likely to move your prospect to accept terms or fees higher than the others. If your prospect needs your specific talent and capabilities, you are more likely to be kept in the picture. That is why I recommend targeted marketing and promotion. It positions you in the prospect's mind as special, and that gives you an advantage when it is time to close the deal.

The first step in closing the deal is to make contact after the prospect has received the estimate. If you have followed the

previous chapter's advice, you know it has been received. You assume that it has been read and understood. And you place a call to the prospect. Here's another sample dialogue that could take place over the phone or in person.

HAPPY: Hello Pat. I wanted to check in to see if you have any questions about my estimate for the Slippery Snowmobile assignment. If you don't, I am ready to get started on the job.
PAT: I did look at it, and I have a few concerns that I do not have about the other two estimates I have for the job.
HAPPY: Let me resolve your concerns. What are they?
PAT: The option for different fees and rights are not what I expected. The other photographers just quoted the "buyout" that I asked for. When I compared their prices to yours for that deal, your fee was the highest.
HAPPY: I'm not surprised that I am the highest because my work is so well suited to your needs. I believe that is what got us together in the first place. I do my homework very carefully when I look for a client. I took the time to examine the fit between you and me before I even promoted myself to you. I was sure that you would see that I was particularly suited to do the Slippery Snowmobile work. It's that "particularly suited" that makes me cost a bit more than my competitors on this one. Getting those action shots you need out in the cold snow banks of Colorado requires skill and experience like mine. I don't know how the other bidders are on this job, but I'm certain that I can do this job better than they can, and now I have to convince you of that . . .
PAT: (interrupting) The fact still remains that you are higher priced. How can I justify that to the account executive and the client?
HAPPY: Ask them if they have Ford mechanics tune up their BMWs. Just kidding. I wouldn't try to justify it. Instead, I'd suggest that you suggest that my option two presents your client with a near-perfect deal. They get all the rights they

really need, and they don't pay for something they want but don't need. Look, they get three years of exclusive unlimited use, and they don't pay for a lifetime of use that won't be needed because of model changes.

PAT: The continuing use is not the issue. The client does not want the images ever being used by another party. They have a fear that someday they will see one of their snowmobiles in a magazine story titled something like "Snowmobiles—Cripplers or Killers." They just want to assure that something awful doesn't happen.

HAPPY: Very understandable. I can solve that problem one of two ways. I can agree in writing to never license the photographs to anyone for any reason. I don't use advertising photos of products as stock photography. Or, I can give them the copyright transfer for the same price as option number two, if they agree to pay for any additional years of usage beyond three at the same yearly rate. How's that sound?

PAT: I think that they'll buy the transfer with a guarantee of additional payment for extended usage. But the price for your option two is still too high compared to the other photographers. So you have to come down.

Happy: I just effectively went from $50,000 to $30,000. I think $30,000 is a very fair price for guaranteeing that your images will never get into the wrong hands and three years of unlimited and exclusive usage.

PAT: Yes, but the client changes models every two years and that is the longest that they will pay for usage.

Happy: Well in that case, option one would have sufficed for their needs. It gives them the two years that they need with exclusive use.

PAT: Yes, but it doesn't give them the copyright.

HAPPY: I think I can solve our problem, but first I need to know what I am competing against. There is no point in my doing so if I am simply going to be asked to drop my price at the end to match someone else's. I need to get a certain

amount for a job like this because the job is worth it and I am worth it. I can't let my competition determine my value. What's your bottom line on the fee for the job? You must have one.

PAT: I've got a budget of $35,000 for the whole thing; fees, expenses, etc. I can't even think about asking for more because the account executive is not about to jeopardize our relationship with Slippery when we can get an acceptable result from a photographer within the budget.

HAPPY: For $35,000 I can give you everything your client needs with the protection they think that they need. I am asking you, if I can structure the deal in way that does what I just said, will I get the job?

At this point the negotiation can go in one of two directions. The buyer either acknowledges that he or she wants to work with Happy, or indicates no preference for Happy over the other bidders. Let's look at each scenario.

Scenario 1:

PAT: If you can meet my client's needs and eliminate the fear factor I spoke about for no more than $35,000 for everything, I can give you the job.

HAPPY: I can do it. I need a little time to come up with the right wording. Can I call you back in half an hour?

PAT: Sure. I'll wait for your call.

Scenario 2:

PAT: Look Happy, you are a good photographer, but I have to go with the lowest, qualified bidder to keep peace with the boss.

HAPPY: So where do I have to come in to get the job?

PAT: The low bid is $25,000 dollars for the whole deal with fees and expenses.

HAPPY: I have to think about it, can I call you back in half an hour?

PAT: Sure.

Now Happy has to get his mind in gear. He has the parameters for the "real" deal. The prospect's client wants maximum flexibility with exclusive use for the product model's lifespan of two years. In both scenarios the budget constraint makes the upper price limit $35,000. In the second scenario there is a second constraint from competitor's bid. Dealing with the first situation is easier than the second because Happy has no real competition. The prospect has already offered him the job, if he keeps his price below the $35,000 limit. In the second situation the prospect has introduced a new ally; that is, Happy's competition. Now let's look at how to deal with each scenario separately.

Under Scenario 1, Happy has only to decide how to present his new offer to the prospect. His upper price limit is established. All he has to do is construct a reasonable proposal that meets the prospect's needs of all rights with exclusivity for two years. In the original estimate the expenses totaled $12,971. This leaves $22,029 for the creative production fee without exceeding the $35,000 price cap. Happy comes up with this rational basis for the new price proposal he will offer: a transfer of copyright for two years, allowing unlimited use for the two-year duration of the transfer for a fee of $22,000. He will satisfy his need to get paid for more than two years of usage by an additional payment condition. This means his price will be $34,791, just under the $35,000 cap set by the client. Under Happy's original estimate, option number three was the closest to the new offer. It read: "Exclusive rights for one year allowing unlimited use for a period of one year from the date of first publication for a fee of $15,000. One additional year of usage would increase the fee to $25,000." It would have brought the entire job to a price of $37,791. Happy is underselling his original position by $3,000. But he has a method to his madness, which he will carefully construct in writing so he can read it to his prospect and than employ the same language in his confirmation letter. Here's a copy of his new offer.

"Transfer of the full title to copyright in the images taken as part of the assignment. No rights can or will be transferred to any other party except that Happy Shooter may use copies of the images

and the advertising in which they appear for the promotion of his business interests, in any picture books or photography exhibits, and as art for display purposes. If the images are used for publication of any kind after two years from the date of initial publication in advertisements, Happy Shooter will be paid an additional fee of $5,000 per year of actual usage."

This offer gives the advertiser all the exclusive protection and the rights it needs for the two years of the product model's life. It also gives Happy the right to do one important thing with the images and the ads themselves. He can use them to continue his niche marketing efforts. He can send copies of both to prospective clients in his routine niche marketing and promotion efforts. As soon as the advertising campaign hits the street, Happy will be sending a new promotion to the agencies and communications directors of other winter sports and off-road vehicle manufacturers. This promotional right is potentially worth many thousands of dollars more than he traded off to get the assignment. Happy has surely learned one thing: The photographer has to be looking down the road all the time. Nobody guarantees a successful future but oneself.

Calling Back

The next step is a call to Pat Buyer to present the deal. Since it meets Pat's price needs, and really offers Pat's client all it needs, then it should fly without a problem. If it doesn't, Happy will have to negotiate to finesse the deal to a conclusion. He will do that by continually reasserting that the deal meets the client's needs. If Pat tries to force a better deal, Happy will remind her of the commitment that a $35,000 buyout would fly, and that she indicated that her client would not use the photos beyond the two-year period before the model change. One thing Happy won't do is to drop his promotional rights position award unless he gets the full amount of his original estimate. Happy has not lowered his price. He has obtained the value of his original price in a fee plus an award of valuable rights. If he lowered his price, Happy would be telling Pat that his prices always comes down for the

asking. In that case, Pat will be sure to ask over and over again. A good deal is one in which items of equal value are exchanged. The successful photographer gets the maximum value obtainable for his or her work in every deal made.

Under Scenario 2 Happy must deal with a bigger challenge. The prospect has introduced the competition as a factor. The competition might or might not be real. It is not uncommon to cite competition to a photographer in an effort to keep the price of work down. Sometimes there is real competition in play, and other times there is not—it's just a tactic. The problem is that you never know which situation you are facing. The way to deal with the problem is to ignore it. You cannot solve the problem. You will never know for sure. Why should it matter? You submitted your proposal based upon your policies and pricing criteria. These are the underpinnings of your business. If you are ready to meet the competition's deal just as the competition proposed it, then your competitor is running your business. I assure you that your competitor will not run your business as well as you will.

This kind of situation calls for confidence on Happy's part. He has it because he understands several things about the business process. The prospect asked him for an estimate like every other bidder contacted. But the prospect pursued Happy's bid even though it was much higher than the competitive bid later quoted by the prospect. Why would a prospect pursue a $30,000 estimate when he claims to have a $25,000 estimate that provides everything he needs? The answer is simple. The prospect wants to work with Happy. If not, the prospect would have just said "Thank you, but we are giving the job to a photographer who has a much better price."

Armed with the positive belief and outlook that Pat Buyer wants to work with him on the Slippery Snowmobiles assignment, Happy plans his response to deal with Pat's attempt to get his price down. He constructs a statement of his reasons so he can be prepared to recite his position when he calls Pat back. That call might go like this:

HAPPY: I've thought about the competitive offer to do the job for $25,000, and I am sorry that I cannot even consider meeting it. I thought that would be the case when we were talking, but I wanted a chance to go back over my figures in case I had made a mistake. I didn't. My quoted prices are as competitive as I can be, and I know them to be in line with those of the other successful photographers in town. Maybe my competitor can do it for $25,000, but all that says to me is that he doesn't command proper professional fees or he is desperate. In either case, I think I don't want to be in his situation so I have to stay with my price. But I did work out what I think is a fair deal, which will allow you to save your client a few dollars while getting the best work available.

PAT: What's your best deal?

HAPPY: For a $35,000 maximum including fee and expenses I will transfer the full title to copyright in the images. No rights can or will be transferred to any other party except that I may use copies of the images and the advertising in which they appear for the promotion of my business interests, in any picture books or photography exhibits, and as art for display purposes. If the images are used for publication of any kind after two years from the date of initial publication in advertisements, I am to be paid an additional fee of $5,000 per year. If there is any good collateral material to be produced to support the ads, I could cut back the fee a little bit more if I can get either a credit line for the photography and/or enough copies so I can use it to promote my business. That would be worth a couple thousand dollars to me. On that basis I could knock the price down to $33,000.

PAT: You are still $8,000 higher than your competition.

HAPPY: Yes, I am, and I am going to stay $8,000 higher because that is a fair price from a professional that has proven to you before he ever met you that he can deliver

the work you need, when you need it, at a fair price. I don't know who my competitor is in this case, but I hope you do. You are talking about a competing photographer who seems to me to be too inexpensive for the kind of work involved. I am a frugal fellow, and I keep my operating expenses as low as I can without sacrificing quality of service. If I were a charging this competitor's rates, I'd have to cut back in ways that would affect the outcome of the work. I can't do that and call myself a professional. I think you want to use me, or you wouldn't have asked me to estimate the job. Give me a shot at this. I'll try to make it up to you in the future with great value and service. Do I have the job?

At this point Happy had dropped his price based upon replacing one kind of value with another. The client's cash price went down and Happy's compensation will now include partial payment by virtue of a credit line and copies of the finished work product for his promotional use. These two items have a cash equivalent value to Happy. Pat is either going to give Happy the job or just stonewall. If she stonewalls Happy, the next move for Happy is to push the matter to a conclusion. In that case it becomes Pat's turn to make the hard decisions. Happy has already staked out his final offer of $33,000. He cannot and will not meet the competitor's price in any event. If he did it would be like telling Pat that his original offer was an attempt to get an extra $8,000 for the work. That is not going to make Pat favorably inclined to use Happy in the future. Pat wants a professional photographer, not a huckster to service her needs. Happy has also turned a favorite buyer's ploy around on Pat. Buyers often ask photographers to cut the price on a current job with the prospect of being better treated on a future job. Happy played that classic move in reverse by offering greater value and service in the future. That greater value and service could be achieved by putting in extra hours on a future job or two without extra charge. It doesn't have to be by cutting a normal fee.

Let's assume that Pat is going to have one more go at Happy. Here's the dialogue.

PAT: Happy, your offer is better but how can I justify spending $8,000 more to use you on this job?

HAPPY: I'd suggest that you explain the reality. Let's face it. If you wanted the $25,000 guy, you wouldn't be talking to me right now. In fact, we might not have ever gotten past the first few minutes of our previous conversation. You know he isn't your first choice, and I know that. Why? Might I speculate it is because you think I will do better work? Your client is going to spend several million dollars on advertising and collateral using the photographs that you commission today. How can anyone risk having less-than-excellent images in a multi-million dollar ad campaign when $8,000 will assure success? If that isn't true, then I can give you the name of my assistant. He is trying to get started in the business. He'd probably do the job for $20,000, so you could save $13,000 over my estimate. I know you don't want to take that risk. Why take any risk? You have a $35,000 client-approved budget. My work comes with insurance and the assurance that the job will get done the way you and your client need it. Pat, I think you have to decide if you want to ride in a Ford or a BMW. Can I start planning the job?

Pat is now up against the wall she put you against. It is now her decision. You have given her food for thought. She decides and you live with the decision. She decides in Happy's favor.

If the Pats of the world are constantly turning you down, maybe you are working in the wrong tier of the business. Maybe you are in B but ought to be in C. You have to find your working tier by the acceptance of your offers made in a fashion consistent with the value of work in any tier. If you cannot get the going rate, there is a reason. Grade C photographers can't earn grade B rates. You have to be honest with your clients and yourself if you are to find your niche and level. That is an important element in being successful at sales. And that, in turn, is important to success.

Confirming the Deal

Once the negotiation is over and you have been awarded the assignment, you are ready to move onto the post-selling phase. While that includes planning and doing the shooting, the very first step is much simpler and very important. You have to send the confirmation to Pat so both she and Happy have a record—the same record—of the deal. The confirmation also offers the benefit of reinforcing your good business ability in Pat's eyes. Working on the basis that Pat and Happy have worked out a deal under Scenario 1, the confirmation letter might look like this:

(On Letterhead)

(Date)

To: Ms. Pat Buyer
Art Director/Buyer
Amiable Advertising

Subject: Slippery Snowmobile Photography Assignment

Dear Pat:

Thank you for the assignment to shoot the images for the Slippery Snowmobile Campaign.

The assignment requires the creation of three photographs. One is an unmanned snowmobile in a snow-covered outdoor setting. The second is a snowmobile manned by two people being driven along a tree-lined and snow-covered path. The third is a single-manned snowmobile crashing through a small snowbank with snow flying through the air. Copies of the sketches supplied by you have been attached for reference.

The location for the work is to be in Colorado during the week of January 20 to 25. The deadline for delivery of finished images is no later than January 29. You require digital files of all images according to the specifications attached.

The expenses that will be incurred include:

Assistants & stylist	$ 1,750.00
Location scouting	1,200.00
Location permits or fees	600.00
Casting & models	4,000.00
Travel	2,900.00
Wardrobe	900.00
Film/processing/digital services	1,621.00
Total	$12,971.00

Creative, production, and usage fees are based upon eight days for preparation, travel, shooting, and post-production work plus the usage to be made of the photographs. The total of these fees for this assignment is $34,971. For this amount there will be a transfer of the full title to copyright in the images taken as part of the assignment. No rights can or will be transferred to any other party except that Happy Shooter may use copies of the images and the advertising in which they appear for the promotion of his business interests, in any picture books or photography exhibits, and as art for display purposes. If the images are used for publication of any kind after two years from the date of initial publication in advertisements, Happy Shooter will be paid an additional fee of $5,000 per year. Any applicable taxes will be charged in addition to the agreed fees and expenses.

1. Being fully insured, I am responsible for any liability incurred through my errors, omissions, and/or negligence. Likewise, Amiable Advertising is responsible for any claims arising from its actions or failure to act.

2. Should there be weather delays on the assignment, my fee for such days will be $800 for each day plus all expenses incurred including crew and model expenses.

3. Invoices must be paid within thirty days of the invoice date. Unpaid invoices are re-billed after thirty days, and a $50 rebilling fee applies. Payment is the responsibility of

Amiable Advertising as the purchasing party. If Amiable Advertising's policy is to make its payments contingent on payment from Slippery Snowmobiles, then I require a purchase order from Slippery Snowmobiles so I can bill them directly, if need be.

4. All original film and images produced remain my property. In the unlikely event that the original images from this assignment are lost or damaged by any party after delivery to Amiable Advertising the full extent of liability shall be the amount of the invoice for the above selected option.

5. Model releases will be secured from each person in the images. Copies of the model release to be used are attached. If a different model release is required, please notify me and provide a copy of the release with the acceptance of this estimate. A copy of the attached independent contractor agreement will be obtained from all service providers including models and assistants.

6. Any alterations, whether additions, subtractions, or otherwise, made to the images after delivery by me are the responsibility of Amiable Advertising and its client. Should a release acquired from a model fail to cover such alterations, it shall be the sole responsibility of the party authorizing such alterations. This also applies to any violation of the terms of a release.

7. Unless cancelled seven or more days before the assignment, this confirmation constitutes a binding agreement on the parties. In the event of cancellation, any unavoidable expenses incurred by the photographer prior to or after the cancellation will be paid by Amiable Advertising.

Once again, thank you for the assignment. I look forward to working with you on this assignment and in the future.

Warm regards,
Happy Shooter

What If You Lose?

What do you do if the buyer accepts your competition's estimate? There are two things you have to do. First, move on. You can't waste time worrying about the jobs you don't get. It's better to use the time to find new prospects, make new proposals, and close different sales. It's also better to work at getting a future job from the prospect that just selected your competition. Remember, you have been passed over for this assignment, not every assignment that Pat has to give out. With that in mind it is always good to send a thank you letter when you lose. Here's a letter that Happy might have sent if he had lost the job.

> Dear Pat:
>
> Thanks for the opportunity to bid on the Slippery Snowmobiles photography and for all your time spent in the process. You are a pleasure to work with. I am only sorry that we won't get to work together on the Slippery Snowmobiles campaign. Perhaps we will have the opportunity to do so in the future on another campaign.
>
> If I can be of any service to you, please call.
>
> I will stay in touch and keep you informed of the new work I am doing.
>
> Warm regards,
> Happy Shooter

Don't Skip Steps

You might be thinking that I have taken you and Happy through a lot of steps to make this sale. I have. That is why the sale was closed. It was closed because it was done right from beginning to end with no shortcuts. It was done to make the prospect not only willing to be a client but eager to be one. Every step was calculated to make the sale, get the assignment, and earn a fair fee.

Sales Negotiating

EGOTIATION DURING SELLING IS A PROCESS OF BAL-
ancing the competitive interests of the buyer and seller. Each
of you has something the other wants. Neither of you want
to give up more than you must to get what you want. OK, stop there.
I used the word "want." That is the killer word. We always want more
than we need. If we have to settle for needs, we usually will. Needs
provide for survival, and wants take care of luxury. In business, survival
is the first priority. Luxury comes only after survival is guaranteed. The
skillful negotiator knows that getting his or her counterpart to agree to
satisfy needs rather than holding out for wants is the key to successful
negotiating.

Negotiating during the selling process takes place as you try to
close the deal. Your estimate or offer is in the prospect's hands. You ask
for the job. You are greeted with an objection or two, maybe more. The
usual objections are about fees and rights. It's part of the business
culture, and you are not going to escape it. You have to deal with it,
and you can, if you learn to. You have to have certain skills, knowledge,
and attributes. Each can be acquired, if you do not have them already.

You have to be a good decision maker and able to live with your
decisions. Each negotiator has one or more decisions to make, and they
have to be made quickly. And you don't get to reverse those decisions,
so you had better be able to live with them—even the ones that you
later wish you had not made. You also have to be a good listener. Your
counterpart's point of view is very important. To understand it you
will have to listen carefully as it is articulated. Understanding
the prospect's reasoning is a key to offering alternatives that might
afford the basis of a compromise to settle differences. And, finally,

good negotiators know the value of what they do. They don't under-sell themselves. Anyone can resolve a disagreement by cutting price or giving away something for less. Good negotiators don't sell out.

Preliminary Steps

Before you negotiate you have to do some analysis. You have to con-sider what objections might come up as you try to close the sale. Fee levels are the most common. Everyone wants something cheaper than offered. Usage is another problem area. Prospects want more usage for lower fees. But there are other potential objections. Maybe the prospect will object to your asking for an advance on fees or expenses. Or it could be that the prospect will be finding fault with the number of days that you estimate the work will take. The good negotiator is prepared in advance to deal with those issues that he or she identified as possible problem areas in closing the sale.

Once you identify the problem areas you move to stage two, developing alternatives. Consider the example in the previous chapter. Happy Shooter knew that he would be asked to estimate for a buyout. He complied with an offer that carried a very substantial fee. But he knew that the fee would be challenged, so he offered a range of fees and rights. These alternatives gave him the means to conduct the third stage of the process, working toward mutual acceptance.

This mutual acceptance process was the dialogue conducted during two consecutive telephone calls. These phone calls were the discussion, the give and take that leads to the final stage of agreement. When agreement is reached, the negotiation is over.

The Aspects of Negotiation

Every negotiation has three aspects. These are the psychology, the methodology, and the substantive.

The psychological aspect is more related to mindset, confidence, and determination of the parties. The important thing to remember is that you cannot change the other person's reality, so you are unlikely to be able to change his or her psychological viewpoint. But having an insight into their point of view is helpful in knowing how far you can push the envelope.

Methodology has to do with the mechanics of the process. Finding out all the information needed, formulating offers and counter-offers, presentation of your offer and point of view, and the way you present your offer and make your counter-offers are all method related. The methodology deals with the who, what, when, and where of the negotiation. We'll look more closely at that subsequently.

The substantive aspect is mostly about rights and fees, although it can be about expense and fee advances, cancellation fees, weather days, deadlines, and any other of the substantive details of an assignment. The substance of a negotiation is always quite evident.

The Psychological Aspect

The most important factors of the psychological aspect are the mindsets of the parties, the nature of the individuals, and the power equation.

Many negotiations take place immediately after creative discussions between the buyer and the photographer. It is a moment in time when the photographer is very invested in the creative aspects of the assignment, but the creative frame of mind is the worst frame of mind to be in when negotiating. To negotiate, you need to change to your business hat and think about your financial needs. Get psyched for the negotiation. That means being determined to meet your own needs. Always remember this is about paying your salary and the bills and making a profit.

You also need to try to understand your counterpart's psychology. Are you dealing with the boss or an employee who would like to get it over with because he or she has too much work to do? Did this person impress you as straightforward during the steps that led up to the negotiation, or did they seem to have a hidden agenda? Are they using you as a bidder simply to justify the bid from another photographer that they really want to do the job? You'll never be certain of the answers to any of those questions, but you ought to consider the other person's possible motivation and mindset. It has a lot to do with how flexible he or she will be as you negotiate.

The Methodology

The place that you negotiate is important. People are more likely to interrupt a conversation in an office than a telephone conversation. You don't want to be interrupted when negotiating. The interruption could be bad news that takes a person's mind off the task at hand and creates concern about something else they are handling. Avoiding distractions is one good thing about negotiating on the telephone. You have the advantage of speaking right into the other person's ear.

One of the best methods to begin the negotiating process is that which Happy Shooter used in the previous chapter's example. The offer letter followed up by a phone call, or two, sets up the parameters of the deal from your point of view. The follow-up discussion is then conducted in an environment where there is likely to be a very direct conversation without distractions.

Making your offer in a way that allows you to suggest alternatives to any rejected offer is also part of the methodology. The estimate letter is a great way to do it. It allows you to present a menu of choices in the first place. You have created alternatives beforehand. It is easier to sell an existing alternative than to conceptualize one and then sell it.

Psychology of Power

An employee of an agency is more likely to be willing to compromise than its owner, because the owner has an investment to protect. A photographer's representative is more likely to make substantial compromises than the photographer because his or her 25 percent comes off the top even if the photographer takes a loss. The incentives of different parties can influence their psychological mindset in negotiating.

Some prospects try to intimidate the photographer in a negotiation. They hope to create a perception that it is their way or nothing. Usually this is done by a power display of some type. The most popular power play is one in which your competition is cited as the reason you should see the prospect's point of view. They want you to cave in because you don't want to lose the job to another photographer. However, if they wanted another photographer it is unlikely that they would be negotiating with you. It is not that you can't lose a job to the competition. Of course you can, and you will from time to time. My point is that, if they

wanted your competition, they would be negotiating with them. The balance of power in such a case is that you have been selected for the job. Now they are trying to get you to do it on terms more favorable to them. But the fact is they want you, not your competition. Your power in the process stems from the fact that they really don't want to exercise their power to work with your competition.

Another form of power that you face is inherent power. Your counterpart controls the eventual decision to give you the job. That means that they have an upper hand if you really need the work. Obviously, when a stack of unpaid bills is growing, and the jobs are few and far between, your ability to shape the deal is diminished. The only way to balance that kind of power is to have good financial reserves and/or a substantial sales effort underway at all times. If you are getting your fair share of opportunities to estimate work, then you know that any single estimate or job is not critical to your business.

The ultimate power in a negotiation is to say no. It stops everything. When a deal is not acceptable to you, you should say no to it. You can make a counter-offer on the heels of the word no, and possibly save the day, but the word no tells your prospect what your boundaries are and that its position is outside of those boundaries.

Risk and Fear

Another factor is in the ability to take risk. Can your prospect really trust the work to your competition? If you have secured the opportunity through the targeted type of promotion recommended in this book, I'll bet that they do not want to gamble. Are you prepared to gamble? The better your sales efforts and the more assets that you have, the more prepared you are to gamble. A strong marketing, promotion, and sales program—like money in the bank—allows you take reasonable risks in a negotiation, like saying no to a demand and offering an alternative as a compromise.

The most serious psychological element in a negotiation is your fear level. The risk of losing a job can lead to fear and then panic. Panic has been the catalyst for many bad deals in the photography business. It happens when you place too much importance on the outcome of the negotiation. Indeed, if not getting the job means you are likely to go out

of business, you have a pretty good reason to be fearful, but it's the rare case in which the loss of an assignment is going to be the final straw in a business' demise. Those who place too much importance on a single job are usually those who have inadequate marketing, promotion, and sales efforts. The way to avoid fear of losing a job is to have many jobs for which you can make an offer. Once again, strong sales efforts cure most business problems including the fear of going out of business.

Negotiating Tactics

Every skilled negotiator uses tactical devices to improve his or her effort in a negotiation. The need for tactical devices usually occurs when a negotiation bogs down and the parties are stuck on an issue. The most useful and appropriate tactics in the negotiation of assignments are easy to grasp and employ. Here's an explanation of each.

Ask Why? If you are presented with a demand that you cannot accept, rather than reject it immediately it is better to ask why such a demand is being made. Then using your good listening skills, take in the reasons for it. Understanding the reasoning behind a demand is the key to being able to create an alternative. If the answer you receive doesn't answer the question, simply point that out. This most often happens when a prospect answers your question with something to the effect of "because my client wants it." Indeed that may be true. But the next question from you has to be why their client wants it. Unless you know the reason for a disagreement, you cannot resolve it. Once you know that reason, you have a chance of resolution. If you don't get the answer, diplomatically repeat the question again, stressing how important it is to you to understand why a party wants something so you can try to understand why you should agree to it.

Be silent! After you ask the question why, be silent and wait for an answer. Listening is active. Hearing is passive. You cannot turn off your hearing. You can't listen while you're talking. Your silence also places all the pressure on your counterpart for the moment. You have asked a reasonable question, and they know you are entitled to a reasonable answer. If their demand was more bluster than need, the prospect may be unable to give a good answer. This often results in their being more prepared to compromise, because you have shown

them the weakness of their position with a simple tactical question followed by a silent demand for an answer.

The broken record tactic amounts to repeatedly asking for what you want until you get it. My favorite occasion to use this tactic was when asking for an advance on expenses, which I did anytime the expenses on an assignment would be over a certain amount. I'd start by making a unilateral assumption that I would be getting the advance: "Of course, I'll be billing you for half the expenses in advance of the job since they are so high." If the reply wasn't "OK," I'd restate my demand differently: "The expenses on this job are really high. You are asking me to tie up a lot of cash on this job until I get paid. I really need an advance on the expenses." If I got another rebuff like: "We don't customarily give advances," I'd reply with "I appreciate that fact, but I need an advance on this job. I am asking you to make an exception. Fifty percent is reasonable. Isn't it?" Of course you can push a good thing too far. If the broken record is starting to annoy the prospect, turn off the player; that is, drop the demand unless you cannot do the job without the advance, in which case keep the record playing.

Bold response. Prospects can try to back you into a corner in a power play. The most common is the threat to use a competitor unless you agree to the prospect's terms. Knowing that this is usually a bluff, a good way to deal with it is to simply call the bluff. Perhaps your client says "Your competition will do this job for half your price." You can try a reply of this sort: "If you really don't think I'm the right photographer for this job, I'll be happy to step aside. I know I'm the best person for this job, but if you don't agree, I can't argue with you. If you want to use my competitor, it is your option, but if you want to use me, we have to come to terms."

Trial balloon. This tactic is used it to test the waters without putting your client on the spot. For example, "What would you say if I told you my fee for this job was going to be $3,000?" Another example of a trial balloon is "How would you feel if I asked you for all the expenses in advance?" You have presented a "what if" question. By doing so you minimize the risk and leave yourself a chance to recover from a rejection. You haven't presented it as a demand, but rather as a test. If the reaction is favorable, you can adopt the position. If the

reaction is unfavorable, you turn the table by asking something like "You obviously have a number in mind. Tell me, what do you think is a fair fee?" You try your position without standing firm. This gives you the opportunity to back down without looking weak.

Nibbling. This tactic is employed after you've made the deal and you have the job. You might come back at the prospect-turned-client and say something like "How would you feel about giving me half the expenses in advance on this one?" If you get No for an answer, you have not jeopardized getting the job. If you get Yes, you have an advance.

Optional offer. An example of an optional offer can be something on this order: Perhaps you are negotiating for an assignment that requires models and a stylist in addition to the routine material and other expenses. You have asked for an advance only to be refused on the basis that the company frowns upon making any payments to photographers until after the work is accepted. You are facing a substantial layout of capital for models and a stylist so you are not prepared to give up some sort of advance, but the prospect is unwilling to write you a check. You propose an option to replace your demand for an advance. The option is that the prospect will pay the modeling agency and stylist directly, thus reducing your advance cash layout for the expenses. It is just as good as an advance to you, and it does not tax the prospect because they will not have to pay the others until after the work is done.

Tradeoff. The substance of a tradeoff is a conditional exchange of demands—if you will give to me, then I will give to you. There are not many opportunities to use this tactic in sales negotiation. It is a more common tactic in multifaceted negotiations like those surrounding labor contracts. However, it is possible. Here's an example. You have the good fortune to be the only photographer that the prospect can use on the assignment in question. Maybe it's because the prospect just doesn't have time to explore other options, or maybe it is because you are so uniquely qualified or equipped for the job. You have demanded a credit line with the picture and the prospect has absolutely refused to give it. You also want two days to do the shoot. The prospect is pushing for one day but has not absolutely said no. The prospect says no to the credit line because his client isn't going to allow

it to appear in print that way, and the prospect knows the advertiser will never change that view. You know that. So you offer a tradeoff. You will drop the demand for a credit line if the prospect will pay for the second day. You know that the prospect can get the extra money, while they cannot get the credit line approval.

Red herring. Herrings are fish that are mixed a gray and white color. Smoked herring turns reddish in color. In negotiating, a red herring is a demand that has been put up as a smoke screen. It is a demand that you make even though you will not be able to get it. Why would you do that? So you can trade it off later. In the example of the tradeoff in the paragraph above, your demand for credit line was a red herring. You knew you would never get the credit line.

Don't look weak. Look the prospect in the eye when you're talking. Stand or sit up straight. Don't lean up against the wall or hang your head down like you need support. Look confident. Speak with a strong voice. Slouching in a chair, leaning over a table, or burying your head in your hands can be seen as signs of weakness. Just as talking too loudly is a sign of aggressiveness, talking too softly is a sign of weakness. Avoid any behavior that makes you look less than absolutely confident that your position is sound, correct, and to be adopted by all.

Don't mince words. Say what you have to say clearly, and don't send out confusing signals. For example, if you don't like a prospect's offer, and you have you an alternative as a counter-offer, say, "No, I can't accept that, but I have an alternative." If something is unacceptable, it's simply unacceptable, and that is OK in business. Don't try to sugarcoat the fact that you won't accept something. Doing so can make the prospect think that you might give in if they hold fast. It's better to let them know where you really stand and how firmly.

TINSTAAFL: This mnemonic device helps you to remember the fact that There is no such thing as a free lunch. In business you get what you pay for and you pay for what you get. I used to carry small cards like the one below. Whenever a prospect was pushing me to do the job for less money than a job was worth I would introduce her to TINSTAAFL. I even had a little card like that in figure 28.

After the prospect had had a few seconds to absorb the message, I would chime in with "If I did the job for the price you offer, I would

Figure 28

Tinstaafl

There Is No Such Thing As A Free Lunch
In business we get what we pay for.

have to cut back on service or quality. This is an important job for you and me. Neither of us wants to sacrifice quality. I am in a business just like you are. I can only give what I get paid, and you can only get what you pay for. Cheaper isn't the way to get better. Nothing is free."

Copyright Demands

Many photographers have a very difficult time when it comes to negotiating copyright ownership with a prospect. One major reason for this difficulty is that most photographers do not know enough about copyright to be able to negotiate the details of it. Many photographers have a faulty understanding of the subject because they have gotten their education from other photographers who do not fully understand it. Rule number one in negotiating is that you cannot negotiate the terms of something that you do not understand. So you have a serious choice to make. Are you going to spend the time to learn all you need to know about copyright, or are you going to set that issue aside in terms of your assignments? If you want to learn all you need to know about copyright to be able to discuss it knowledgeably, there are a number of good books on the subject, some published by Allworth Press, the publisher of this book. You ought to read them—all of them. If you can't read them all, be sure to read these two: *Legal Guide for the Visual Artist* and *The Copyright Guide*.

However, if you are like most photographers and pressed to your limits just to keep up with the learning required to cope with the many changes that are underway in photography because of the digital evolution, then you will most likely want a simple way to handle the copyright issues you will face in negotiating assignments. Fortunately, there

is a simpler way, and it is more reflective of the current state of affairs in the marketplace than the advice given in books written a decade ago.

Before 1978, unless there was an agreement stating otherwise, when a photographer did an assignment all the rights automatically belonged to the commissioning client. Photographers were generally quite happy with the way things worked. We didn't quibble over rights. Sometimes, we received some of the rights back from the client, especially in magazine work, because the images could be marketed to other publications, and publishers didn't care if you did that as long as you did not market their images to a competitor. The law changed in 1978, and the U.S. Congress gave all creators the ownership of the copyright of work they create on the commission of others except under a few specific circumstances. Ever since then, there has been a contest between photographers and clients over the ownership of rights. The clients have the economic clout to freeze the photographers out. They hold the purse strings, and, if you want some of the purse's contents, you have to either comply with their wishes or be uniquely desirable for the specific assignment. Unfortunately, most assignments do not require unique talent. A competitor of equal talent who is willing to surrender more rights for the same fee as you offer is likely to get the job. It is just a value equation for the prospect. More similar quality for the same fee is better than less. That is difficult to overcome, as economics is a hard reality in business, and better deals are more appealing to all of us. You cannot combat this in daily business. All you can do is accommodate the reality. Still you have to have some reasonable manner of dealing with the issue. One way to deal with it is by taking a different approach than your competition when he or she concedes without attempting to negotiate to retain some rights.

Differentiation can be achieved by dealing with the needs of the prospect rather than the wants of all those dispensing with copyright advice. You start on that path by never using the word copyright in the negotiation of a proposal. You only refer to copyright after a deal is done or near done and the issue of usage has been determined. When you read the dialogues in the previous chapter you might have noticed that our friendly photographer, Happy

Shooter, mentioned copyright only in an affirmative, rather than confrontational, manner. If you don't remember that, maybe you ought to read the dialogues again.

Prospects generally want "all rights" or a "buyout" for very specific reasons. Understanding the reasons is helpful in trying to fashion usage to meet their needs. Let's look at a few of the reasons.

- Corporate image and proprietary information are very valuable. Companies want to protect both. They do not want their product or service associated with anything negative. They do not want their personnel's images used in any way that might be even remotely unflattering to the individual or company. These things have happened to companies, and they want to guard against it. Having all rights is a way to protect their interests.
- Liability is another concern. Prospects that buy substantial amounts of photography are aware that there can be lawsuits for lost or damaged original photographs. They do not want to defend a lawsuit for such a loss, especially when they paid to have the photographs produced in the first place.
- Prospects prefer to make as much use as they want (not need) and all rights gives them that right. Again, we all want as much as we can get for our money.
- Prospects often want to avoid negotiating any future usage because once they are committed to a photograph they cannot change easily or cost effectively. Their fear is that you will hold them up for an unrealistic fee for that future usage because you will have the power.

In the previous two chapters the photographer anticipated these concerns and offered a proposal that was meant to relieve the prospect's concerns. Happy Shooter, recognizing that clients have "fears," accommodated them in his estimate. He offered exclusivity to take care of the corporate image and proprietary interest concerns. No one else was going to have the use of the images. He offered liability relief if the images were lost or damaged. He didn't get hung up on some esoteric argument about the value of images. He simply

recognized that the images wouldn't exist if the prospect didn't pay for them so he had no real investment in them. He offered all rights (the prospect's want) in the form of the copyright for a substantial fee, and then provided alternatives by making it less expensive to purchase all rights for a limited period of time, which is what the client needed. Finally, he included a way that the client could escape the fear of future negotiations by setting reuse fees in his initial estimate. Happy's common sense told him that he was not going to be shooting pictures that had high resale potential. He had the best opportunity to make money from the photographs right in front of him, not from future sales. Consequently, he did not seek to retain residual rights so he could make future sales to other parties. He did, however, build in a way to make future revenues from the advertiser. Happy's objective in business is to create an ongoing stream of revenues, but he has no illusions about losing a job in the present due to the hope of making more money from the images later. He simply wants to be paid fairly for the work and its use. If he had a substantial probability of making more revenues from using the assignment photographs as stock photography, he would have bid a lower fee to make his retention of the necessary rights appealing to his prospect.

As you can see, it is possible to deal with the prospect's needs and wants when it comes to the rights they want and/or need to acquire. Understanding usage and having a simple system for dealing with it is a key to managing a negotiation.

All Rights and Buyouts

Buyers of photography often use the words "all rights" and "buyout" to indicate that they want unrestricted use of the photograph(s) that they are commissioning. Buyers can also mean that they want the exclusive use in addition to unrestricted use. While the term "buyout" is not a legal term the term "all rights" is an imprecise legal term as in the phrase "all rights reserved" that often accompanies copyright notices on creative works. You should avoid the use of the term buyout because it is undefined in the trade. "All rights" means exactly all (each and every) rights that exist. Granted exclusively and without termination, all rights is the same thing as providing a copyright transfer.

If you limit the term that the client will own all rights or all rights exclusively, you are retaining the copyright while giving the buyer the right to exercise all the copyright rights for a specified period of time. Granting a time-limited transfer of all rights is better than making a transfer of copyright because it keeps ownership in your hands.

Rights and Market Segments

In the advertising market the common demand from buyers is for copyright or an exclusive grant of all rights. Advertisers want their images themselves to protect the perception of their products and services. In the corporate segment, the buyers will most often want the copyright or an exclusive grant of all rights to those images that identify the company or its processes. These are usually called proprietary images. In the editorial market the buyer usually wants limited rights. The exceptions would be prestigious magazines that want copyright or an exclusive grant of all rights only for photographs used on the cover of the magazine since the cover is its flag in the trade and as precious as a logo is to the corporate buyer and the product or service identity is to an advertiser.

The examples offered in this book are framed in the context of the advertising market because it is the most difficult market to penetrate successfully. The approach to estimating and negotiating assignments of corporate and editorial market segments is no different than that employed in the advertising photography deal. All that changes is the level of the fees and the extent of the rights needed. Those changes grow out of the fact that advertising photography has a production component that corporate and editorial photography do not usually have, and the result is that the cost of the average job in corporate and editorial photography is lower than in advertising.

Corporate photographers will often find complacency on the part of the buyers of their services. This complacency exhibits itself as an interest only in how many days of work are necessary and how much it all costs. The corporate photographer will most often be negotiating to retain useful rights and for an appropriate fee for the level of rights demanded.

Editorial photographers will run into the problem that buyers will rarely negotiate since they are forced to adhere to day-rate fee schedules set by the publisher, and the only way to increase the fees to be paid is to increase the number of days that the assignment will take. This rarely happens because most editorial assignments are of a nature requires that no more than a few hours to a full day on location. However, when a photographer has unique access or a unique capability it is possible to negotiate higher rates than the publication's standard rates.

The best strategy corporate and editorial photographers can employ in a negotiation is to ask for higher fees than what they think the prospect is willing to pay for the level of rights being demanded. Then base any reduction of fees on some concession on rights, allowing the photographer to exploit the residual rights by using the images as stock inventory. Keep in mind that the corporate and editorial photography segments offer a great opportunity to build your business. This will allow you to support your enterprise and negotiate for higher advertising fees with the independence of knowing that your corporate and editorial work are paying the freight and your advertising fees are making you the higher profits that you seek. Having a strong financial base through corporate and editorial work is empowering when you negotiate in the advertising marketplace.

Usage and Value

You can simplify dealing with usage issues by having a simple value chart. In its simplest form, terms usage can be divided into four basic categories: limited, unlimited, exclusive, and nonexclusive. The chart in figure 29 portrays the relative value of the categories.

Figure 29

Exclusive	Unlimited	Highest value
Exclusive	Limited	Upper middle value
Nonexclusive	Unlimited	Lower middle value
Nonexclusive	Limited	Lowest value

The rights/value levels in the chart can be put into real-world terms easily. Looking at the editorial magazine marketplace we can see examples of the principle in action. Magazines like *Time* and *Newsweek* deal in the exclusive categories of rights. For a cover, they insist upon exclusive rights for any purpose and for all time. That is exclusive unlimited. For inside use they insist upon exclusive use for a limited period of time, with additional payment for additional editorial use. That is exclusive rights limited by time and additional use. They generally pay three to four times the inside, full-page space rate for the cover. That is, if they pay $500 for an inside full-page photo, they pay between $1,500 and $2,000 for the cover. So we can see that a jump from second place to first place warrants a multiplier of three to four times. Lower tier magazines will usually want nonexclusive rights limited to one use in one issue of the magazine. This nonexclusive limited use will not command a high fee when compared to the cover of *Time* or *Newsweek* magazine. Likewise, if a publisher wants to run your images on a non-exclusive basis but in several issues of one magazine or in different magazines, the value increases.

To better understand how the chart can help you establish relative values, it is important to understand the parameters of the terms. Exclusive means that only the person to whom you grant the rights can use those rights. You can assign all rights or any number of rights exclusively. For example, you could assign print media rights only on an exclusive basis in place of all rights. Limited means that there are restrictions on the use. What restrictions might there be? Time, distribution copies, and/or region are good examples. Obviously the opposite terms have opposite parameters. Regardless of the parameters, the concept is that the more you buy, the more it costs. It's a quantity proposition.

In editorial work, the fees do not come close to the fees paid for middle-level advertising assignments, and they are also lower than the fees paid for most corporate photography. But lower fees are no easier to negotiate than higher fees. Each prospect has a budget. That budget limits the amount that they will spend on photography for a given job or a given year. They have a perception of the value of

photography from experience—the experience of buying it. They know when a photographer is overpriced, and they know when a photographer is worth the higher price.

Fee Negotiations

Negotiating your fee is always the hardest task in a selling situation. The reason for that is because photographers do not have and have never had an industry-wide pricing method. It is impossible to price creativity by formula, and your fees include your production and overhead costs plus your creativity. You can isolate the production costs and know your overhead, but how do you put a price tag on the creativity that you bring to any job? You can't— at least you can't do it before the job is done. After it is over you know, or at least have a good feel for, the level of creative energy that went into the work, but can you really put a price tag on it? I don't think so, and neither can your prospect or client. But each of you knows that some jobs require more creativity than others. For example, a studio photograph of a teacup and saucer on plain white background requires craftsmanship, but how much creativity does it take? It takes some creativity, but not as much as shooting a snowmobile crashing through a snow mound in a winter mountain setting.

The fact is that much work that photographers do requires careful craftsmanship, but it doesn't tax the photographer creatively. While most photographers will try to be more creative than the job calls for, according to the client's specifications, there is often little room to introduce highly creative thinking into an assignment because either time or circumstances do not allow it. This means that you have to distinguish between what I call the "bread and butter" jobs and the "champagne" jobs. Most businesses run on bread and butter jobs, and they get a real boost in monetary and psychic income from the occasional champagne job. The first thing you have to distinguish before you offer your fee or negotiate it is which kind of job are you being considered for. You will have more serious competition for the bread and butter job, and that means that you have to be more conservative in pricing it.

Decide your fee on the basis of the level of experience, capability, and creative talent that the job really requires, and how much better you are than your competition when it comes to the kind of photograph you are being asked to make. If your fee is questioned or challenged, use those factors to sell the fee. Remember TINSTAAFL!

You can point to other assignments of a similar nature, whether done for the same client or a different one. Demonstrate that you received a fee similar to the one quoted for the present job being negotiated. Show tear sheets of the similar work that was similarly paid. It is your responsibility to justify your fee. Do it with facts and common sense. Quality includes completing the job on time, within the estimated price, and in a creative manner. That is what you are pricing. Anyone can deliver a photograph that meets the prospect's basic needs, but you are going to deliver a photograph that meets the prospect's wants. This is more about selling than negotiation. It is a good time to be a "broken record." Be direct and confident. Reassert that your fee is reasonable.

An Important Question

If your prospect cannot accept your fee offer, then try asking a question like "Based upon your experience, what do you think the fee should be?" If the prospect's answer is close to yours, you can compromise. If it is not, you have a problem, and you have to ask them if they really want to work with you specifically. You cannot cut your fee by a substantial amount. If you do, you have told the client that you were just trying to exploit him or her with your first offer. The job cannot be worth $5,000 when you present it and $4,000 the next day. That is a 20 percent decrease, which is saying that you padded the estimate by 25 percent. Do you want to work with people who pad their estimates to you?

No matter what people preach to you, there is no such thing as the right fee. If anyone knew the correct fee for photographic assignments, he or she would be indispensable, famous, and wealthy. Fee negotiation requires balancing interests: yours, your prospects', and, in the case of an ad agency or design firm, their client. Your fee has to reflect the value of the photograph to the prospect while

preserving the value of what you bring to the job. Value is relative to the experience, creativity, capability, and reliability that you bring to the job, and it is relative to other costs the prospect will incur in the project. When a company is doing a million-dollar media buy for ads, it is not looking for the cheapest photography around. That would diminish the return on the advertising investment. Keep that in mind. Tell the prospect that if they want to maximize their client's investment, the best way they can do it is by maximizing the quality of the photography. And that means that you are the right person for the job, and that the right person costs more than the wrong person.

Certainly you have noticed that the most successful photographers have a bit of an ego. If they didn't, they wouldn't be successful. That, however, is not permission to be rude, abrasive, or anything other than a decent and respectful person. Having a high opinion of your own talent and worth does not give you a license to be anything other than decent. In fact, it should compel you to be superior in that respect.

Always keep in mind when closing a sale that what you do has value. If it did not, the prospect would not be trying to buy it. You know the value of your services. The prospect might not agree with you. If you can develop a good rapport with your prospect, you might be able to get the prospect to share insights into the value of a job with you. That is not easily done, and it usually requires that you have some kind of ongoing relationship with the prospect. But your value increases as your rapport with the client does. When a prospect convincingly tells you that he or she wants you to do the work, but that the fee cannot be more than a given amount, you have achieved some level of rapport. You have convinced the prospect of your value and gotten the admission that they cannot afford your price. It is up to you to decide whether to meet their limits. Maybe you can do it with a reasonable rationale for lowering your price. Reasons like I want to show you what I can do, or because you are such a good client, are acceptable reasons to lower a fee, but not to take a loss. You might not be able to do that. Some differences of opinion cannot be resolved. Sometimes you have to say No. No one ever went out of business by saying No to a bad deal. Many

people have gone out of business by saying Yes to bad deals. Stay out of the latter group. Know your value and don't work for less unless you surely know that it is a one-time step to achieving greater value in the future.

The Bottom Line

You must have a bottom line when it comes to fees. That bottom line is usually based upon the costs of operating your business. Every day you work on assignments you have to earn a certain average of dollars to stay in business and pay yourself a reasonable salary. You should have calculated that in your financial and sales planning. This fee-per-job is your bottom line. When a job doesn't measure up to that level, you ought to pass on it. If it does, you have a reason to take it. Whether you take it or not depends on how badly you need it. In times of good business we are inclined to pass on marginal jobs. When business is scarce we are often happy to have them.

You should avoid thinking that it is OK to take a small loss on some jobs because the cash will come in handy and you can make it up on another job. You are better off borrowing money to tide you over than financing operations with price cuts. History has proven over and over again that taking a loss is not a path to success.

Your bottom line is also a great decision-making tool in one special way. When a prospect puts an offer or counter-offer on the table and tells you that it is a take it or leave it proposition, it becomes quite simple to decide. If the offer is below your bottom line, you refuse it. When it is on or above your bottom line, you take it.

Common Sense

The struggle over who owns the rights to assignment photography will continue. There will always be photographers who are staunch defenders of their rights and who will not surrender them easily. Photographers need to be encouraged to preserve and protect their copyrights. They are valuable. Retaining your rights will always be dependent upon a meeting of the minds between you and your client. Nothing promotes a meeting of the minds like common sense.

At one point when I was heavily engaged in the photography business and the battle for rights was waged everyday, I was asked to speak to a group of art buyers. I prepared and delivered written copies of my talk to the buyers. Subsequently, the paper has been published and re-published in a number of publications. Now, twenty years later, the paper is still applicable to our business. Accordingly, I have included a slightly revised version of it. I do it in the hopes that it will give you some insights that will help you to build meeting of the minds with your clients and prospects. It has been reported to me that it has helped many photographers do that.

Common Sense and Plain Dealing

Ralph Waldo Emerson once wrote: "Nothing astonishes men so much as common sense and plain dealing." Photographers and their clients could profit immeasurably if each lived by Emerson's words in their daily dealing over the rights to use images.

Professional photographers and their clients share at least one thing in common. They own businesses, which have to be run like businesses, if they are to succeed. Every business has needs and the right to fulfill them. Consequently, many business owners appreciate that a mutual concern for each other's needs is simply common sense. And plain dealing, through negotiations aimed at meeting each other's needs, is the way to a fair deal. People fight out of need more than greed, and the key to resolving any conflict is to meet the needs of both parties. Hence, the first step requires an acknowledgment of these needs by the parties involved.

Let's look at the needs of the typical client being serviced by the typical photographer.

Clients need to:

- Exploit every dollar they expend to the maximum.
- Maximize their income to assure their future profits.
- Protect their corporate images from harm.
- Avoid disadvantaging themselves in future dealings.
- Avoid liability and damage from unforeseen circumstances.

193

Now, when a client makes a demand that a photographer sign over his or her copyright, it is usually for one of these underlying, abstract, but understandable reasons. However, what the photographer hears from the client is something quite different. Clients say that a copyright must be transferred to protect a proprietary process, or corporate identity; they say that they do not want to have to renegotiate additional use; they say that they must have it because their legal departments have told them that this is the way to do it.

All of these arguments are understandable but unconvincing to the majority of photographers who put their hearts and souls into their work. Photographers, like their clients, are in business, and, in fact, share many of the same needs. And, when working together, clients and photographers also have similar interests. Both desire a quality job, that they can exploit and from which they can obtain future value, and for which they will exchange fair value. This makes perfect sense. Now let's get to plain dealing.

Photographers have to recognize that their clients have the right to fulfill their needs. Supporting that right and fulfilling those needs is good business. Clients must also recognize that photographers have the right to fulfill their own needs and recognize and support that right. However, many businesses fail to see the needs of their photographers. They take a shortsighted view of the business relationship and try to win it all in their negotiations, under the assumption that the supply of talented photographers will never shrink. In other words, they put copyright control as their bottom line and tell photographers to take it or leave it.

Take-it-or-leave-it copyright demands bring to mind the story of the shortsighted businessman who made such a good deal with a critical supplier that it put the supplier out of business, which in turn crippled the buyer's business when other suppliers could not meet his demands. So let's examine the other side of the story. Why should photographers need to retain the copyright to their works? The answers are simple. Photographers' business needs are: To establish a body of work that serves as asset and identity; to have the right to promotion by showing the fruits of labor; to increase future income

and profitability to assure future stability and growth; and to guard against improper exploitation of creative efforts.

Just like the needs of any business, the photographer's needs are logical. But let's look at some specific needs of the client commissioning a photography assignment. From each job, the client needs the right to:

- Increase usage and expand to other media.
- Control and maximize the benefit from expense.
- Maintain necessary confidentiality and exclusivity of use.
- Have predictable costs and avoid uncertain future pricing.
- Profit from commissioned creative work.

Interestingly enough, this set of needs is not irreconcilable with those of a photographer. In fact, it is competitive and complementary at the same time. The competitive aspect rests solely in the price to be negotiated. Each party wants the most to be gotten from the investment of time and money. This kind of competitive interest is good for the relationship and is easily negotiated. The interests of each party are complementary in that neither side is in conflict with the other. The needs of each can be met with simple understanding based on common sense and plain dealing. Here's how:

First, it should be stated that the copyright can be bought or sold when deemed appropriate by both the client and the photographer (anyone can sell an asset). However, it isn't necessary. There is no client need or interest regarding copyrightable work that cannot be licensed and contractually provided for by the photographer/copyright owner. For example, pricing of future uses, expanded circulation, reuses, etc., can all be agreed to in the early stages of a negotiation. Whether by fixed fee, percentage of original fee, or by no increase in fee at all, both the financial interest of the client, as well as the right to exercise such future uses at will, absolutely can and should be protected.

Clients often have a need to protect their image, processes, executives, and employees from undesired exposure. This proprietary interest can and must be protected. Again, this can be done by the photographer who as copyright owner should agree not to

license such images for any other use by anyone except the original client. When clients protect their needs and secure only the rights they need, the photographer is able to exploit the value of the non-proprietary images for his or her future gain, whether indirectly from the promotional value of the work or from the residual value in the rights not granted to the original client.

On the photographer's side, the majority of photographers make some share of their revenues from the sale of residual rights. These revenues contribute to the profitability of the business, which in turn keeps the general cost of assignment photography lower. It is simple mathematics. If a photographer cannot use a commissioned work to obtain residual fees, it will simply drive the price of commissioned work up and up. If you take away that right, you must pay the price to cover the loss of that right.

A simple understanding of the needs of the client and the photographer can lead to a dramatically improved working relationship—one in which the photographer and client work together to produce the finest possible images, at the best possible price; one in which the photographer and the client get all the value to which they are entitled by their needs, not their wants; and one in which the mutual dependency of both parties is recognized and provided for. The interests of photographers and clients are not irreconcilable. These interests can be accommodated by negotiations aimed at meeting the needs of both the client and the photographer. The simple fact is that all of this conflict over copyright ownership could be put to rest with common sense and plain dealing.

Getting Paid

NOTHING IS MORE FRUSTRATING THAN COMMITTING YOUR time and money to doing a job and then not being paid for months or perhaps never being paid. During my fifteen-year tenure as ASMP's executive director, I spoke with hundreds of photographers who were having such problems. In some cases I was able to advise them and they collected. In some cases ASMP intervened using its "good offices" to pressure the late payers. ASMP even had an arrangement with a collection service for its members, and when that failed we were quick to advise members how to use the legal system as a means of collecting.

Reasons for Nonpayment

After you have done everything right to get clients and jobs you still have one more very important, if not the most important, task: You have to get paid. Experience has taught me that photographers do not get paid for a few reasons. These are

- The purchaser intended to bilk the photographer.
- The purchaser is bankrupt.
- The purchaser is having cash-flow problems.
- The job was unsatisfactory.
- The invoice was lost by the purchaser.
- The photographer did not comply with the client's purchasing process.
- The photographer never sent an invoice.

Let's look at each of these in turn.

Bilking the Photographer

An unfortunate fact of business is that there are con artists who are hard at work trying to find ways to steal from you. While it is rare, some photographers have had their work stolen, when they expected payment for it. This most often happens with stock photography. A person solicits stock images for a project. The photographer sends his or her valuable images with the intent of making a sale. The person is never heard from again. The photographer thinks the person is just taking a long time deciding. When phone calls are not returned the photographer sends an invoice for holding fees. It doesn't get paid. A few months later the photographer sees his or images in print. Pressing the issue to get paid, the photographer learns that the phone is disconnected and the person who requested the images is nowhere to be found. When the image user is contacted, the photographer finds out that he or she thought the person who was in fact paid for the images was the photographer's agent.

Welcome to the world of white-collar crime. Someone just used the photographer's images, maybe several photographers' images, to sell to a user who legitimately paid for them in good faith. The photographer is not going to be able to get paid for the use of the images because the user paid already and is also a victim of the same crime that victimized the photographer. The police are sympathetic, but they have a backlog of much more serious crimes to work on. This new crime is on the list. Maybe they will get to investigate it in a few months or even years. The photographer isn't going to get paid in any event.

I was always amazed when photographers were defrauded in such a fashion. I could never understand how any photographer would send off images to any party that they knew nothing about. There is only one way to avoid being such a victim, and that is to take precautions. Here are a few:

- Ask for references.
- Search for the name on the Internet to see if you can establish its legitimacy.

- Go on photographers' Internet list servers and ask if anyone has heard of them.
- Send low-resolution digital files or small prints for review.
- Recognize that sending an original is like sending money. Treat everything accordingly. You don't send money to strangers, do you?

In the end, if someone does defraud you, you just have to accept the fact that it was your turn to be one of life's victims. You can deter thieves, but you can't stop them.

Bankruptcy

Businesses go bankrupt. When they do, the money they owe you and whether and how much you get paid are subject to a complex body of law and long action timelines. You are not going to be able to do anything but wait for an outcome. Secured creditors get paid first, and that usually eats up all the assets of the company. Photographers are unsecured lenders. They wait. If unsecured lenders get anything, it is usually pennies on the dollar. If the bankrupt company is reorganizing, you will get paid something, but again it is pennies on the dollar. Once the bankruptcy is concluded, the company's debt is discharged, and you can do nothing to stop that. There is only one way to protect yourself from being damaged by a company's bankruptcy. Don't deal with financially shaky companies. There are ways to find out if companies pay their bills. We'll explore that subsequently.

Cash Flow Problems

Every business has occasional cash-flow problems. The difficulty with cash-flow problems is that they are contagious. Someone doesn't pay your client who doesn't pay you because they needed that payment to do so. Then you might not have the money to pay someone else. Of course, adequate reserves or good credit will get you past your cash-flow problem, but your reserves won't help you get paid.

You cannot adopt your client's problems when it comes to its inability to pay. You have no obligation to be a financier. Your best course of action is to have a collection policy and system. Many photographers do not want to pressure their clients who are late in

paying their bills for fear of losing their business. Good collections practices allow you to keep a friendly relationship until it becomes clear that the client is not such a good client to have. A sample of a policy and system will be presented later in this chapter.

Unsatisfactory Work

Unless you hear this claim shortly after you deliver the work it likely to be a bogus claim aimed at getting the price down after the work is done. If the client has used the work, it is satisfactory. If it has not, you have a problem that is deeper than collecting your money. You now face the probable loss of future business, and you will have to re-shoot or negotiate a settlement to keep the business. This is not a collection problem. It is customer-relation problem.

Lost Invoice

Have you ever lost an invoice or other important paper? Enough said. It happens. A good collection policy and program will catch and remedy this problem. Again, I refer to the sample system a bit further on.

Failure to Comply

All too many photographers fail to find out how to invoice the client. In many cases the photographer sends an invoice with the finished work to the art director or editor only, when the client requires it to be sent to the accounts payable department. Do not assume the person receiving the work will pass your invoice on. Almost every company has a policy for receiving and handling invoices. Here are the things you need to know about invoicing any client.

- Who (person or persons) should the invoice be sent to?
- What department is (are) this person(s) in?
- Is the department at the same address as the purchasing party?
- How many copies of the invoice are required?
- What client reference(s) must appear on your invoices to identify the job?
- What is their payment cycle?
- Who should you contact if the payment is late?

The last question above has a subliminal effect. It puts the client on alert that you are attentive to such details as getting paid on time.

No Invoice Sent

Yes, it happens. The photographer is a one-man shop and has to rush from one job to the other and maybe the next job is a two-week trip. Upon returning from the trip the photographer is faced with post-production work, new estimates, sales work, and the other things in life that didn't get done while he was away. Invoicing the earlier job slips through the cracks. The client can't pay invoices before they are received. Once again, the system will solve this problem.

Collection Policy

A good businessperson has policies to govern his or her actions. The advantage of policies is that you do not have to make decisions about how to handle situations as they come up. You already have a policy for handling that situation. The most important policy your business can have is a collection policy. After all, getting paid is why you are in the business and what allows you to stay in business. You don't want to be wondering what you should do when you have to collect money. Every day you waste in a collection process means that you are less likely to ever collect. The fact is that businesses that are having problems paying often get worse before they get better, if they get better. Proper and prompt collection practices are essential.

Efficient Recordkeeping

Keep an accounts receivable tracking log such as that in figure 30. Enter every job on it when you are awarded the assignment. This way you will not forget or fail to do it because you have other pressing work. Check the list for overdue invoices at least once a week.

Send invoices as quickly as possible after the work has been delivered. In many cases you have to wait until your final expense bills are received before billing the client. Consider sending an invoice for fees immediately and a second invoice for billable expenses. Send a completed invoice with the finished work, if you are able to, but be sure that doing so complies with the client's payment policy.

Figure 30

Accounts Receivable Log

CLIENT	JOB REFERENCE #	INVOICE DATE	FOLLOW-UP DATE	PAYMENT RECEIVED
Acme News	Rally photos	June 15	July 20	July 1
Advance Adv.	P.O. # 65473	June 21	July 5	In collection
Green Corp.	AR photos	June 30	Aug 5	Aug 1
Hat Magazine	Hat show			

Always specify payment terms on your invoice. Be sure that they are reasonable terms. No one pays bills on receipt. Thirty days from the date of the invoice will accommodate the vast majority of companies' payment cycles. If payment terms are not met, begin the collection process.

Above you see paid, unpaid, and to-be-invoiced items. If the payment is not received by the follow-up date, you indicate that it is "in collection" so you know that you are working on it. Once the item in collection is paid, you change its status in the log.

If you use a computerized accounting program, this work can be done by setting up an invoice to be issued upon receiving an assignment. Enter the billing information on the invoice when created. You complete the details of the invoice when the work is completed. Either way, you have an invoice that is in the system. It will be part of your accounts receivable (AR) until it is paid. Calling up an AR list will provide you with the status of all invoices. Those with full details are ready to be issued. Invoices with no details are not. If an item is in the AR list it is not paid. At the end of the month you can print out all unpaid invoices complete with details and send them out. This way the system will be tracking the paid and unpaid invoices. The AR list should be by order of date that the payment is due. This way you will be able to quickly distinguish the invoices on which payment is overdue.

Collection System

The likelihood of being paid is enhanced by good systems. You have read about the types of problems that cause tardy payment and how to remedy them. Above you have a simple policy to follow in deciding

when to begin collection action. Now you need to begin the process. Collecting money can be quite aggravating to both the late payer and the collector.

Photographers don't like to push clients and clients don't like to be pushed. Still, you have to be paid. The system I am recommending starts out with very friendly reminders, which become progressively harder in tone. If you get to the end of the process, you are probably not going to have this client any longer. But you don't need clients that you have to take to the mat to get paid. Collecting money takes time, and time is money—*your* money. You don't want to waste it on deadbeat clients.

Like all good collection systems, this one is based on a timeline that is relative to the general value of overdue invoices. If you were being evaluated for a business loan, the lender would require a copy of your balance sheet to see what your accounts receivable amounted to. It would also probably require you to "age" the receivables. Lenders know that the longer overdue an invoice is, the less likely it is to ever be paid. When receivables are aged they are broken down into categories and assigned a relative value. Different lenders use different evaluation methods. This is the one that my bank uses:

Age of Receivable	Asset Value
Up to 30 days	100%
31 to 60 days	60%
61 to 90 days	30%
Over 90 days	No value

Aging policies of lenders tell you how fast you ought to collect your money. And they provide the basis for a timeline for collection action. You don't want to let invoices go unpaid for more than sixty days.

Figure 31 is a chart with a collection task list and timeline. This can easily be set up by hand or by computer. An efficient way to do it is in a spreadsheet program, because formulas can be used to calculate the task dates automatically. But, no matter how you do it, make certain that you do it.

The first invoice date is the date you send the invoice to the client, so be certain to send it on the date you construct it. It should

Figure 31

Client: Cumulus Cloud Advertising	Job Reference Number: P.O. # 12345	
AGED DAYS	ACTION/DATE	ADVANCED DUE DATE
0	1st Invoice date/September 12	October 12 (30 days)
35	2nd Invoice date/October 17	October 27 (10 days)
40	Telephone call/October 22	
48	1st Letter/October 30	Immediate
58	2nd Letter/November 9	Immediate
72	Final action/November 23	

clearly state in large letters: Payment due by (insert due date). People ignore messages like payment due in thirty days. The client set a specific deadline by date for you. Return the favor.

The second invoice date is five days after the payment due date to allow for tardy mail delivery. It allows ten days from its date for payment. This invoice should be clearly distinguishable from the first invoice. The best way to do that is to clearly state in large letters (red letters are best): Second Invoice—Payment Overdue—Payment must be received by (insert date).

Call the Debtor

The telephone call is made to your client's accounts payable department. Don't hassle the art director or editor with a call unless you think he or she can really get you some action. When you call, have all the information about the job and copies of both invoices and any purchase orders or other paperwork. This is an important call. You are going to be very friendly, but you are going to push for action. Once you have the person on the phone you might say something like this.

"Hello. I need some help with a payment that I invoiced back on (date) for (insert $). It was for photography on the (insert account name or job). I sent a second invoice last week, and I need to check on its status. Can you help me?"

If the person answers No, you say: "Please connect me with someone who can." Most likely they will help you or connect you with

someone who can. You repeat the same introductory message to everyone that you have to talk to. Once you get to the right person you ask when the check will be sent out, because you have to have the payment by (second invoice due date). If you get a commitment that the check will be sent by the required date, your call is done. If you do not, then you have to negotiate a date, if you can. If you cannot, it is probably a sign that the company is having some sort of problem. If so, you offer a suggestion like this:

"From what you are saying I sense that payment is a problem. I'd like to suggest that you make a partial payment now and spread the balance out over the next few weeks to make it easier. I'll be happy to work with you, but I do need to be paid something now."

You will either get cooperation or you will not. If you do not, the thing to do is get ready to send out the first letter on the task timetable. Send it out on time. The letter might read like this:

Dear (insert name):

My invoices (copies attached) have gone unpaid in spite of my attempt to work out a partial payment with (name) in accounts payable. As a businessperson, I understand that sometimes it is difficult to make timely payment of an invoice. But I don't understand anyone being unwilling to work out a payment arrangement, as I tried to do with you.

I want to be reasonable about this matter so neither of us has to deal with an unpleasant situation. This letter is an attempt to resolve the matter fairly and amicably. Please send payment in full immediately, or contact me to arrange a payment schedule.

I expect a reply no later than (insert date five days hence). Failing that, I will have to take additional action.

Sincerely yours,

(signed)

If you do not get the phone call to settle the matter, or a check, you send out the second letter on the date planned. It might be written like this.

Dear (insert name):

My polite attempts to amicably resolve your failure to pay the attached invoices and your failure to reply to my previous letter (attached hereto) force me to offer you this final chance to make payment before I take more severe action to collect the money you owe me.

Unless I receive payment in full immediately or a partial payment of (insert amount) along with a phone call to set up a payment schedule I will be forced to take the following action.
(insert option depending on your circumstances)
Option 1
A claim for the full amount owed will be filed in small claims court. The claim will name both your company and your client company, (insert their client's name), citing your company as an agent of your client. You can avoid a very unpleasant experience by complying with the above demand.
Option 2
I will turn the collection of this invoice over to my attorney with instructions to do whatever he deems necessary to collect my money from you or your client (name client). You can avoid a very unpleasant experience by complying with the above demand.
Option 3
I will turn the collection of this invoice over to a collection agency with instructions to do whatever it deems necessary to collect my money from you or your client (name client). You can avoid a very unpleasant experience by complying with the above demand.

Regrettably,

(signed)

Be brief when making threats. Long-winded threats lose their impact. The letter must be simple to understand and comply with.

Your final action is taken if the second letter goes ignored. You do what you threatened to do. If you do not, you will never collect any of the money owed to you by your ex-client. You have been as flexible and have shown as much patience as anyone should in trying to collect your due. When you are ignored in such circumstances you are dealing with a person who ought not be in business. If you teach him a lesson, maybe he will pay the next photographer. If a photographer before you taught him a lesson, you might not be having the problem.

Checking Credit

A great way to avoid deadbeats is to check a prospect's credit. I have been surprised at the number of photographers who will complete an assignment for a prospect for whom they have never worked before, is in a different part of the country, or they know practically nothing about without checking the credit worthiness of the prospect. There are five ways to check credit. One of them costs money. The others only take a little bit of your time.

A basic credit report can be obtained from one of many commercial credit-reporting companies. Basic credit reports can be acquired over the Internet and cost as little as eight dollars. A Web search under the heading "company credit reports" will produce a number of companies that offer such services. One company, Collection Industry™ can be found at *www.collectionindustry.com*. It offers a variety of reports, which vary in detail, and prices vary accordingly. D&B™ at *www.dnb.com* is another supplier, and it offers a collection service too. You should investigate and evaluate different services before you need them. Then, when some company asks you to lay out thousands of dollars in time and money to do work for them, you will at least know something about the level of risk you are taking by having a report on their credit history.

Credit references are a good way to check payment habits (not credit history). When you seek credit at a local supplier you will normally have to supply credit references of other businesses that have already given you credit. That is an everyday, normal request. You

may not want to ask the buyer for a credit reference, but you can ask the accounts payable department, which normally handles such requests. The problem with such credit references is that companies generally know which suppliers they are not paying on time, so they are unlikely to give you those names. Still, it is a good idea to check. Sometimes one supplier knows what is happening to another by virtue of the commercial grapevine.

Peer credit checks are also a good idea and easy to make. They amount to contacting other photographers who have worked for the company. You can ask your contact for a couple of names. Be honest about why you want them. Any person you call could report your call back to the person who gave you the name. You can put out a request for information on photographers' Internet bulletin boards and e-mail list services. Be sure to word any such request carefully to avoid any liability. Here's an example of a request for credit information:

"I have been asked to do some work for (name of company), which is located in (city, state). If anyone has had any dealings with this company would you please e-mail me at (your e-mail address)."

The message is worded in a manner to discourage any negative replies online. You do not want to initiate an Internet discussion about a company if negative things might be said about it. That is not to say that replies will be private as you asked them to be. But you will have asked properly, and if the person replying chooses to go public with negative information, it is their choice. You asked for a private reply.

If you are checking on a local company, you might be able to find a local photographer or two who has worked with the company, depending on how deep your peer network goes. If you belong to any local photographers' organization or chapter of a national organization, you should be able to ask at one of its meetings, assuming the sched-uled date of the meeting is compatible with your need for information.

Advances

If you are working with a company whose credit worthiness is ques-tionable, you should consider asking for an advance payment. An advance on fees and expenses is best, but at least an advance for

expenses is in order. That way you only risk a loss of your time and not of money spent to buy materials and services to compete the job. Getting advances from poorly funded companies is not easy. Companies that cannot pay their bills on time are unlikely to have the money to make an advance payment. Obtaining an advance on fees is not easy. You have neither done work nor delivered any product. Yet asking for an advance or a partial advance on expenses is reasonable, especially when the expenses will be substantial. You are a small business and your ability to finance the expenses of a larger business is limited. You can make a reasonable argument for an expense advance. If your request is turned down, it might be a reason to exercise more caution from that point forward.

Protecting Yourself

You can protect yourself in several ways when you are concerned about the creditworthiness of your prospect. Providing an estimate that contains one or more of several conditions is the key. Here are examples of language that can help you weed out bad payers and/or make your likelihood of being paid higher. I do not recommend using these conditional terms when you have faith in your prospect's ability to pay. They can raise red flags in your prospect's mind.

A "condition precedent" is a legal term that refers to a term or condition in an agreement, which precedes an occurrence to be governed by the term or condition. The principle is that if a party knowingly accepts a conditional statement before the assignment is begun, then the party cannot later claim not to be bound to comply. To establish a condition precedent you have to present it to the prospect before any work is done and in a timely enough fashion that the prospect could find another supplier. The best way to set a condition precedent is in the estimate and subsequent confirmation letters sent to the prospect. When terms and conditions are presented only on the client's invoice, they can be unenforceable because they are presented after the fact; that is, after the work is done and the client cannot back out. That is why estimates and confirmations are among the best legal assets that you can have. They represent the deal

that was made before the job was begun, not after the job is done. Here are two clauses that help protect you in the event you are dealing with a possible credit risk.

Option 1
The rights to use the images supplied as part of this assignment do not transfer to any party until full payment of all money due is paid. Failure to make full payment means that any use of the images is a copyright infringement, which may be prosecuted under federal law.

This option is a warning to the prospect that you might turn what would normally be a collection claim into a copyright infringement claim. Keep in mind that prosecuting copyright infringement claims can only be done in federal court. It is expensive to bring a case in the federal courts, so you are unlikely to actually do it unless the fees and expenses are high enough to warrant it and the use of the images is substantial enough to bring an award of damages sufficient to cover the costs of the suit, the money that went unpaid, and more.

Option 2
The rights to use the images supplied as part of this assignment do not transfer to any party until full payment of all money due is paid; therefore, payment must be made upon delivery of the work commissioned under this agreement.

This option is really a COD (cash on delivery) clause with a rationale attached for having it. It does not threaten a lawsuit. It threatens something much more immediately problematic—the prospect of not getting work they need to collect from their client. You can be assured that almost no one will ever accept this condition. So why offer it? You offer it because the prospect appears to have credit/payment problems, and you can offer to drop the clause for an advance on fees and expenses. If you use it, you cannot mince words when explaining why. You simply tell the prospect that you are

concerned about their ability to pay, and you have to protect yourself by a COD policy or an advance. If your prospect professes to have a good credit record, ask them to demonstrate it by a credit report or references. If that is refused, you might not need this client. Chances are they won't work with you anyway. Companies that consistently have trouble paying their bills don't assign work to photographers who show the resolve to collect what is owed to them. The best thing you can do if you have that kind of prospect is walk away. Then go find a good prospect; that is, one who pays its bills.

The Goal

You have only one good reason to be a professional photographer. You had only one good reason to read this book. This last chapter is all about those reasons. You want to get paid. Well, getting paid is the final step in a long process that starts with having a strategic vision of what you want to be paid to do. Follow the lessons and advice in this book and you will get paid as a professional photographer for many years to come.

Index